D0825522

DOUBLE TALKING
ESSAYS ON VERBAL AND VISUAL IRONIES IN CANADIAN CONTEMPORARY ART AND LITERATURE
DOUBLE TALKING

NOUS·SOMMES·PRETS

SIMON FRASER UNIVERSITY
W.A.C. BENNETT LIBRARY

NX 513 A1 D68 1992 c.2

DOUBLE TALKING

ESSAYS ON VERBAL
AND VISUAL IRONIES
IN CANADIAN
CONTEMPORARY ART
AND LITERATURE
EDITED BY
LINDA HUTCHEON
PUBLISHED BY
ECW PRESS

DOUBLE TALKING

CANADIAN CATALOGUING IN PUBLICATION DATA

Main entry under title:

Double-talking

Includes bibliographical references and index.
ISBN 1-55022-139-6

1. Irony in literature. 2. Irony in art.
3. Canadian literature (English) - History and criticism.*
4. Art, Canadian - History.
I. Hutcheon, Linda, 1947- .

NX513.A1D6 1992 C810.9'18 C91-095013-X

Copyright © ECW PRESS, 1992
All rights reserved.

Double-Talking has been published with the help of a grant from the
Canadian Federation for the Humanities, using funds provided by the
Social Sciences and Humanities Research Council of Canada. Additional grants
were received from The Canada Council and the Ontario Arts Council.

Set in Monotype Perpetua, Felicity, Perpetua Titling, and Gill Sans.

Design and imaging by ECW Type & Art, Oakville, Ontario.
Cover design and artwork by Gordon Robertson.
Printed and bound by The Porcupine's Quill, Erin, Ontario.
Distributed by General Publishing.

Published by ECW PRESS, 1980 Queen Street East, Toronto, Ontario M4L 1J2

TABLE OF CONTENTS

LIST OF ILLUSTRATIONS

PREFACE

This book owes its existence to the Robarts Centre for Canadian Studies at York University. In 1988–89, this research facility offered the context in which several colloquia and a regular faculty/graduate student seminar took place around the topic of irony in Canadian art and culture. For its hospitality, its intellectually stimulating environment, and its gracious "enabling" assistance, I should like to offer our collective gratitude. Special thanks goes to Sharon Harrison for her assistance with preparing the initial manuscript and to Susan Houston, then director of the Centre.

We should also like to extend our thanks to the editors and editorial staff of ECW PRESS, for their calm, skill, and enthusiasm. This book has been published with the help of a grant from the Canadian Federation for the Humanities, using funds provided by the Social Sciences and Humanities Research Council of Canada. For this we are most grateful, as we are to the Federation's readers whose reports helped make this a better book.

As editor, I should personally like to thank the authors of the articles for their cooperation, professionalism, and patience. Rarely has editing been such a pleasure. No doubt, that simply reflects my even greater intellectual pleasure in the time we spent together at York University before dispersing across the world to our now very different places of work.

Linda Hutcheon
Toronto, 1991

INTRODUCTION
LINDA HUTCHEON

. *University of Toronto*

ARE WE LIVING through an "irony epidemic"? In March 1989, *Spy* magazine announced that we were, and certainly in the mass media as well as in what we like to call "high art" · and the academy, there has been a lot of talk about irony lately. Why? After all, irony is nothing new; it has been around for a long time, if Quintilian and Cicero are to be believed (see too Gaunt; Good; Green). Some people blame (and that is the appropriate verb, given the tone of most commentary) the rise of what has been labeled "postmodernism"; others simply point out that irony is a popular *fin-de-siècle* trope and that the twentieth century is merely poised to go out on the same note upon which it came in. But either view neglects the important changes in the *use* of that trope over the last hundred years. One of the major changes has been the shift in the usage (and therefore meaning) of irony, from the idea of it as an absurdist, fundamentally pessimistic, and detached vision of existence (see Glicksberg) to the notion of irony as a more positive mode of artistic expression with renewed power as an engaged critical force, that is to say, as a rhetorical and structural strategy of

resistance and opposition. In other words, irony today is neither trivial nor trivializing, despite some Marxist critics' contentions to the contrary (see Jameson; T. Eagleton, "Capitalism"). As Italo Calvino once reminded us: "there is such a thing as a lightness of thoughtfulness, just as we all know that there is a lightness of frivolity" (10) — and the two should not be confused.

The focus of this collection of essays is the particular and "thoughtful" use of critical irony in certain works of literary and visual art in Canada today. From the very start, a few obvious qualifications are in order. Clearly, not only these art forms are (or can be) ironic, but some limitation is necessary in any discussion, and the similarities in the functioning of irony in these two arts seemed to warrant bringing them together and letting them play off implicitly against one another. Second, there is no intended sugges-tion that *all* Canadian art is ironic, nor that *only* Canadian art deploys irony in a critical manner. Nevertheless, the writers of these essays are not the first to see that there is a structural and temperamental affinity (though not causality) between the inescapable doubleness (or even multiplicity) at the base of irony as a trope and the historical and cultural nature of Canada as a nation. Indeed, one of the familiar clichés about Canada is its doubleness: historically, this was first inscribed in the "meeting" of native peoples and colonizers, of French and English, then reinscribed in the governmental con-figuration of Upper and Lower Canada; later the politico-geographic doubling came to be articulated as well in terms of east and west, north and south. There is also, of course, the French/English linguistic and cultural doubling and the federal/provincial and House/Senate legislative ones — as we know only too well in the last few years. In other words, many feel that there is something about Canada or maybe about Canadians that makes us, in Miriam Waddington's words, "sensitive / to double-talk

double-take / (and double-cross) / in a country / too wide / to be single in" (149).

Two particular features of irony as used by Canadians or about Canada form the specific focus of this collection: its inherently doubled formal nature and its critical functioning. As the long history of satire's deployment of irony shows (see Worcester; Büchner; Elliott, Hass and Mohrlüder; Rodway), irony has always been a critical mode; but what the more recent discussions about issues such as cultural specificity (as opposed to humanist universality) have done is to show how irony can potentially engage its critique from the *inside* of that which it contests. Saying one thing and meaning another (the basic semantic part of the definition of irony) is certainly one way of subverting a dominant language from within. Saying one thing and meaning another is also, by definition, a dialogic or doubled mode of address. And any attempt to juggle simultaneously both literal and ironic meanings cannot help but disrupt our notions of meaning as something single, decidable, or stable. The complex plural meanings of irony, then, as these essays show, are only grasped in context and with the realization and comprehension of double-voicing.

This is nothing new; it has always been the case. As historians of irony throughout the ages have shown at great length (see Quintilian; Knox, *The Word*, "On the Classification," "Irony"; Thomson; Muecke, *Compass* 47–52), though the scope of irony and its evaluation have changed, the elements of doubleness and critique have remained constant. The scope has changed drastically, of course. From being a limited rhetorical trope of classical oratory, irony (in the hands of the German Romantics) became a comprehensive vision of life; today it has changed again, as these essays show, into what could be called a discursive strategy — a notion that is different from and yet related to both its classical and its romantic

antecedents, for it is rooted in discourse, but takes effect in (and on) a broader context. However, Friedrich Schlegel's revolutionary rethinking of irony (see *Kritische Friedrich-Schlegel-Ausgabe* and *Lucinde and the Fragments*) in the last century made at least one distinction that has been consciously challenged today: Schlegel separated what he saw as a lower kind of irony (rhetorical, polemical, parodic) from a higher one (the one we have come to know as Romantic irony), which is the other's metaphysical extension. The latter was considered more "authentic," for it involved transcendence (as well as retention) of the contradictions that are seen to characterize the experiential world (see Behler; Conrad; Furst; Garber; Immerwahr; Mellor; Prang; Strohschneider-Kohrs). In historical terms, the perception of life's (and art's) paradoxes have often led to such transcendental theories whenever the concept of irony was extended to represent a central mode of understanding or the basis of human subjectivity (see Kierkegaard; Handwerk).

This romantic notion of overcoming paradoxes, however inevitable they may be acknowledged to be, can be seen to have conditioned this century's literary version of the modernist view of irony, and in particular, that of one of modernism's critical corollaries, American New Criticism. Irony was a key term in New Critical discourse (see Brooks; Empson; Richards, chapter 32). In his much cited article, "Irony as a Principle of Structure," Cleanth Brooks used the word "irony" to mean "the *obvious* warping of a statement by the context" (1042). He suggests that irony may not be quite the right term to describe the indirection he sees as characteristic of poetry in general, but he admits that it appears to be "the only term available by which to point to a general and important aspect of poetry" (1043). The importance granted to context and incongruity in his discussion of irony, here and elsewhere, masks the fact that, in practice, the aim of New Critical reading was in the end to reconcile

the paradoxes, to normalize and even to neutralize the ironic incongruities through the act of interpretation.

This kind of textualized transcendence is precisely what deconstruction in criticism and postmodernism in literature have challenged today, and with that challenge has come yet another perspective on irony. The historical relation between premodernist, modernist, and postmodernist irony is the topic of Alan Wilde's important study, *Horizons of Assent: Modernism, Postmodernism, and the Ironic Imagination*. It is important to note from the start that, for Wilde, a self-confessed modernist, irony is not a discursive strategy so much as a historicized vision of life. However, he makes useful distinctions among three kinds of irony. The first, premodernist irony, is largely satirical or "mediate" in the sense of aiming to recover some ideal or norm of coherence and harmony. In contrast to this, modernist irony is "disjunctive" in the paradox of its recognition of the fragmented nature of the world and yet its desire to control these discontinuities, at least through aesthetic closure (this is, in some senses, the basis of New Critical irony). Postmodernist irony is more "suspensive" than this, in that it is seen as more radical in its awareness of contingency and multiplicity. In other words, to risk a generalization, whereas modernist art had used irony to signal both ambiguity and its transcendence, postmodern art seems to omit the transcendence step and accept doubleness and instability.

There is little doubt that the advent (or perhaps simply the labeling) of postmodernism has renewed interest in irony, but it has also confused even further the issues raised by this never unproblematic trope. If we see postmodernism as initially (however co-opted by now) the domain of the ex-centric, the off-centre, the marginalized, as many have (see Lipsitz; Hassan; Nadaner; Hutcheon, *Poetics, Canadian, Politics*), then one of the postmodern additions to the critical functioning of irony would have to include

an increased emphasis on its ability to subvert *from within*, to speak the language of the dominant order and at the same time suggest another meaning and another evaluation. This forked-tongue, even fence-sitting mode of address deconstructs one discourse, even as it constructs another. Its very doubleness can also act to contest the singleness of authority and the ahistorical claim to eternal and universal value that frequently underlies it. As Umberto Eco puts the historical situation today: "the past, since it cannot really be destroyed, . . . must be revisited: but with irony, not innocently" (67). As a number of the essays in this collection show, irony allows a kind of retrieval or even repetition of history, but it is a reflexive and querying repetition that "interrogates the habits of mind inscribed by the past" (Spanos 217). Much poststructuralist theory today includes irony among the reflexive tactics that can work to unmask the constructed nature of those conventions in art and criticism which, over time, are usually normalized into "common sense." As Robert Siegle argues:

> reflexive irony undoes the search for a center [of single mean-ing] by bending that search back around its starting assump-tions. The oscillation between convention and subject, or between either of these and culture, disperses any originary prime mover or first cause and makes *the oscillation itself* the crucial constitutive energy of the cultural, narrative, or indi-vidual act. (18)

This oscillation of irony is destabilizing; it makes people nervous. But it is also a source of pleasure — and not only the pleasure of elitist put-down, of excluding those who don't "get" the irony. There is also a pleasure that comes from works of art that are critical or even transgressive in their use of irony to subvert, to resist, and at the same time to have pointed fun with conventions, be they social

or aesthetic. But we should always keep in mind that to have fun with something is not necessarily to trivialize it; the serious and the solemn are not synonymous.

Since the examples in the other essays here are from literature and the visual arts in Canada, I would like to discuss this deconstructively constructive kind of irony in a few examples from other art forms, in order both to broaden the scope of the collection as a whole and to combat any inferred suggestion that the role of ironies discussed in it are limited to the literary and the visual. Despite all the fine work done on the theory of "dramatic irony" (see Bolen; Sedgewick; Sharpe; States; T[hirwall].; Thompson), actual performance — both theatrical and musical — is still a much neglected area in irony studies, but potentially a rich one, in Canada as elsewhere. For example, television and video have made possible such provocative playing with ironic incongruities as John Weinzweig's *Hockey Night in Canada*, a performance of a choral piece that uses as its text the discourse of a hockey game. It doesn't stop there, though: it also breaks with the conventions of the dress and behaviour of the chorus in classical music for voice. The singers (of the Opera in Concert Chorus) — sitting in bleachers, dressed in hockey-game-watching casual clothes, and reacting with emotion both to the game we too watch and to the appropriate words — sing (to atonal music): "slap shot," "body check," "ten seconds to go," "over the blue line" and so on, building up to the final crescendo of "He scores! . . . Great shot!" Weinzweig believes that "music has national roots" and that, through the medium of video/television, he can bring together, with provocative but constructive ironic incongruities, Canada's favourite sport and atonal modern music for voice in such a way as to resist our received notions of both "high" art and popular entertainment and sport.

This is serious fun — no oxymoron intended. So too was

Toronto's Theatre Passe Muraille's 1989 production of Brian Richmond, Don Horsburgh, and Deanne Taylor's parodic version of that canonical Italian nineteenth-century opera *Rigoletto*. This musical reworking effectively deconstructs Verdi's music, Piave's libretto, and even Hugo's original play *(Le Roi s'amuse)* in complex ways, using irony to point up the similarities as well as the differences, in both musical and social terms, over 130 years. The sixteenth-century Duke of Mantua's court, with its jester Rigoletto, is transformed into the "court," so to speak, of Duke, a present-day rock 'n roll star; Rigoletto becomes his manager. But the hunchbacked and bitter jester-figure of the opera appears here as an Afro-American: his black skin is made the modern equivalent of both the physical mark and the cause of social anger. These ironic differences all work, however, to underline the similarities. Mantuan courtiers may be made into "the brainless toadies" but this is not an inaccurate description of the opera's parallel characters. The modern plot does take certain liberties with the original text(s). For example, it makes the female figures more active and independent, as may well befit our times. But the essential emotional dynamics of lust, envy, anger, revenge, and pain remain the same, in spite of the many changes of detail. The most radical and ironic of these changes is the musical one. The frequently heard claim that the emotional power of Verdi's opera — or any opera — lies in the music alone gets ironized by the complex transcodings of this reworked version of it. The Duke's music is all rock, and when he sings, a drummer plays, suspended above the stage, signaling his position as a central member of any rock band. The black Rigoletto sings the blues — literally. Only Gilda, the closest thing to a female protagonist, sings the Verdian operatic score. And only Gilda sings without a microphone: the others ostentatiously pick one up and walk with it, as they sing, leaving stage hands to run around, equally ostentatiously untangling

cords. This deliberate stage(d) awkwardness foregrounds the conventions of popular rock and blues music performances, but it also implicitly unmasks the "naturalized" conventions of grand opera: it may use no (visible) microphones but that does not mean that opera is any less an artifice, any less an un-"natural" dramatic representation.

Another example of the unmasking of convention through irony would be the 1990 performance by the Esprit Orchestra in Toronto of John Beckwith's piece, *Peregrine*. In this work, Beckwith plays ironically with our (often unnoticed) expectations about how orchestras behave on stage, about where players are positioned spatially — and where they usually stay put. His title gives a hint of the major site of this ironic play: the peregrine or wandering pilgrim here turns out to be the viola soloist. Before the piece begins, the conductor enters holding a viola, which he places at the front of the stage. He then walks to the podium and begins conducting the piece. Shortly, a violin sounds off-stage, from the rear right; then the soloist enters, wearing a bowler hat, a ski jacket, and goggles — not, in other words, your usual performance garb. He makes his way through the orchestra, playing all the while; at the front he exchanges the violin he has been playing for the viola brought in by the conductor. He then marches off the stage, only to reappear minutes later in the traditional tuxedo, but this time standing in the middle of the auditorium, where he is joined by a percussionist, who starts playing odd, often comic, rhythms on a number of strange sounding (and portable) instruments.

The two musicians then proceed through the audience and make their way back to the stage. The title's peregrination is clearly connected to this ironizing of the performing space limitations conventionally set for classical musicians. The first violist of the Esprit Orchestra is a man named Douglas Perry, and Beckwith says

the verbal link to "peregrine" is not accidental; nor is it accidental that Perry is a tall man and that the percussionist is short. Beckwith chose to pair them because of certain echoes with other travelling pairs in art — Don Quixote and Sancho Panza being the most obvious. These inter-art echoes are encouraged by the percussionist's humorous noises and facial expressions, by his castanets (semiotically suggesting Spanish-ness), and by his particular side-kick-like interactions with the violist. There are other ironic intertextual moments in this piece too: the ukulele chorus parodically recalls the duelling banjos in the film *Deliverance*; nine instrumental sounds resembling animal cries are imitated, not without considerable humour, by the soloists. Beckwith's program notes also point the audience to the ninth Gregorian psalm-tone, known as the "tonus peregrinus" by virtue of its odd migration from one mode to another — a tone that has been used intertextually in Bach's *Magnificat* and Mozart's *Requiem*, among other famous works.

The end of the piece is as ironic as its opening in contesting the conventions of both performance and audience expectation. While the music is still playing, the clarinetist suddenly stands up, looks disgusted and walks off stage. One by one, others leave; then a group leaves together, along with the conductor. What is finally left on stage is a classic string quartet, but the violist/soloist can't seem to decide which chair to sit on — there are many empty ones — and so shifts uneasily between two (perhaps enacting, incarnating irony). As the four play on, the lights go out and finally all is silent. As a member of the audience who had been baffled, provoked, and in the end delighted, I realized we could now applaud, which all did with the kind of enthusiasm that could only be mustered by listeners who love irony — and don't mind being mocked, ever so gently.

Some of the same combination of seriousness and fun, critique and pleasure, can be seen in the works of art and also in the analyses

of them that follow in this collection, though many of both are more overtly political in their contestations than are any of my examples here. There is, however, a common set of concerns and a common vocabulary of terminology and allusion that unites these discussions. In an attempt to combat the customary diffuseness of essay collections, all were written in response to a short statement entitled " 'Speaking Canadian': The Ironies of Canadian Art and Literature" (reprinted here as Appendix 1 of the introduction) which I offered simply as a starting point for this volume's investigation of the study of irony in contemporary Canadian art and literature. Instead of incorporating the general ideas of that piece into the body of this introduction, I have chosen to leave it in the form of a separate statement at the end, largely because several of the articles cite it and its separate printing should make for more ease of reference. For the readers' interest, I have also reproduced (Appendix 2) the general terminological "guidelines" — actually simply an overview of the "received wisdom" on the topic of irony — that each author used as a base. These two documents account for some of the shared linguistic and theoretical contexts that unite these articles.

Jamie Dopp's opening volley, "*Who* Says Canadian Culture Is Ironic?", is a fittingly self-questioning way to begin a collection on this topic. In his essay, Dopp examines the underlying assumptions of the very premise that a dominant mode of Canadian rhetoric (verbal and visual) is irony — the premise of this volume and numerous other exercises in Canadian cultural criticism (see McGregor 416–20). By asking questions about what (and whose) interests are served by such a premise and by linking the issue of irony's epistemological foundation to that of postmodernism in Canada, Dopp sets up an important context for the theoretical and practical investigation of the possibility of a specifically Canadian kind of (or perhaps use of) irony: that is to say, the context of what

we could call the discursive politics of irony. His historicization of certain critical models for understanding Canadian culture at large, including the ironic one, is apt as both background and general introduction to the specific analyses of Canadian literature and art in the subsequent essays. This contextualizing also makes clear the important role of oppositional irony in the artistic discourses of historically marginalized groups of Canadians: women, racial and ethnic minorities, gays and lesbians, and so on. This essay also shows how the particularly postmodern reading of ironic double-talk — paradoxically as a way out of thinking in restrictive dualities — can open up new interpretive possibilities, possibilities illustrated by its analysis of Frank Davey's *The Abbotsford Guide to India*.

While Dopp's interest is in general cultural models or paradigms for understanding, his particular focus of analysis is literary. Mark Cheetham's "Postmodernism in Recent Canadian Art: Ironies of Memory" offers another overview of the intersection of irony and postmodern discourse but this time from the perspective of contemporary visual art. In discussing the process of putting together an exhibition of Canadian postmodern art entitled *MemoryWorks* (for the London Regional Art Gallery, which toured elsewhere in Canada), Cheetham presents a critical analysis of a representative group of the works finally selected for inclusion: a painting/text installation by Allyson Clay, a sculpture by Robert Wiens, two mixed media pieces by Janice Gurney, and a number of photographs by Stan Denniston. In the analyses of these works, Cheetham addresses that historical issue raised by Umberto Eco — the role of irony in memory, in the recovery of the past in art today. The particular past invoked here is not simply the aesthetic one (of modernism or figuration or abstraction); it includes memories that are at once social and political.

Cheetham's focus on the parodic work of art and on the artistic

process of ironizing is complemented by the next essay's concern for the other, hermeneutic side of the coin, so to speak: the role and work of the interpreter or decoder of irony. The relation between the perception/interpretation of irony and the trope itself has recently come to be the focus of much work in what, in European semiotic circles, has been called the "pragmatics" of irony, that is, the relationship between ironic signs and their users (see Berg; Dikkers; Ferraz; Groeben and Scheele; Japp; Kerbrat-Orecchioni; Martin; McKee; Richter; Sperber and Wilson; Stempel). In this sense, then, the implications of Manina Jones's investigation of the special instance of the Canadian "found poem" extend well beyond that particular corpus, beyond even that of the Dadaist "readymade" from which she theorizes this literary form. "Double Exposures: The Found Poem and Ironic Reading" raises the theoretical issue of the crucial role of *context* in the reader's perception and comprehension of irony. As her detailed analyses of found poems by John Robert Colombo, Eli Mandel, and F.R. Scott reveal, irony turns out to be as much something inferred from context as something textually implied. This insight broadens both the scope and the role of the notion of context in the functioning of irony.

Continuing in the same vein as this "pragmatic" and deconstructive mode of contextualized "reading," Julie Beddoes's essay, "The Writing on the Wall: The Ironies in and of Lothar Baumgarten's *Monument for the Native Peoples of Ontario*, 1984–85," adds to it an important ideological dimension — first raised in Dopp's argument — that suggests the inseparability of issues of political effectiveness from questions of context, the context of both production and reception. Do interpreters *make* ironies? Or are ironies *contained within* the texture of the work of art itself? Or — either way — can they be different even from those intended by the artist? Beddoes roots her investigation of these questions in a very specific analysis

of the form and content of this particular installation, a textual inscription of the names of Canadian native peoples, which was executed (and remains) on the walls of the Walker Court space (at the Art Gallery of Ontario) by a German artist, as part of a 1984 exhibition of contemporary European art. Playing out the inherent incongruities of this situation and their attendant ironies — intended and inferred — she deconstructs not only the work and its multiple contexts (physical, historical, hermeneutic), but also her own position as interpreter.

This kind of self-consciousness about the act of interpreting and inferring irony should not make us forget that ironies are also often intended by their encoder. Indeed, in most theoretical work on the "pragmatics" of irony, the issue of context is not separable from the notion of intentionality, however out of fashion it has come to be in some formalist circles. Karen Smythe's "The 'Home Truth' about *Home Truths*: Gallant's Ironic Introduction" investigates these intertwined, problematic concerns by focusing on the function of the authorial preface in Mavis Gallant's collection of short stories entitled *Home Truths*. The complex argument here suggests the dizzying possibility of an intended authorial ironic subversion of prefatorial (and titular) conventions — including the convention of privileging authorial intention. This essay also argues that Gallant's ironies are directed as well at a tendency in Canadian criticism to contextualize only in a nationalistic framework. Gallant's text, it contends, actually forces the reader to participate in the creation of this kind of ironic meaning. This, Smythe implies, is the kind of reflexive double-talk the expatriate Canadian writer is aiming at her specifically Canadian readership, her own personal "home truth."

The next five essays all address less the "pragmatics" than the politics of irony. They treat irony as a mode of subversion, not to say transgression. The oppositional voice of the ex-centric, they suggest,

has often been ironic, in Canada as elsewhere. This is the ideological framework within which Susanne Becker examines the gothic (itself historically a marginalized and feminized genre), as it is being reworked today by Canadian feminist writers. "Ironic Transformations: The Feminine Gothic in Aritha Van Herk's *No Fixed Address*" investigates both a generic question — the ironizing of the gothic — and also a political one — the reclaiming of the gothic for and by women. Her extended analysis of the multiple intertextual and textual ironies of Van Herk's complex parodic novel reveals some of the particular mechanisms of that fruitful reclamation.

Of course, it is not only Canadian *writers* who are reclaiming lost territories by planting the flag of irony. As Karen Bernard's study "Ironing Out the Differences: Female Iconography in the Paintings of Joanne Tod" shows, women visual artists have also contested the politics of the representation of women, and irony has frequently been one of their favourite weapons. This essay takes as its subject three recent paintings by Joanne Tod in order to show how both contextual and structural ironies function as specifically feminist strategies of both polemical resistance to and critical subversions of the traditional construction of the iconic spectacle of woman in art. In his *Rhetoric of Irony*, Wayne Booth calls irony the "mother of confusions" (ix), and the gender designation may not be accidental. Certainly it is apt, at least for Canadian art and letters, given the increasingly important position of women in anyone's definition of the canon today. It is as hard to think of Canadian art today without considering Joyce Wieland's work as it is to think of Can Lit without considering Margaret Atwood's or Alice Munro's. And it is not accidental, perhaps, that, in so many of these artists' work, irony is a common characteristic.

In fact, it has lately become a kind of cultural truism that there is some connection between the history of Canada as a colonial (and

some would say, post-colonial) nation and the history of women's oppression (see Irvine; Howells). The complexity of the relationship between gender and nationality, especially when that relationship is ironized, is one that is touched on by a number of essays in this collection, including Wendy Waring's study of marginalization and ironizing entitled, with Boothian echoes, " 'Mother(s) of Confusion': End Bracket." Moving from the ironically pointed play with titles in Nicole Brossard's *L'Amer* and Gail Scott's *Heroine* to the even more biting textual ironies of work by Lenore Keeshig-Tobias, Robin Endres, and Suniti Namjoshi, this essay probes the ironies of race, class, gender, and sexual preference in such a way as to raise new questions about both the power and limits of irony as a tactical weapon deployed by and from the margins. However — and this is the provocative focus of Waring's study — it also questions the validity (and the politics) of even wanting to circumscribe the variety of such responses under the heading of irony.

Related issues are brought to the fore in Arun Mukherjee's "Ironies of Colour in the Great White North: The Discursive Strategies of Some Hyphenated Canadians." This essay expands outward from its own ironic title to a study of the role of irony in the articulation of racial difference in Canadian literature. In opposition to both universalizing humanist notions of "man" and official multicultural definitions of Canada's paradoxical "unity," Mukherjee presents the ironic, critical voices of non-white Canadian writers such as Himani Bannerji, Krisantha Sri Bhaggiyadatta, Dionne Brand, Claire Harris, Joy Kogawa, Marlene Philip, and Maria Campbell, all the while foregrounding her own ironic — and often bitter — experiences as a non-white woman working in a white, Eurocentric political and academic context.

Obviously, however, it is not only women or non-whites who have turned to irony as a way of speaking to a culture, from within

Its values, without being utterly co-opted by it. Many other groups within Canadian society have felt marginalized in some way and have also used irony as one possible discursive strategy of resistance and opposition. Richard Dellamora's "Becoming-Homosexual / Becoming Canadian: Ironic Voice and the Politics of Location in Timothy Findley's *Famous Last Words*" addresses two of these groups and their complex interrelations and problematizes, in so doing, the very concepts of place and ethnicity in Canada. Traditionally those Canadians of British background have rarely been designated as "ethnic," since it is the associations of foreign-ness and otherness that usually come into play in the usage of that word. British roots are, if anything, the colonial norm against which ethnicity has been defined as difference. It is against this norm and its normality that this essay positions a new and perhaps unexpected articulation of homosexual aesthetic discourse, one that speaks with the forked tongue of a (silently negating) irony, addressing both all Canadians and gay readers too. Dellamora's analysis of Findley's historical novel, *Famous Last Words*, raises a number of interconnected questions concerning national, ethnic, aesthetic, and sexual politics.

The many and complex functions of irony within contemporary Canadian art and literature are by no means exhausted by the analyses of these ten essays. But this is a start. Whether we want to talk about postmodernism or not, there seems little doubt that irony is very much in the air today, and not only in *Spy* magazine (which, I am told, is run by expatriate Canadians). It is not that irony is suddenly back in fashion; it never went out of style. It has simply been retooled or "refunctioned" as a rhetorical and structural strategy, particularly useful for marginalized artists who want to speak *to* what they see as the centre, who want to be listened to as well as merely heard. Irony is by no means the only weapon in their formidable arsenal, but it seems to be a significant one. Without

having to elevate irony to a keystone of contemporary poetics (Smythe) or a paradigm of criticism (Lang) or a philosophical stance *vis-à-vis* the universe (Kierkegaard), it is still possible to see it as an important and provocative mode of double-talking in much contemporary Canadian art and literature.

APPENDIX I

"SPEAKING CANADIAN": THE IRONIES OF CANADIAN ART AND LITERATURE

E.D. Blodgett once defined the "Canadian" we speak as "a mixed language, by law ambiguous, and always offering possible escape routes . . . without ever leaving home" (60). It is also, I think, "by law" or by preference, frequently ironic. Obsessed with articulating its identity, Canada's voice is often a doubled one, that of the forked tongue of irony. Although usually seen as either a defensive or an offensive rhetorical weapon, irony (in the basic semantic sense of stating one thing and meaning another) is also a mode of "speech" (in any medium) which allows speakers to address and at the same time to confront any "official" discourse, that is, to work *within* a dominant tradition, but also to challenge it, *without* being totally coopted by it. It is the voice of Al Purdy, speaking to those Canadians who want him to explain what "being Canadian" means to him in a North American and post-colonial context: "But you want heroes, you want history, you want, you want etc. Lindbergh you want; George Patton you want, or guys like Churchill and Wellington maybe? Would you settle for Norman Bethune, John A. and J.S. Woodsworth?" (D6). The verbal markers of irony here — the repeated "you want" and the understatement of "would you settle for . . . ?" — make what might be taken for straight nationalistic defense into something else too: an implied attack on the very need to ask what "being Canadian" might mean. Irony of this kind is clearly not the evasive expression of fence-sitting: it involves taking

a position, however open to divergent interpretations that position might appear to be. Its power depends on the twin conditions of context and community of belief.

I would like to suggest that we use as a starting point this notion of the possibility of a perhaps particularly Canadian use of irony today in relation to a series of self-defining self-positionings: that is, our position in response to our political pasts, both French and English, and our present (in terms of American culture); the positions taken by the regional in relation to the central; and "minoritarian" (female; ethnic; visible minorities; native; gay, etc.) positioning with regard to majority groups. In the light of the general postmodern questioning of any notion of coherent, stable and autonomous identity (either individual or national), these positions are, almost by definition, provisional and tentative — not because they are weak, but because they stand ideologically opposed to the mastery (and presumption?) of dominant and dominating cultures. Irony becomes a mode of addressing those cultures from within, while simultaneously signaling a position of difference and even opposition.

Irony seems to have two possible functions: what we could call deconstructive and constructive. The first is a kind of critical ironic stance that works to distance, undermine, unmask, relativize, destabilize . . . and all those other postmodern verbs. This is primarily a form of critique which can at times border on the defensive, but which is always concerned with internally oppositional positions. Here *marginality* becomes the model for internal subversion of that which presumes to be central. The other, constructive kind of irony is distinct from this only insofar as it works to assert difference as a positive and does so through double-talking doubled discourses. Instead of marginality, this irony's focus is on *liminality*, a term used by anthropologist Victor Turner to refer to the open

space "whence novel configurations of ideas and relations may arise" (97). Irony opens up new spaces, literally between opposing meanings, where new things can happen.

Irony has become one of the major strategic rhetorical practices of postmodern art in general today. Perhaps it is not surprising, then, that in the visual arts this has meant that Canadian art has flourished in a postmodern context — with its problematized ironic confrontations with both history and representation. I think the same is true of literature in Canada today, as it too relates to the aesthetic and social histories out of which it comes with "irony, parody, mimetism, allegory, collage, appropriation" — to use Chantal Pontbriand's list (51), originally drawn up for the visual arts. The individual ironic voice of the artist — be it Pier Giorgio di Cicco's or Timothy Findley's or Leona Gom's — is no longer separable, perhaps, from both the collectivity and the history in which it is rooted. The tactics used to bring about both the critical deconstruction and the creating of liminal spaces are common enough: those familiar rhetorical devices of understatement, hyperbole, anticlimax, and repetition; those modes of strategic positioning that provoke counter-expectation (incongruity, re-contextualization, defamiliarized or literalized cliché, parody). Whatever the medium, however, and whatever the function (marginal or liminal), irony seems to be at least one of the ways in which we have learned to "speak" that contradictory, ambiguous "Canadian."

APPENDIX 2

THE CORE CONCEPTS OF IRONY:
THE "RECEIVED WISDOM"

[L. *ironia* from Gk. *eironeia* — simulated ignorance]
[Gk. *eiron* (dissembler) — "the underdog, weak but clever, who regularly triumphed over the stupid and boastful alazon" in Greek comedy (*Princeton* 407).]

*DEFINITIONS AND TYPES OF "THE ART
OF SAYING SOMETHING WITHOUT
REALLY SAYING IT" (Muecke, Compass 5)*

1. *VERBAL IRONY*

- a trope or figure of speech of double signifying power (i.e., two signifieds; one signifier) in which the intended or implicit MEANING differs from that expressed in the actual words used.

- a "double-layered or two-storey phenomenon" (Muecke, *Compass* 19)

- "usually involves the explicit expression of one ATTITUDE or EVALUATION, but with the implication of a very different attitude or evaluation" (Abrams 89).
 e.g. "simulated adoption of another's point of view or laudatory tone for purposes of ridicule" *(Concise Oxford)*
 e.g. "sarcasm or ridicule in which laudatory expressions are used to imply condemnation or contempt" *(OED)*

e.g. "humor, ridicule, or light sarcasm . . . as when expressions of praise are used where blame is meant" *(Webster's Third New International)*

- can be STABLE (intended, covert, fixed, finite) or UNSTABLE (with no fixed standpoint which is not undercut by further ironies) (Booth)

- related to *New Criticism*'s use of irony as "our most general term for indicating that recognition of incongruities" (Cleanth Brooks); as equilibrium of oppositions (I.A. Richards); as "internal equilibrium" (T.S. Eliot)

- related to *postmodernism*'s sense of irony as a "way of writing designed to leave open the question of what the literal meaning might signify: there is a perpetual deferment of significance" (Muecke, *Irony* 31).

2. *STRUCTURAL IRONY*

- sustained use of some structural feature (e.g., naïve hero or narrator) to produce duplicity of meaning (Abrams 90).

- doubled meaning is perceived by privileged audience only; only overt meaning is perceived by those involved (from root meaning of pretence or dissimulation).

- related to *Socratic Irony* — Socrates's pose of ignorance (and willingness to learn) in order to confound or provoke or confute others by enticing them into a display of supposed knowledge and making their errors conspicuous (by adroit questioning).

- generalized to "assuming ignorance for the sake of taking advantage of an opponent in debate" (Holman 502).

- related to *Dramatic Irony* — irony produced by incongruity between a dramatic situation and words or actions whose inappropriateness it reveals *(Webster's)*: e.g.,

 1. spectators know more than protagonist or character;

 2. character reacts in inappropriate way;

 3. characters or situations are contrasted, as in parody;

 4. contrast between character's understanding of own acts and what play shows about them. *(Princeton* 407)

- related to *Tragic Irony* — term usually used to refer to 4. above (in tragedies).

3. SITUATIONAL IRONY

- a state of affairs in which events or circumstances, desirable in themselves, are either perversely ill-timed or turn out in a contradictory manner to what might be expected.

- as if in mockery of the promise and fitness of things *(OED)*.

- related to *Irony of Fate* — "the contrast between the individual's conscious aspirations and what fate (or biology or society or psychology or the 'immanent will') eventually makes of him" *(Princeton* 408).

- related to *Cosmic Irony* — "God, or destiny, or the universal process, is represented as though deliberately manipulating events so as to lead to false hopes, but then to frustrate and mock the protagonist" (Abrams 92).

- related to *Romantic Irony* where irony is taken (i) as a general term to refer to a recognition of a reality different from appearance (Holman 279), and (ii) as expressing two meanings simul-

taneously and therefore emblematic of polarities (absolute/rela-
tive; subjective/objective) of post-Kantian philosophy (*Princeton*
407); in its late eighteenth- and early nineteenth-century German
usage, it designates a mode in which the text creates an artistic
illusion only to destroy it by revealing its own process of arbitrary
manipulation or construction.

FORMS AND TROPES RELATED TO IRONY

A) SIMILARITIES OF STRUCTURE

- *antiphrasis* or contrast: "the satirical or humorous use of a word or
 phrase to convey an idea exactly opposite to its real significance"
 (Holman 33).

- *paradox*

- *ambiguity*: "the use of a word or expression to signify two or more
 distinct references, or to express two or more diverse attitudes
 or feelings" (Abrams 8).

- *metaphor*: "a condensed verbal relation in which an idea, image, or
 symbol may, by the presence of one or more other ideas, images,
 or symbols, be enhanced in vividness, complexity, or breadth of
 implication" (*Princeton* 490).

- *allegory*: "a narrative in which the agents and action . . . are
 contrived both to make coherent sense on the 'literal' or primary
 level of signification, and also to signify a second, correlated order
 of agents, concepts, and events" (Abrams 4).

- *pun*: play on words that are (more or less) identical in sound but
 different in meaning.

- *lie*

- *hoax*

B) *SIMILARITIES OF ETHOS OR EVALUATION*

- *sarcasm*: "crude and blatant use of apparent praise for dispraise" (Abrams 91); "a form of verbal IRONY, in which, under the guise of praise a caustic and bitter expression of strong and personal disapproval is given. *Sarcasm* is personal, jeering, intended to hurt, and is intended as a sneering taunt" (Holman 472).

- *innuendo*: insinuation or indirect suggestion, usually with harmful intent.

- *charientism*: joke

- *chleuasm*: mockery

- *mycterism*: sneer

- *wit*: quickness of intellect and gift for expressing ideas in entertaining, humorous or pointed ways, often suggesting "a certain brittle unfeelingness" (*Webster's*).

- *repartee*: ingenious, quick rejoinder; "a retort aptly twisted" (Holman 445).

FORMS THAT USE IRONY TO STRUCTURAL AND EVALUATIVE ENDS

- *satire*: the art of diminishing a subject by ridiculing (with intent to discourage) its vice or folly by the use of irony, sarcasm, humor.

- *parody*: imitation characterized by ironic inversion; repetition signaling ironic difference at the heart of similarity (Hutcheon, *Theory* 6).

SOME OF THE RHETORICAL
DEVICES USED TO IRONIC ENDS

- *hyperbole*: overstatement; bold exaggeration; consciously extravagant or excessive statement not always meant literally (*Princeton* 359)
- *understatement*: "a form of irony in which something is intentionally represented as less than in fact it is" (Holman 543); expressed meaning is mild, intended meaning is intense (*Princeton* 407):

 a) *litotes* (Gk. simplicity): understatement in order to intensify; "affirmation by the negative of the contrary, usually used to secure emphasis or irony" (*Princeton* 459);

 b) *meiosis* (Gk. lessening): "figure employing ironic understatement, usually to convey the impression that a thing is less in size, or importance, than it really is" (*Princeton* 488).

- *anticlimax*: deliberately flattening let-down.
- *contradiction*: explicit or implicit.
- *asteismus*: "a speaker replies to another, using the first man's [sic] words in a different sense" (*Princeton* 681).
- *syllepsis*: a word used once with two meanings, both grammatically correct in context; an economical ellipsis.
- *anaphora* or *repetition*, especially with a change of context or a building up of meaning.

MODES OF STRATEGIC CONTEXTUALIZING
FOR IRONIC EFFECT (i.e., POSITIONING
FOR COUNTER-EXPECTATION)

- juxtapositioning

- revealing incongruity in context

- re-contextualizing the familiar

- literalizing or otherwise defamiliarizing clichés or stereotypes

WHO SAYS THAT CANADIAN CULTURE IS IRONIC?
JAMIE DOPP

· *University of Victoria*

L ET ME BEGIN by pointing to a verbal irony in my title. "*Who says that Canadian culture is ironic?*" The two senses in which this question can be read nicely prefigure the structure of my answer. On the one hand the question asks for a descriptive survey of the field of Canadian culture, for a list of citations. On the other hand it contains a challenge: "*Who* says?" The two meanings are important because the apparent neutrality of a list would occlude a crucial fact: that definitions of culture always take place within a context of struggle. Certain interests are inevitably served by particular cultural definitions or by particular interpretations of definitions. From one point of view the "garrison mentality" is a natural consequence of the harsh environment faced by early Canadian settlers; from another it is a way of rationalizing acts of imperial aggression committed by the European powers. Certain kinds of definitions also reinforce particular epistemological assumptions, and although it is reductive simply to identify epistemological systems with class or gender interests, there is a sense

in which such systems are always ultimately implicated.

This essay attempts both to suggest the historical pattern of the question of "irony" in Canadian culture and to read this pattern in terms of a struggle over cultural definitions. I will argue that "irony" has a place within the "dominant ideology" of Canadian culture, but that it becomes most acutely an issue when writers assert it as part of a resistance to or a redefinition of that ideology. My discussion concludes with three critics, Robert Kroetsch, Linda Hutcheon, and Frank Davey, whose assertions or demonstrations of irony emerge from an interest in a particular redefinition of Canadian culture. This interest can be loosely defined as "postmodern." The works of Hutcheon, Davey, and Kroetsch implicitly promote postmodernist concepts as useful tools for understanding Canadian culture. In so doing, they undertake a telling use and abuse of the ideology they seek to redefine.

By "dominant ideology" I wish to refer to what Terry Eagleton calls "a relatively coherent set of 'discourses' of values, representations and beliefs which . . . so reflect the experiential relations of individual subjects to their social conditions as to guarantee those misperceptions of the 'real' which contribute to the reproduction of the dominant social relations" (T. Eagleton, *Criticism* 54). In English Canada, the dominant cultural ideology has tended to be concerned with: 1) our status as a colonial nation, and 2) the fact that our country has developed without revolution or civil war. The first of these involves our relationship with Britain; the second, our relationship with the United States. Good examples of the most common ways of articulating these relationships can be found in the writings of Alfred Bailey and Northrop Frye.

Bailey's "Evidences of Culture Considered as Colonial" articulates the characteristics usually ascribed to Canada's colonial inheritance. English-speaking Canada, according to Bailey, "has been

subject to a measure of discontinuity, dispersion and division"
(183). Unlike French-Canadians, who have established a measure of
"internal continuity," English-Canadians have maintained "an
attitude of dependence upon the Mother Country" which has in
effect stunted their cultural growth. English-Canadian artists have
imitated the English but have failed to rise to the same heights:
"Successive creative impulses have prompted developments which
have usually turned out to be *culs de sac*, each living out its limited
span, and failing to flow together with others to form a vital and
continuous stream" (184).

According to Frye, the effect of Canada's lack of a revolutionary
tradition has been to perpetuate the cultural inferiority complex
described by Bailey. Unlike the United States, which has largely
enjoyed "a sense of progressive and linear advance," Canada has
"never defined itself as a unified society in this way" (*Divisions* 47).
There is no "Canadian way of life," no "hundred per cent Canadian";
as a result Canadians lack a certain self-confidence. This lack of
self-confidence is central to Frye's famous formulation of the "gar-
rison mentality" as the determining feature of the Canadian men-
tality (see "Conclusion"). For Frye, the difference between the
United States and Canada can be illustrated by contrasting the
rationales behind their respective capitals. "Washington became a
capital because it was the logical place for one, between the north
and the south: Ottawa became a capital because it was not Montreal
or Kingston. A sardonic commentator, writing in 1868, remarks
that its name was obviously derived from 'Hoot awa,' or out of the
way" (*Divisions* 48).

Both of these conceptions have had wide currency. Less obvious
perhaps is the way in which they have worked to reproduce domi-
nant social relations. Like cultural matters generally, there is a sense
in which definitions of this sort have what some Marxists would call

a "relative autonomy" from the "economic base." In other words, the definitions operate with a logic of their own even as they are implicated in the wider determining system. Without being overly reductive, connections can I think be made. There is for instance a relationship between the "colonial mentality" and the historically most common forms of literary criticism in Canada. Until fairly recently, and even to some extent today, a key role of the Canadian critic has involved measuring the emergent Canadian tradition against the "great works" of the past. Critics like Desmond Pacey and A.J.M. Smith have devoted much of their work to asking which Canadian writers measure up to "international" standards of literary excellence, or as Pacey has put it, to wondering when and to what extent "our literature will be taken seriously by non-Canadians" (192). The implicit assumption of such criticism is that there *is* greater value in the works of the "tradition." So our colonial heritage is seen as a yardstick against which to measure ourselves rather than as an instrument of power or domination.

Within the dominant ideology there have been at least two ways of talking about irony in Canadian literature. The first alludes to a mildly ironic tradition that includes Haliburton, Leacock and, according to Elizabeth Waterston, John Galt. Waterston, in her representative essay, speaks of a tradition of "ironic realists" in Canadian literature running through writers like Leacock, Montgomery, and Munro. Such writers emphasize "the discrepancy between the ideal of civility and the actualities of a disorganized small town" (60). Waterston argues that these chroniclers of small-town life have a peculiarly Canadian significance. "Galt's rough form seemed to fit easily into stories of a rough land. . . . In social terms, the form seemed also appropriate for the disunified unharmonious small-town life of Canadian communities" (61).

The second way of talking about irony is the more interesting. It

has to do with an essential irony thought to be at the heart of the Canadian. This position is most influentially taken up by Margaret Atwood in *Survival*. According to Atwood, Canada's experience as a colony leads Canadian literature to be unusually pessimistic or "ironic." Because "Canada as a whole is a victim, or an 'oppressed minority,' or 'exploited,' " the Canadian literary gloom "is more unrelieved than most and the death and failure toll out of proportion" (35). Canadian heroes are preoccupied not with achieving some greater glory, like their American counterparts, but with simply surviving. As a symbol for the archetypal Canadian experience, "survival" embodies what D.C. Muecke would call a "general irony":

> General Irony lies in those contradictions, apparently funda-
> mental and irremediable, that confront men when they specu-
> late upon such topics as the origin and purpose of the universe,
> free will and determinism, reason and instinct. . . . Most of
> these, it may be said, are reducible to one great incongruity, the
> appearance of free and self-valued but temporally finite egos in
> a universe that seems to be utterly alien, utterly purposeless,
> completely deterministic, and incomprehensibly vast. (121)

Both Atwood and Waterston work within the dominant ideology in a number of ways. Both see the ironies they describe as products of the colonial cultural experiences defined by Bailey and Frye. Atwood's notion of "survival" is directly related to Frye's notion of the "garrison mentality," with its sense of the defensiveness of the Canadian position. Waterston sees the disunity of Canadian small towns reflected in Galt's fiction as a product of "small-minded" townsmen with a "colonial awareness that the real centre of life is far away" (60). Atwood and Waterston also work within the main

epistemological assumptions presumed by Bailey and Frye. This congruity helps to explain the tremendous influence of Atwood's formulation in particular. Indeed the general irony Atwood articulates has become in many ways synonymous with the dominant ideology of Canadian criticism. It is hard not to connect allusions to the colonial status of Canada or to the "garrison mentality" to a general irony at the heart of the Canadian. Perhaps Gaile McGregor refers to this connection when she writes that "the single adjective most often applied to Canadian literature by critics is probably 'ironic' " (419).

The epistemological assumptions of the dominant ideology are nicely encapsulated in Frank Davey's groundbreaking essay "Surviving the Paraphrase." According to Davey, the dominant approach to English-Canadian literature until at least 1974 (the year of his essay) has been "thematic":

> Language [in this kind of criticism] . . . is a tool employed not for its own intrinsic qualities but for the expression of ideas and visions. The critic's role is not to attend to language, form, or even to individual works of literature but to something called by Jones in *Butterfly on Rock* "our imaginative life," by Moss in his *Patterns of Isolation* the "national being," and by Frye in *The Bush Garden* "cultural history." (2)

Davey singles out *Survival* for particular criticism in his essay. In accounts of literature of this sort "[a] novel is reduced to its declared themes and its plot outline; a poem to its declared themes; the Canadian culture ultimately to catch-words . . ." (3). Attempts to define a peculiarly Canadian "identity or psychosis" from which to explain cultural phenomena are inevitably reductive, according to Davey, because of their failure to account for the mediations of language.

During the 1970s, there were a number of attempts to resist the view of Canadian culture offered by Bailey, Frye, and later Atwood. D.G. Jones argued in *Butterfly on Rock* that the "only effective defence for a garrison culture" was to "let the wilderness in" (10). A new, affirmative community was possible for Jones because of the power of language to recover and define our experience, to "re-creat[e] . . . our cultural vision" (11). In a polemical review in *This Magazine*, Robin Mathews attacked *Survival* for failing to account for a tradition of struggle in Canadian literature. Mathews attempted to outline this other tradition in *Canadian Literature: Surrender or Revolution?* And Ronald Sutherland argued in *The New Hero* for the celebration of the anti-hero. According to Sutherland, the outcast was becoming the new hero of Canadian literature, replacing the old order with the new. Sutherland's "new hero" is in fact similar to the old self-reliant hero of American culture (16).

As Davey suggests in "Surviving the Paraphrase," the limit of the counter-formulations of the 1970s is that they remain largely within the thematic paradigm. Though Mathews tries to counter Atwood's reading of Canadian culture, his argument for a different tradition accepts the methodological assumptions of thematic criticism. Sutherland and Jones, in offering strategies to overcome our cultural limits, explicitly accept the adequacy of the thematic description that sets out those limits. Davey, by contrast, argues for a different *method* of criticism. This method could be characterized briefly as "formalist." According to Davey, thematic criticism needs to be countered by an emphasis on "writing as writing," on an attention to literary history that does not explain texts through a kind of cultural determinism (12). Davey makes a telling criticism of Frye's reluctance to apply the principles of his own critical theories to Canadian literature. Not only is this a refusal to treat Canadian writing as "serious literature," but it suggests that Cana-

dian literature is "incapable of sustaining analytic, phenomenologi-
cal, or archetypal inquiry — of sustaining any kind of criticism
whose existence is not also supported by the ruse of sociological
research" (7).

When Robert Kroetsch speaks of the "total ambiguity that is so
essentially Canadian" he also resists the dominant ideology of
Canadian culture, but his resistance takes the form of a peculiar use/
abuse of that ideology (Kroetsch and Bessai 2 1 5). In many ways the
positing of a "total ambiguity" echoes the cultural history arti-
culated by Frye and Bailey. It could be another way of suggesting "a
measure of discontinuity" or a general irony at the heart of the
Canadian. Yet Kroetsch's work in general is a critique of the totaliz-
ing gestures that make such assertions possible. In "Unhiding the
Hidden" he writes that the problem with the received myths is that
they can never be more than an inauthentic set of images. If we
perpetuate them we simply submit to someone else's truths.
"Offered the consolation and pride of the old names," he writes, we
need to "decline to be christened" (*Essays* 2 1). Kroetsch's suspicion
of myth is akin to Davey's suspicion of thematic criticism: both myth
and thematic criticism offer metanarratives to explain/reduce texts
to a stable configuration of meaning(s). The assertion of a "total
ambiguity" undercuts the relevance of any such explanatory meta-
narrative in regard to Canadian culture.

Though Kroetsch's formulations do not mention "irony" expli-
citly, they implicitly reassert the ironic as central to Canadian
culture. At the same time they contain a critique of the way in which
irony has been asserted within the dominant ideology. In good
postmodernist fashion, then, Kroetsch opens the way for a
reinstallation of the historical (the dominant ideology) while shift-
ing contexts in order to subvert its traditional authority.

The postmodern character of Kroetsch's formulation can be seen

in the way it both reasserts and subverts elements from the dominant ideology. In "Surviving the Paraphrase" Davey describes the attempt to explain literature in terms of sociology as a "ruse"; by contrast, Kroetsch, while sharing in many ways Davey's formalist concerns with language, rather than rejecting, takes advantage of (in both senses) the "sociological ruse." In another place he elaborates on the "total ambiguity" that is Canadian as follows:

> To make a long story disunited, let me assert here that I'm suggesting that Canadians cannot agree on what their metanarrative is. I am also suggesting that, in some perverse way, this very falling apart of our story is what holds our story — and us — together Lyotard [in *The Postmodern Condition*] writes: "Simplifying to the extreme, I define *postmodern* as incredulity toward metanarratives. . . ." I am suggesting that by Lyotard's definition, Canada is a postmodern country. ("Disunity" 1–2)

For Kroetsch, total ambiguity comes not from outside of the traditional Canadian metanarrative — not from an ahistorical or formalistic position free of the dominant ideology — but rather from within it. As a new "master theme," total ambiguity bears interesting congruencies with the ideology it seeks to unsettle; at the same time, Kroetsch offers this new "master theme" within a context that paradoxically asserts the necessity of incredulity towards all such metanarratives.

One way to understand the effect of Kroetsch's assertion is to see how it shifts the context of the ironic in Canadian culture. The shift is analogous to Derrida's work to articulate the structurality of structure. In "Structure, Sign, and Play in the Discourse of the Human Sciences" Derrida defines a traditional structure as one

organized around a stable point, a centre which itself escapes the "play" of elements, the displacements and substitutions made possible by the structure (279). "Post-structuralism" in effect tries to think structures in which the centre is itself subject to displacement and substitution. A stabilized or centred irony can be seen perhaps behind McGregor's assertion, in the last chapter of *The Wacousta Syndrome*, that because traditional Canadian heroes are survivors "the ironic element in Canadian fiction is . . . *contained* or neutralized" (422). According to McGregor, "nothing is ironic unless it is juxtaposed with a countering ideal or at least set against a *relatively* preferable state of affairs" (419). Irony is produced by the failure of life to live up to a preferable state of affairs. The Canadian emphasis on survival involves an acceptance of the impossibility of such countering ideals, and as a result a "balance is achieved" and "the chasm *within* experience disappears" (423). Once balance is achieved, once the chasm which embodies the "necessity for wrestling with discrepancy" disappears, irony, for McGregor, disappears (423).

Kroetsch's formulation implicitly points to an irony in McGregor's formulation. From the point of view of total ambiguity, "balance" is itself a "countering ideal." To acknowledge the impossibility of countering ideals, then, would be to acknowledge the impossibility of balance, thereby deepening rather than resolving the condition of irony. If balance is itself an ideal, then it is ironic to suggest that acknowledging the impossibility of balance (a countering ideal) is a way to achieve balance. Total ambiguity suggests that there is no resolution to the "irony at the heart of the Canadian," no balance that can be achieved as a stabilizing centre. Total ambiguity suggests that the "chasm *within*" is in fact constitutive of experience and in particular, in Kroetsch's formulation, of Canadian experience.

In *A Poetics of Postmodernism*, Linda Hutcheon describes the "curious mixture of the complicitous and the critical" that is involved in postmodernism (201). The essentializing language of Kroetsch's formulation — the "*total* ambiguity that is so *essentially* Canadian" — points to both its critique of and complicity with the metanarrative represented by the dominant ideology of Canadian culture. Hutcheon's readings of contemporary English-Canadian fiction in *The Canadian Postmodern* help situate Kroetsch's assertions within the Canadian struggle over cultural definitions. Like Kroetsch, Hutcheon argues for the appropriateness of "postmodernism" as a way of engaging important elements in Canadian culture:

> Perhaps the ironies and contradictions of postmodernism are the most apt mode of expression for what Kroetsch has called the "total ambiguity that is so essentially Canadian: be it in terms of two solitudes, the bush garden, Jungian opposites." The postmodern irony that refuses resolution of contraries — except in the most provisional of terms — would appear to be a useful framework in which to discuss, for example, the obsessive dualities in the work of Margaret Atwood . . . or the echoing doubling of (and within) characters and plots in the novels of Kroetsch. Perhaps "postmodern" is the best way to describe the genre paradoxes in the works of Michael Ondaatje (4)

A number of issues are at stake in this formulation. For the literary critic, new interpretive concepts are first of all devices to liberate new readings. New readings allow one generation of critics to be heard over another; they are also, quite simply, a source of pleasure. Kroetsch's emphasis on "total ambiguity" comes in part from his sense that the explanatory power of "myth" can put an end to

writing. As a writer he is quite naturally interested in the "generative" rather than the explanatory power of myths (see Kroetsch, *Labyrinths* 109–18).

But more broadly political issues are also at stake. The redefinition of a dominant ideology always has implications within and beyond the academy. The most direct effect is on the canon — on what is considered by those with cultural power to be worth preserving and teaching. Given that a canon, like "capital" in Marx's formulation, involves not only a collection of objects but a set of relations guaranteeing the employment of those objects in certain ways (in the case of the canon, a set of interpretive assumptions that justify/ perpetuate the selection; in the case of capital, a set of relations that guarantee the use of physical resources — machines, human beings — for the production and appropriation of surplus value) any change in those relations would have an effect on the whole. Changes in the canon have an effect on a host of institutional practices, from methods of pedagogy to the selection or promotion of professors. They also effect the struggle of historically marginalized groups — women, racial minorities, gays — to be represented in culturally positive ways.

Hutcheon's list of elements throws an interesting light on the postmodern generation of new meanings, for most of the elements on the list have been read before in quite unpostmodern ways. Dualities, as Derrida tells us, are the mark of "metaphysical" thought: "two solitudes," "Jungian opposites," "doubles" could all be read not as images of postmodern indeterminacy but as specular images that reinforce a larger unity. By suggesting postmodern irony as a potentially useful concept Hutcheon seeks to liberate other readings of these elements. Her suggestion is based not on something "outside" but apparently "within" the elements, as if the elements themselves latently contained postmodern readings waiting to be

released. In fact, this is always true. The technique of postmodernism is to open up new readings by taking "old" elements, particularly elements associated with a dominant ideology, and situating them in a new, destabilizing context. By a shift of contexts one could read Frye's description of the selection of Ottawa as the Canadian capital as an image of Canada's "postmodern" heart: in more ways than one, the Canadian centre is "out of the way." Similarly, Kroetsch rereads *Wacousta*, the archetypal novel of the "garrison mentality," as the novel which commences the (postmodern) search for "[a] grammar that occasions rather than prescribing; a grammar that, against its own prescription of repetition, invites breakage" (*Essays* 58).

The reassertions of irony by Kroetsch and Hutcheon can be read as interested, postmodern uses/abuses of the dominant ideology of Canadian culture. As a final illustration of the potential effects of such use/abuse, I would like to offer a short reading of Frank Davey's *The Abbotsford Guide to India*, a clearly parodic, likely "postmodern" text, and an example where Davey's literary practice extends the theory of "Surviving the Paraphrase." The irony of *The Guide* depends upon a familiarity with at least two "old" contexts: the travel guide and the "small town" story or novel. It is also helpful to know that Abbotsford is Davey's own small hometown. Irony is signalled by the opening comparisons between Abbotsford and India in which Abbotsford is ultimately asserted to be "the centre of the world" (3). The rest of the text proceeds by understatement; at times it seems (almost) really to be a guidebook, even offering photographs of tourist sights with mostly "unironic" captions.

The postmodern irony of *The Guide* offers a critique of some key products of our dominant cultural ideology. The reduction of India and the elevation of Abbotsford point to the ethnocentricism of our voyeuristic Western culture, while also exposing the absurdity of the Canadian obsession with the "small town." At the same time, the

"getting" of the irony, on the part of the reader, is dependent upon a certain complicity: if we are familiar with tourist guidebooks we have likely been tourists ourselves, and the understatement of much of Davey's text draws us into reading somewhat as tourists. *The Guide* contributes to the struggle over cultural definitions by making it difficult to go back to unironic readings of similar texts in the future. For example, the shift of context engendered by the "getting" of *The Guide* unleashes a host of new readings from a book like Sylvia DuVernet's *Egyptian Themes in Canadian Literature*. In her study DuVernet argues that E. J. Pratt was influenced by Egypt because he worked with a man who actually went there. As a result, "[i]n 'The Ice-Floes' [sic] we read that 'seals in pyramids arose.' " And " 'In Absentia' [sic] contains the phrase 'His face a hieroglyph of stone' " (10). DuVernet's reading of David Godfrey's *The New Ancestors* makes generous Western acknowledgements of the universality of man: "Speaking broadly, there is, Godfrey suggests, little difference between the problems found in Egypt and those experienced by universal human nature. We are all basically Africans" (83). Through the lens of postmodern irony, DuVernet's study becomes either an extreme example of the reductiveness of thematic criticism or a brilliant parody of those very tendencies within the dominant ideology.

No definition or redefinition of cultural identity is itself sufficient for political struggle. There is a relative autonomy to cultural matters which suggests that, although they occur within the wider context of human activity, and thus affect and are affected by this activity, they also develop in response to certain internal imperatives. "Making it new" is one such imperative, and the postmodern rereading of Canadian culture can be read as another self-interested exercise by critics to open up new vistas for criticism. The postmodern project itself has certain political limitations, as Fredric

Jameson, amongst others, has argued. In the context of the Canadian debate the limit might be illustrated simply: the assertion of "total ambiguity" is as likely to lead to quietism, to lead literally nowhere fast, as it is to encourage political struggle. And yet, for all that, the postmodern use/abuse of the dominant ideology is, it seems to me, a useful step. The Canadian reassertions of irony make it impossible to accept the comfort of the old names, with all that the old names exclude. In so doing they produce a space for new names, and for new meanings. Nothing is for certain, but with the possibility of new meanings there is still the possibility of a better way.

POSTMODERNISM IN RECENT CANADIAN ART: IRONIES OF MEMORY
MARK A. CHEETHAM

· *University of Western Ontario*

M Y REASON FOR LOOKING at the recent visual arts in Canada through the double lenses of memory and the postmodern is that I have been struck — in discussions with artists, in looking at their work, in reading about it, and in studying contemporary theoretical discourses generally — by the overlapping of notions of the postmodern and (usually rather oblique) references to memory.[1] My goal is to begin to conceptualize these widespread interlockings and unlockings with specific reference to Canadian visual art and to do so in ways that are at once specific in their involvement with contemporary artistic practice *and* quite general in their power to illuminate present culture. This double focus will also allow me to suggest how irony figures centrally in the workings of memory and postmodernism in the visual arts. These reflections are based on a large group exhibition called "Memory Works" and on research done for *Remembering Postmodernism: Trends in Recent Canadian Art*.[2]

Memory is integral to postmodern artistic practice; reciprocally, theories of the postmodern offer ways to comprehend what I claim are *new* deployments of memory in the visual arts. This mutual engagement is neither binary nor dialectical. Rather, it is at once concentrated and diffuse, by turns explicit and elusive, and, in ways that I will try to make sense of shortly, it is consummately ironic. These interactions can be construed under three discreet yet interrelating headings: *Memories of Modernism* in the visual arts, where the vexed but crucial questions of postmodernism's self-announced relationship with modernism, however it is defined, may be addressed; *Recollections of the Subject*, where the quintessentially postmodern construction, rather than discovery, of the subject can be examined; and finally *Social and Political Memories*, an area in which postmodernism's characteristic attention — to not forgetting (as critics like Fredric Jameson would have it) — history, both personal and public, frequently effects telling social and political critiques.

I am well aware of the risk of reduction in the presentation of such a schema, and I would not for a moment suggest that these three areas of intense interaction between memory and the postmodern expend the possibilities of either notion, let alone those of contemporary Canadian art. At the same time, I am suspicious of any claim to exhaustive analysis and conscious that we must, however provisionally, adopt some sort of rubric if we are to examine the claims I am making here, or indeed the claims others make about the postmodern. I will thus address the complex relations between memory and the postmodern in terms of these divisions. Risking reduction again, or perhaps even worse, the danger of appearing to claim that a small number of works and artists somehow *represent* the work of their contemporaries, I am going to focus on only four artists in this essay in order to present evidence for the importance

of the memory/postmodern relation. Though I have consulted a large number of artists to arrive at the ideas presented here, I make no apology, really, for focusing on only a few of them. One thing postmodern theory teaches us is that we are always selecting and excluding from within a particular context.

The works I will discuss are by Allyson Clay (a Vancouver painter), Robert Wiens (a sculptor in Toronto), Janice Gurney (a multi-media artist also from Toronto), and Stan Denniston (a Toronto photographer).[3] It is worth mentioning that three of the four were born in 1953 and that almost all of the artists who define the postmodern in Canada matured in the late 1960s and early '70s.[4] Most importantly, all four use memory explicitly and ironically, and I think the resulting work is prime postmodernism.

Allyson Clay's *Lure* is an installation of four small abstract paintings and four texts that was first exhibited at the Artspeak Gallery in Vancouver in June, 1988. The paintings were hung in a horizontal line on one wall; they faced the similarly displayed texts over a gap of about twelve feet. One type of comparison made possible by this spatial arrangement can be seen in the final pair, called *Eye to Eye*. The painting is a simple alternation of black and white vertical bands, each of equal width. *Lure* speaks directly to and within the tradition of abstract painting, a tradition that is frequently seen as representative of modernism in general. The parallel text describes, in apparently neutral terms, how to make the painting we see. Clay begins: "Using either cedar, hemlock, pine or fir, build a stretcher with bevelled edges 13″ square and 1¾″ deep. Over this stretch a medium weight linen"[5] The descriptive voice on the one side of the verbal/visual comparison is, we might say, echoed by the materialization on the other. But this doubleness is anything but a neat opposition. Clay intervenes in the textual component of *Eye to Eye* with two other voices that run *vertically* on either side of the

seemingly straightforward recipe for abstraction. These voices are strongly gendered: on the right of the text, a passage based on a contemporary painting manual reveals the discourse of dominance over a passive medium: "I read that art inspired him to prove he was in charge even if it required occasional mutilation and penetration of the surface with gentle strokes." On the left, Clay inscribes a gently erotic evocation of what seems more like a relation between two people than between artist and canvas: "I touch your mouth face to face breath to mind wet to wet myth of her always yes look not at but into me eye to." In a statement accompanying the catalogue to the *Lure* exhibition, Clay writes: "it is necessary to reveal some of this implicit historical hierarchy in order to be able to claim painting as a viable territory for an alternative set of values which are not primarily defined within patriarchy." She tries to understand what the premises of the decidedly masculinist tradition of abstraction are in order to "take back painting." The simplicity of the images and their instructions work within a formalist tradition of reductive *purity* in which Clay too was trained. (See Cheetham, *Rhetoric*.) But she dis-members this process in order to re-member modernism differently. She is inevitably implicated in the maleness of this tradition and *lured* by its authority, its aura, but she can also use this point of reference to offer a critique of its hierarchical assumptions and methods. *Lure*, then, is an emblem of painting: of its modernist past *and* its postmodern potential for critique.

The doubleness of Clay's gesture embodies a potent irony. By questioning, as she puts it, "how to paint without demonstrating complicity with painting's patriarchal tradition," she must work both within and without this set of naturalized conventions. Irony in the postmodern context can thus be construed as that *space for critique* opened up by this double movement. Clay herself — like numerous theorists — uses such a spatial metaphor when she speaks

of a "viable territory" for new values. So common is it these days to image one's "distance" from, yet inevitable relation to, a particular position or value by employing a spatial image that it sounds quite odd to substitute a metaphor from one of the non-visual senses. For example, could postmodern irony be the sweet taste of difference for its supporters, or perhaps the bitter tang of declining values for its many detractors? Perhaps it has the ambivalence of the bitter-sweet. I indulge in this levity only to suggest that there may be something worth investigating *behind* the use of spatial metaphors, a use that I endorse, but that I wish simultaneously to question.[6] Without trying to sound like Lessing, this powerful rhetoric of the spatial seems specially adapted to the visual arts. Tellingly for my theme, memory too has habitually been envisioned spatially. Think of Plato's wax tablet or St. Augustine's storage rooms. Postmodern-ism, too, is distinctly, if metaphorically, spatial in the sense that its manifestations are self-consciously context-bound, particular to a certain historical nexus of social, personal, and ideological inter-sections, a particular place of this extended sort. Postmodern memory, however, is not as legible as Plato's wax tablet or as organized and secure as the rooms in Augustine's storehouse. There is a lot of leakage in postmodern memory. Perhaps the multi-screen cinemas found in many cities now provide a better spatial metaphor for the mnemonic ironies of the postmodern than do Augustine's self-contained rooms. Each projection area may be somewhat inde-pendent, but sounds, smells, information, people — all move from one space to another in unpredictable ways. In Allyson Clay's *Lure* too, the most telling spatial disruptions are effected in the texts, not the paintings, and the result is a productive blurring of those generic categories.

The result can be what Merleau-Ponty once called a "dehis-cence," an opening up and unpredictable dissemination of meanings

within what is supposed to be a controlled situation. Robert Wiens's sculpture *The Rip* from 1986 is a case in point, now dramatized within the sphere of both personal subjectivity and social statement. Wiens has here constructed a memory theatre of his own. What we see is a scale model of a movie theatre, built with painstaking attention to detail. On the wall is an accompanying text that reads as follows: "The rip was small when it first appeared. It began when an Indian poked a knife through the screen. Later a bottle was thrown through it. The rip continued to grow. Eventually it became impossible to ignore." The rip that gives the piece its evocative title, we thus discover, is in the movie screen. But when we look inside the theatre Wiens presents, the screen, ironically (if we have read the text first) is both fully intact and blank. Just as film is projected onto such a screen, memory's gaze is directed into one's own past, which is thus very much constructed in the present. *The Rip* allows each viewer to complete this process individually, and Wiens himself is in part projecting his own memories of boyhood experiences in the Vogue Theatre in Leamington, Ontario. But what of the text? It too recalls an experience Wiens had in a movie house in Whitehorse, and with *The Rip* he looks back at what was for him a formative interaction with native culture. The rip in the screen was made during the excitement of a film starring Anthony Quinn in which the "Indians" "won." In one sense, then, the rip is a spatial metaphor for the growing political activism of native Canadians, which "became impossible to ignore." But the irony is that just as in the film, the Indians are not in Wiens's piece the agents of their own actions, of their own social commentary. "The rip," in the sense of cultural difference, also "continued to grow." Wiens's reconstructed memory here evolves from his self-understanding as "white" to a statement about social and political disenfranchisement. As viewers of this work, we approach both the outside and the inside of his

Robert Wiens, The Rip *(1986; wood, glass,
75 watt lights, 1.2 x .9 x 1.8 m.). Carmen Lamanna
Gallery, Toronto. Photo by Cheryl O'Brien.*

memory-cinema, just as his recollection of the rip in the screen in Whitehorse is one of both sympathy for the Indians' plight yet complicity in their colonial denigration. Without overdetermining the result of each viewer's gaze, Wiens has presented the potential for individual memories to intersect with social concerns.

Janice Gurney's 1986 mixed media piece called *Screen* also works initially as a mnemonic and, again, there is an explicitly filmic construction of a sense of the subject. It is built on ironic displacements and replacements. The work has three parts: on the left, a dark background holds a text (from the Marguerite Duras poem "The Lover") that reads: "At that time she'd / thirty-eight. And the / ten. And now, when / she's sixteen." The centre image is a haunting still of a young woman holding a baby, taken from Erich von Stroheim's film *Foolish Wives*. On the right, the text continues: "time she'd just turned / And the child was / now, when she remembers / she's sixteen." These texts do not "read" normally from top to bottom, but when we scan them from left to right (across the body of the young woman and child), they gel into a more conventional narrative:

At that time she'd / time she'd just turned
thirty-eight. And the / And the child was
ten. And now, when / now, when she remembers
she's sixteen. / she's sixteen.

The border running under each of the three sections is a photographic blowup of canvas, and it suggests another set of displacements and replacements. Painting is already displaced by photography, which in turn is replaced by references to film made by the title — screen — and by the sense we have of a film strip. The central image of the woman and child is a photograph of a photograph of a

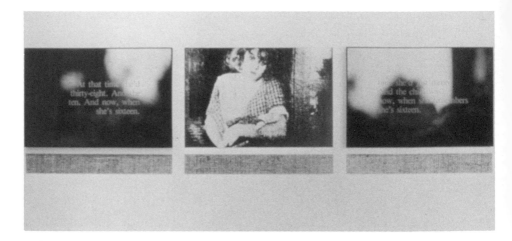

Janice Gurney, Screen *(1986; photostats, cibachromes, plexi, 38.5 x 143 in.). Wynick Tuck Gallery, Toronto.*

film still. Memory explicitly constructs the sense of self that the woman/narrator has in the present as she *reflects* on her past both in language and with the image we see. Ambiguities and ironies abound when we try to hold onto this subjectivity, however. The repetitions as we read the text from left to right mimic and blur the two subjects denoted as "she." We look through the screen of memory, ours and hers, and that screen perpetually changes what we see. We also look through plexiglass, which Gurney uses precisely because it *reflects* our own image and those of other people and objects. The experience is again mnemonic (both personally and socially) in a way that is quintessentially postmodern.

Janice Gurney's *The Damage Is Done* (1986) provides another excellent example through which to consider the mutual infiltration of art-historical recall, the construction of a subject as source for a work, and the social and political ramifications of these memories. This complex painting — or should it be called an assemblage? — has lost none of its ability to shock its viewers into reflections on the notion of artistic ownership (by the artist and commercially), of a work's "integrity," and of claims to originality in light of which the term "appropriation" can assume damning connotations. These and related issues are as topical in 1990 as they were in 1986, despite Gurney's attempts with this (and many works in which she employs another artist's image as a "support," like *Portrait of Me as My Grandmother's Faults* [1982] — using an Andy Patton canvas — or *1001 Details from "Genre"* [1988], which works on a painting by Will Gorlitz called "Genre") to have us re-examine the premises according to which we might feel distress at her actions. Her art-historical reflection is literalized by the underlying layer of this work, which is (or should we say "was"?) a painting by Joanne Tod called *The Upper Room*. Gurney asked Tod for a support of the right size, without specifying what might be on it, and then proceeded to enact on this

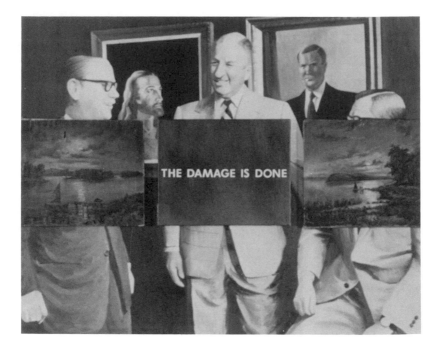

Janice Gurney, The Damage is Done *(1986; oil on canvas, 49 x 66 in.). Private Collection.*

surface what memory itself always effects (though usually less materially): change. Tod's image itself cites a once potent moment of art's history and radically re-contextualizes it: she has reproduced the famous Saltzman image of Christ in the background of a boardroom scene. Although Gurney and Tod are friends and Tod was consulted initially, *The Damage Is Done* is no more a collaborative work than was Tod's "original." On the top of what is already a double art-historical appropriation, Gurney has attached three panels. Those on the left and right are "actual" nineteenth-century landscapes that she found and bought in a Vancouver antique store. The centre panel was executed by Gurney and frames the not unambiguous title: "the damage is done."

Gurney's physical layering reminds us of the veils we look through and which look back in *Screen*, even though she understands these two pieces to represent somewhat different paths in her career: the physical and potentially political with *The Damage Is Done*, and the photographic with *Screen*, which focuses more on the nature of the subject. Yet both works investigate the status of originality, the putative uniqueness of artistic images — the von Stroheim clip and the Tod painting — and the sense in which an artist is an origin for a work. Memory is in both cases the rubric for this research. Just as it appears that there is no essential, original subject in *Screen*, so too *The Damage Is Done* makes it impossible for us to find either an essential work within its layers or an essential artist. Each potential source is doubled and re-doubled: there are at least four "signature" works of art here. If we work back spatially, we have the anonymous landscapes (which, because of their damaged state, appear without signatures but which have been valued as art in the antique shop by the person who sold them, the person who painted them, and by Gurney herself), the Tod painting, the Saltzman Christ, and the anonymous portrait to the right of it, which is Tod's but not Tod's.

Then there is the conglomerate called *The Damage Is Done*, which significantly Gurney *does not* sign on the front. This spatial, temporal, and ultimately philosophical regress could be continued, since the nineteenth-century landscapes are very much in the style of earlier British and European views, which themselves of course are indebted to seventeenth-century Dutch models in particular. Though I want to argue that damage is done mostly to the privileging notions of originality and intentionality, Gurney's wilful *use* of Tod's canvas and the landscapes demands that we read the title again. Tod's work is quite graphically defaced, especially when we look at its right-hand side, where the man's head is blocked by the landscape panel. Physical damage is done as the three panels are attached, and most importantly to most viewers, the "integrity" of the underlying work is impinged upon. The latter issue, with all its emotional and legal overtones, has been discussed by Lawrence Alexander in an article tellingly entitled "Moral Rights and the Visual Artist." Alexander examines — in light of several contemporary examples — the pending legislation designed to protect artists and their work. "With a painting, sculpture, or engraving," he writes, "integrity is treated as the integrity of the work itself; *any* modification of such a work violates the right of integrity" (16). Alexander condones this definition, and there is little doubt that many apparent defamations of works would be subject to redress under these terms. Since Alexander's article reproduces *The Damage Is Done* prominently at its outset, we seem to be asked to consider this "case." But curiously, the author doesn't mention the work at all, perhaps because it would prove too difficult a test for his would-be law of integrity.

Alexander claims that "in most cases, it is impossible to separate the personality of the creator from the object she has created, so [defamations of various sorts] . . . constitute a direct and personal assault on the integrity and reputation of the individual involved"

(14). This statement has the "correct" political ring, but it assumes much of that which *The Damage Is Done* contests with its overlapping memories. Who is "the individual involved" when we reflect on the unstable postmodern subject? What is "the object"? These are not the merely "theoretical" quibbles Paul Smith warns against, since if Alexander's law were enacted, Gurney would be guilty of violating integrity — though it becomes quite impossible to say whose, since we would then become trapped in the infinite regress of originality relayed above. In these complexities, we can perceive the social and political implications of *The Damage Is Done*.

"Damage," as Gurney here presents it, is not entirely negative or avoidable. As a re-using, a re-contextualizing, her version of damage is nothing other than the process of memory itself, a process without which art cannot exist. Works "damaged" in this way maintain their sentimental and economic value. And *The Damage Is Done* dramatizes the productive potential of such reconstitutions of images. By partially concealing the boardroom scene with scarred landscapes, Gurney takes our memories in another direction, toward environmental concerns (also an issue for Tod). The self-satisfied men in the picture seem to have made a decision, one that is sanctioned not only by a predecessor or colleague whose image hangs behind them, but also by Christ, through the inclusion of the other image. Could this decision in some way impinge upon the sort of pastoral scenes of nature to which damage has already been done? The "damage is done" is a clear and by implication irrevocable statement about the past. By memorializing and destabilizing the past's referents, however, Gurney is able to speak to our collective futures.

In the late 1970s, Stan Denniston produced a series of photographic pairings that he calls *Reminders*. One of the most complex and interesting pieces from this series is *Reminder #20*, from 1979. These images were inspired explicitly by the workings of memory.

Stan Denniston, Reminder #20 *(1979; two
silverprints, 42.4 x 100 cm.). Artist's Collection.*

During extensive travels, Denniston would be "reminded" of a familiar place by a new scene that presented itself. He would then shoot this scene — always displayed on the left of the pairing when the work is exhibited — and *before* developing and printing this image, travel to the remembered place and photograph it. In this example, we see that "Edmonston, Texas, from the West" triggered a memory of "Downtown Toronto from King St. West." Of course these images invite comparison, both formally and thematically. In a sense — and I think this is especially true when one first sees this pair — the pictures are very different. Yet as in memory's workings themselves, it seems to me that differences are increasingly elided and the profound similarity of feeling between these photographs comes to the fore. Despite the "business" of the Toronto image, what we begin to see is the dramatic focus directed by the streetcar tracks, a visual pull that is echoed by the tire tracks in the Texas image. Ironically, then, the two places end up looking very much alike.

Art historians are all too used to setting up comparisons like this, and it would be an injustice to Denniston's photographic instantiation of memory to remain in the hold of such binarity. In conversation, Denniston suggests that for him there is always a third image in these pairings, an image that remains in his own mind underdeveloped, we might say, and certainly unprinted. This is the memory image, an unresolved third term. It is necessarily personal and, as Denniston's technique for the *Reminders* series shows, decidedly contingent upon particular encounters. At the same time that this memory-work helps to define Denniston's subjectivity and that of the viewers of his work, however, it also has the potential to become resolutely political. A more recent work, *Kent State U. / Pilgrimage & Mnemonic* (1982 / 1990), makes this point powerfully.

The "original" piece of this name was executed in 1982 as a response to the murders at Kent State over a decade earlier. The

work is graphically "re-collective" in the sense that Denniston went to Kent State, gathered impressions that were of course coloured by his own memories of the political events now associated with this place, and then returned to Canada to take photographs of specific sites, memories of which were triggered — the punning here is meant to be more poignant than amusing — by what he had seen at Kent State. The resulting photomontage was, in effect, a recreation of Kent State in Canada many years after the "original" event, an ironic and politically jarring displacement and replacement of images and associated ideas. As mentioned, Denniston has recently reworked his 1982 piece, so we now have a triple-mnemonic vision of Kent State, a triple reflection not only on the artist's personal recollections of Kent State, and not only on his own work, though this is of course important, but centrally on a time of radical political activism from the vantage point of the late 1980s and early 1990s. Over the Kent State images, Denniston has placed altered photographs of the notorious Bathhouse raids in Toronto in the early '80s. He discovered that this event was indeed the trigger for his own thoughts about Kent State, yet only recently has he made this overlay of associations visible. The addition of these images — clearly brutal even if we don't recognize them from their wide circulation in the press — makes *Kent State U.* at once more explicit and an even more intricate exploration of memory. What we cannot see but might glean from the fact that Denniston was drawn back to his 1982 version, is his assertion of the possibility of memorialization, the positive potential of his own social and political agency in keeping memories alive through his work. This guarded optimism, Denniston will say in conversation, parallels his own sense of pleasure at being involved in the protest marches after the Bathhouse raids, the sense of participating, of intervening quite physically in a political situation. And of course this demonstration is itself a reminder of

the abhorrent results of the students' civil actions at Kent State.

In Milan Kundera's *Book of Laughter and Forgetting*, we read that the struggle of civilization "against power is the struggle of memory against forgetting" (3). If one can agree that art is in an essential way a process of selection — whether material, formal, or thematic — I think it follows that art too is profoundly involved with forgetting and with the overcoming of amnesia, with memory. Art certainly produces reflections of and on important experience, but these reflections are the result of radical cropping. They are thus partial and provisional; the very mode of their production should prevent us from ever suggesting that images are in any way timeless. Much postmodernist art remembers this lesson and embraces it without any nostalgia for a more complete presence of the subject or of history. Ironically, perhaps, postmodernism is concerned with history but avoids giving us *History*. In this act of remembrance, the works I have discussed are resolutely if ironically personal, historical and, as Kundera reminds us, political. Allyson Clay remembers and resists the historical and personal patriarchal power that would dominate the material production of paintings; Robert Wiens projects his own memories of racial tension both back into personal experience and ahead, temporally, as social commentary; Janice Gurney provides a powerful image of the complexities of remembering, and thus defining, one's subjectivity; Stan Denniston, finally, evolves a wide-ranging object lesson in social and political tyranny from both personal and cultural memories of Kent State. I am, of course, not suggesting that memory and irony are postmodern or Canadian inventions. What is postmodern about them is that their deployment in Canada over the past two decades is often directed towards making memory *work*, to keeping open possibilities for historical, personal, and political commentary.

NOTES

1 I am not aware of any discussion of this particular connection that attempts to extend our understanding of either postmodernism or memory. The 1985 New Museum exhibition and catalogue *The Art of Memory / The Loss of History*, though extremely challenging, does not engage with the nature of postmodern discourse to a significant extent. Campbell's essay on the German artist Gerhard Merz (*Mnemosyne or the Art of Memory*) typifies a menacing amnesia characteristic of high modernism, as I have argued at length elsewhere (see "Purity").

2 "Memory Works: Postmodern Impulses in Canadian Art." Curated by Mark A. Cheetham. London Regional Art and Historical Museums. 15 Dec. 1990–3 Feb. 1991, and touring. Passages from *Remembering Postmodernism* appear here with the gracious permission of the publisher.

3 The "Memory Works" exhibition itself is much more representative of artistic practices across Canada.

4 For a discussion of the important generational factors in the development of postmodernism, see Huyssen.

5 Quotations are from the catalogue to the exhibition, Artspeak Gallery, Vancouver, 1988, n.pag.

6 To my knowledge, Alice A. Jardine is one of the few critics to thematize this spatial metaphor.

DOUBLE EXPOSURES: THE FOUND POEM AND IRONIC READING

MANINA JONES

· *Carleton University*

I N HIS BOOK *Irony and the Ironic*, D.C. Muecke describes what he calls "a sense of irony" (42). This sense, according to him, involves both the ability to perceive ironic contrasts, and the power to shape them in one's mind (42) — the power, that is, to make disruptions of sense meaningful. A sense of irony, then, like a sense of humour, is a function of the receiver's ability to respond, his or her ability to recognize and *make sense* of conflicting interpretive possibilities. Irony is not irony unless the receiver "gets it," and "getting it" necessarily involves a self-conscious act of interpretation. Muecke provides this illustration of the way a sense of irony might be put into play:

> There is a street in Paris named Impasse de l'Enfant Jésus. To see this as ironical one need only be (unlike him who named it) sensitive to the incompatible connotations of 'impasse' and 'Jésus'; but the irony is enhanced if one recalls the Gospel of St. John: 'Jesus saith unto him, I am the way . . . no man cometh unto the Father, but by me' (John 14:6). (42)

Muecke's example distinguishes two stages, seeing and shaping ironic contrasts, but the act of "shaping" or interpreting irony is inseparable from ironic reading (or "seeing") itself, since, for example, the significance of the world "Jésus" is by definition already predicated on its position within a religious discourse that draws on figures of access (to truth, to eternal life, etc.). Muecke has simply articulated the process by which a dissonance between "Jésus" and "impasse" is produced.

The ironic reading Muecke recreates in his example doubles the kind of interpretive strategies that are central to the definition of the literary form known as the found poem. In fact, in transcribing the Parisian street sign, and in drawing our attention to its ambiguities, Muecke acts as a found poet. Franz Stanzel's definition of found poetry, "poetry not written by a poet but found, that is to say, taken from a non-literary context and printed in the traditional format of poetry" (91), hints at the importance to that form of the perception and recuperation of a contrast between the conventions of "non-literary" and "literary" reading, and the kinds of meanings each produces. This perception is facilitated by the translation of a "found" text from one context to another.

Like Muecke's example, the found poem foregrounds the fact that an "original" text functions as a point of intersection of alternate, conflicting readings. Gary Handwerk cites "an incompatibility between competing meanings" as the identifying trait of irony (1); the found poem might similarly be characterized by a sense of contrasting readings embedded within one another. The awareness of the given text as a point of semantic intersection, in keeping with Muecke's example, results in its own "impasse," a kind of linguistic "traffic jam" which is typical of the found poem. Read as a found poem, a given prose text can no longer be seen simply as a passage through which the reader can travel, but rather becomes a place

where the reading process gets stalled. "Final" significance is deferred; if one meaning prevails absolutely, the found poem ceases to function, just as irony depends on an irresolvable duality which "is not merely a matter of seeing a 'true' meaning beneath a 'false,' but of seeing a double exposure . . . on one plate" (Allan Rodway, cited in Muecke 45).

At least three writers have supplemented their definitions of the found poem by referring to a historical relationship between it and the Dadaist "readymade" or *objet trouvé* of the visual arts from the years following the First World War (Stanzel 91; Colombo, "Found Introduction" 308 and "A Note" 124; Nesselroth 186). The analogy between the two projects is based on their mutual use of ironic dislocation. Duchamp's *Fountain*, a urinal displayed in the famous Armory Show, simply signed "R. Mutt," is perhaps the most famous example. The "readymade" object is presented as a *text*, open to a multiplicity of interpretations. Indeed, Jack Burnham sees the ready made as an object that by definition exceeds any closed, monologic reading: "the readymade suffers from excessive meaning (its functional use) and a lack of articulation by the artist (its rawness so to speak)" (61). In a play on words that reveals the frequently linguistic and linguistically ironic focus of his works, Duchamp calls attention to the fact that his practice presents the very notion of certified/ sanctified canonical Art (and the criterion that the aesthetic be non-practical) ironically: ". . . wanting to expose the basic antinomy between art and Readymades I imagined a 'reciprocal readymade': use a Rembrandt as an *ironing* board!" (142, emphasis added). It is worth noting, that at the same time as the Dadaist readymade tends to undermine aspects of institutional art, it draws on the latter's apparatuses through, for example, its use of title, artist's signature, and conventions of presentation. The found poem, similarly, both draws on and ironically undermines poetic and prosaic convention.

In the earlier-quoted passage on irony, Allan Rodway uses a photographic metaphor when he refers to "a double exposure on one plate." Tom Hansen's definition of found poetry makes possible a refiguring of "plate," since it uses a gastronomic trope. It also employs a variation on the term "exposure":

Most found poems begin their lives as passages of *expository* prose. Their intended purpose is to feed easily *digestible* information to the reader. Nothing could be less poetic. But suddenly poetry is discovered imbedded within the prose. The discoverer is someone alert to the possibilities of irony, absurdity, and other incongruities (271, emphasis added).

Found poetry is "easily digestible" utilitarian prose made, somehow, "indigestible." A readily identifiable or familiar piece of prose can no longer be passively consumed because it is now perceived as (at least) two things at once: prose and poetry, obvious and devious, ordinary and literary. The process of reading the found poem creates a double exposure: not only is a specific alternate meaning "exposed" on the reader's plate, but expository prose in general is "exposed" as encoding something more than simple reference. Hansen's digestive metaphor suggests a Barthesian approach in which the poetic reading of the found passage transforms it from a readerly work whose "message" may be easily consumed, to a productive, writerly text, whose "excessive" elements (like those involving conflict and indeterminacy) are foregrounded. (See Barthes, "From Work to Text.")

Daniel O'Hara's definition of irony, in this context, may be equally applied to the found poem, since it describes the way both problematize the reading process. According to O'Hara, with irony,

the power to entertain widely divergent possible interpreta-
tions [may be used] to provoke the reader into seeing that there
is a radical uncertainty surrounding the processes by which
meanings get determined in texts and interpreted by readers.
(363)

The found poem, like irony, "provokes" us into wilfully and radically
"misinterpreting" texts whose meaning is, superficially at least,
obvious. John Robert Colombo, Canada's most widely published
found poet, comments on this "provocation" of the reader:

> When a reader comes across a poem on a page, he has an excuse
> to react, but when he learns the poem that has triggered his
> emotional reaction is prose in the guise of poetry, he finds
> himself unable to see the poem for the prose — suspicious,
> angry or embarrassed, possibly amazed. (*Mackenzie Poems* 20)

The "embarrassed" reader, too, then, is "exposed," since the
assumptions s/he has undertaken in the reading of the text at hand
are revealed, assumptions the presentation of the text both affirms
and undermines. In Colombo's description, the found poem has
a-mazed the reader or taken her/him in by appearing to call for the
reading conventions and responses of poetry. The poem then reveals
an alternate status as "ordinary" prose, which calls for a different set
of conventional responses.

Colombo's poem "Found Object," from his volume *ABRACADABRA*,
provides an example whose reading pivots on ironic doubleness:

> "The retreat of the ice
> left Canada much
> in its present condition,

except for certain
post-glacial changes of level
which seem to be
still in progress."

"Canada"

Encyclopaedia Britannica

(Eleventh Edition)

1910

Volume V

Page 143 (45)

A "stratified" poetic presentation of the poem both encompasses and conflicts with the "footnote" identifying the text's prosaic context. The poem thus suggests a "change in the level" of its own reading. *"Encyclopaedia Britannica"* and the bibliographical detail provided connote a discourse of empirical "knowledge" and "truth" and suggest a reading of the text as geologically and (pre)historically referential and "accurate." "Canada" in this case, is merely a geographical locus. The poetic presentation, however, permits a shift in reference and convention. "Canada," we realize, might also be a cultural and political entity, and the poem may be read as an ironic comment on its lack of development. Another of Colombo's found poems, "Canada: Etymologies," cites a number of alternate historical sources for the word "Canada," ironically dismantling the notion of a fixed "Canadian identity" by presenting it as a historical-discursive problem (*The Sad Truths* 39).

The effect of these found poems, and many others, hinges on the wilful violation of the "original intention" the reader infers from the prosaic context: the *Encyclopaedia Britannica*, we know very well, "intended" no such particular cultural commentary. The same is

clearly true for many other ironies. Muecke's analysis, for example, hinges to some degree on the present reader of the street sign being self-consciously "unlike him who named it" in his awareness of its "incompatible connotations." Meaning, as the found poem indicates, is located and relocated depending, not on the prior intention of a speaking subject or on an essential meaning contained in the words, but on the nature of the verbal transaction.

Another of Colombo's found poems actually thematizes language's ability to exceed its scriptor's intentions. Michel Foucault notes that, while writing was once considered something to ward off death by somehow prolonging the presence of its writer in his actual absence, freed of its strictly expressive dimension it, ironically, possesses the right to kill, to be the author's murderer (142). Colombo's "Memory Gardens Association Limited" revolves around just such a figurative death of the author. It appears in *Translations from the English*, where the title assigns Colombo the role, not of author, but of translator or *interpreter* of the given.

The poem transcribes a "circular letter" advertising a funeral parlour. Much of the langauge in the circular combines the "terminal" languages of death and finance: it concerns "The purchase of a final resting place / for our loved ones," for the sake of "financial protection and peace of mind," and offers help recording information for "your estate settlement"(15). In colloquial terms, the message is to tie up those loose financial ends before the inevitable happens. The "limited" in the company's name is therefore appropriate to both its legal status as a business and to the aim of its business, which is to close off unforeseen possibilities, making the future — even the future beyond death — secure; one might even say "carved in stone."

A bracketed post-script attempts to limit yet another form of liability:

. . . (This letter
is in general distribution. Should
it reach any home in which there is illness,
it is completely unintentional). (15)

This post-script involves an attempt to limit significance, to refine precisely what the cited text means. It might, therefore, be seen as a kind of memorial to the letter's absent scriptors, testifying to their intentions, but irrevocably marking their inability to enforce them. The poem postulates both the literal death of the reader and the figurative "death" of the author. In his famous essay on the latter topic, Roland Barthes comments on Mallarmé's groundbreaking recognition of

the necessity to substitute language itself for the person who until then had been supposed to be its owner. For him, for us too, it is language which speaks, not the author; to write is, through a prerequisite impersonality . . . to reach that point where only language acts, "performs," and not "me." (143)

Because the letter (and this, as Barthes's comments make clear, applies to the condition of letters in general as well as to correspondence) is "in general circulation," its context and therefore its reading is always varied and variable, necessarily beyond the control of its authors, from whom it is, as Derrida would have it, "separated at birth" ("Signature" 181). Each reading constitutes a different instance of quotation, and a reading of the letter by a member of a household in which there were illness would change its frame of reference in such a way as to violate its otherwise "decorous" character(s). The inclusion of the letter in Colombo's volume *Translations from the English* is another route in the circulation of the letter beyond its appointed rounds.

"Post-script" is a significant term for this analysis, since it denotes what comes after the fact, after writing. Finding "surplus" meaning (or any meaning, for that matter) in a text is literally post-scripting: it is both after writing and a writing, after. The "excess significance" which goes beyond a "practical" or "obvious" context is what we sometimes choose to call "poetic meaning," sometimes "irony." Jonathan Culler observes that the reading of verbal irony is contingent on the recuperation of an inconsistency or "excess" at one level of reading to another level. It depends, he writes,

> upon a set of expectations which enable the reader to sense the incongruity of an apparent level of *vraisemblance* at which the literal meaning of a sentence could be interpreted and to construct an alternative ironic reading which accords with the *vraisemblance* which he is in the process of constructing for the text. (154)

Eli Mandel's ironic found poem "First Political Speech" incorporates a number of contextual cues that indicate different possible levels of assimilation. These are literally con-textual, since they condition the reader to read the passage at hand *with* a certain repertoire of *texts* and conventions in mind. The work is appropriately located in Mandel's volume *Crusoe: Poems Selected and New*, since the found poem is *simultaneously* selected and new:

> first, in the first place, to begin with, secondly, in the second place, lastly

> again, also, in the next place, once more, moreover, furthermore, likewise, besides, similarly, for example, for instance, another

then, nevertheless, still, however, at the same time,
yet, in spite of that, on the other hand, on the contrary

certainly, surely, doubtless, indeed, perhaps, possibly,
probably, anyway, in all probability, in all likelihood,
at all events, in any case

therefore, consequently, accordingly, thus, as a result,
in consequence of this, as might be expected

the foregoing, the preceding, as previously mentioned

as already stated. (94)

A footnote to the poem reads: "Transition Table from *Learning to
Write* by Ernest H. Winter (Second Revised Edition) Macmillan
(Toronto, 1961), p. 156" (94). The footnote acts as a kind of index,
indicating that this passage is both a quotation taken *from* a reference
work, and that it *is* a kind of reference work: it refers to another
book, to the conventions we use when reading such books and the
expectations we have of them.

The poem's title, however, a kind of "headnote," identifies a
different context. As a style guide, we expect the passage to operate
as a compendium of conventions, but as a political speech it can be
read ironically, since it is *all* convention and no content. As Douglas
Barbour observes of the poem, it "furiously and wittily calls political
and poetic discourse into question, opposing form and content . . ."
(33). This empty "speech" ironically demonstrates a kind of coher-
ence or "shape," a "development" (reinforced by the stanzaic
arrangement) through a series of set rhetorical stages that proceed
logically, but without really saying anything: it proceeds from intro-

duction ("first, in the first place . . .") to reinforcement by reitera-
tion ("again, also . . ."), comparison (". . . similarly . . ."), antici-
pation of objections ("then, nevertheless . . ."), and summing up
("therefore, consequently . . ."). The final line, ironically, gestures
toward the reinforcement of a statement that has never been made.
The passage, then, is not just a guide to stylistic conventions, but to
stylistic conventions as the rhetorical terms that persuasively
"frame" positions of power; it is a guide to *political* speech. As
Barbour observes: "the particular aesthetic and ethical frame of the
concept 'poem' can . . . focus attention on the problems raised by
those forms of discourse that surround and seek to manipulate us"
(32).

Signals of the poetic context of the work include its division into
lines, position in a volume specifically identified as poetry, and the
signature of the known poet "Eli Mandel." These sanction a self-
reflexive reading which attempts to recuperate the passage's incon-
sistencies at yet another level of irony. In this context, the poem is
a "Second, Revised Edition" of a previous text. Its interpretation is
also a kind of "learning to write," because it is necessarily aware of
reading as a process of interpretation, or writing.

In his discussion of André Breton's "PSST," a work that presents
as poetry a page from the Paris phonebook, Jacques Ehrmann
comments that the very re-presentation of that page "presupposes
a certain minimum movement. . . . If, in this respect, it is possible
to speak of 'poetry,' it is in this slight movement of 'texts' that we
must look for it, discover it, *invent* it" (238). The term "transition
table" might be read as a comment on the "shifty" status both of the
politicians and of the poem itself: this "table" is a displacement, a
"transition" which might be seen in terms of two meanings of
"table": the poem hovers between an "objective" referential status
(table as an item of furniture), and a textual one (table as a written,

itemized list). One cannot, then, simply "table" a text as "documentary evidence," since the very locus of presentation is itself in transit, un(s)table.

Louis Dudek refers to the found poem as "really a piece of realistic literature" (3), referring, presumably, to its strategy of merely excerpting writing that "really exists" in the world. If we are to accept this view, however, "reality" itself must be read as a found text, a space of intersecting discourses, open to the possibility of (re)interpretation. Martha Rosler stresses that it is through irony that the act of quotation (found poetry's central gesture) can be critically forceful: "One speaks with two voices, establishing a kind of triangulation — (the source of) the quotation is placed *here*, the quoter over *here*, and the hearer/spectator *there* — and, by inflection, one saps the authority of the quote" (196).

F.R. Scott's poem "Treaty," for example, from his 1967 volume *Trouvailles*, examines a set of prescripted values involving Native peoples: it transcribes an 1854 agreement for the transfer of the Newash or Owen Sound Indian Reserve to the Governor General. It is quoted here in full:

TREATY

Ningaram ✤ (HIS MARK)

We
The undersigned Chiefs and Warriors
On behalf of the people
Of the Newash Band
Of Chippewa Indians
Residing at Owen Sound
Send greeting.

Whereas we and our people
Having the fullest confidence
In the eternal care
And good intentions
Of our kind Father the Governor General
Towards all his Indian children
And foreseeing all the benefits
that we and our posterity
Are likely to derive
From the surrender of large portions
Of our Reserve
In the year of our Lord 1854,
We have after mature consideration
In several full councils
Held at our village of Newash
Arrived at the conclusion
That it will be to our advantage
To place at the disposal of our Father
The Governor General
The land upon which we now reside
Commonly known as the Newash
Or Owen Sound Reserve
In order that he may cause the same
To be sold for our benefit.

Wabuminguam o o o o (HIS MARK)

A footnote identifies it as "Treaty displayed at Indians of Canada Pavillion, Expo 1967" (10). The title of the poem highlights the document's status as "contract" or agreement. Superficially this is simply a land transaction among parties who agree, presumably, on

a "literal" reading of the document that implies not just ownership of the land, but also a certain proprietary sense of words: in a legal contract, one means what one says.

The date of both Scott's and the Expo quotation is, significantly, Canada's centennial year, a time of revival and celebration of the nation's history. However, the Expo 67 presentation of the document puts that history in question, inviting an ironic reading, since the centennial celebration itself marks the emergence of a nationhood that erodes, both legally and psychologically, the "other" first nations apparently within but actually marginalized by "Canada." Expo's "Indians of Canada Pavillion," in one sense, is a pat symbolic gesture that simplifies the complex historical dilemma of Native peoples, much of which involves treaty negotiations, by constructing a stable space for them as mere tokens in the celebrated Canadian multi-cultural "mosaic," without really taking them or their aboriginal claims seriously. "Indians *of Canada*" makes "Indians" both subordinate to, and possessed by, the Canadian nation.

The ironic quoting of the historical document is one way of resisting this dismissive gesture without abandoning the forum it makes possible. The contemporary enunciation of the document breaks a verbal contract because it puts words to uses for which they were not "originally" intended. In so doing, the citation foregrounds the element of betrayal in the contract itself, exposing both its supposedly "dated" terms (both the terms of agreement and the language in which they are stated) and the extent to which the subsequent treatment of Native groups in Canadian history in fact continues to fulfil those terms. The very trope of the "familiar" relation of benevolent parent and submissive child ("our kind Father the Governor General") is, in its contemporary context, de-familiarized and read ironically as paternalistic in a negative sense. The

manifestly written context of the quotation draws attention to related verbal incongruities, exposing compromising positions. The contradiction between "Having the fullest confidence" and "surrender," or the ironic contrast between "We have after mature consideration . . ." and "Indian children" are significant examples.

We might note that the signature of Ningaram and Wabuminguam is absent, substituted for by symbols and explained in brackets as "(HIS MARK)" (10). Ningaram and Wabuminguam literally do not participate in the contract because they do not participate literally, that is, in its written language, a language imported by Europeans and framed within their culture. The "We" of the opening line (emphasized by Scott's line break), then, is ironic, since Indians do not speak in the historical treaty. The irony is emphasized by the poem that follows "Treaty" in *Trouvailles*, "Pavillion Misrepresents Outlook." This poem is a transcription of a letter to the *Montreal Gazette*, 11 July 1967, in which a Catholic missionary claims to speak for "the majority of Canadian Indians," concluding that:

"Most Indians aren't so bitter —
They're happy with what is being done for them
By the Government and by the missionaries." (11)

The Expo citation of the 1854 treaty allows its readers to "listen" for the exclusion of Native voices, and to consider the significance of that exclusion both to the historical contract and the ongoing contracts that structure current beliefs. At the same time, the document itself functions, ironically, as an enunciation by contemporary Native peoples who can engage subversively with its language. As such, it constitutes a transgressive seizure of European language.

Scott's intrusion as signatory also contributes to the reading of

the document. In a sense, the poetic reading of "Treaty" is a verbal contract F.R. Scott frames, especially since our biographical knowledge of Scott as law professor, social philosopher, political activist, and poet-satirist seems to encourage a combined consideration of the social and the literary. Scott's phrasal line breaks may attempt to "restore" a Native voice to the original written contract (although they may also function less positively as an allusion to the legendary "native eloquence" that has so often been used to relegate the political to the realm of the "merely" — i.e., marginally — aesthetic).

As co-signer of the treaty, Scott's own position is an ambivalent, compromised one. Scott may be seen as complicit with the framers of the document who were, like him, white, affluent, English-speaking and -writing males of European descent. Scott's own position of authority, particularly as Professor of Law, depends on the very discourse he cites. His quotation of the treaty and acknowledgement of its Expo recitation, however, also points to an attempt at alignment both with the cause of historical Natives whose geographical/discursive "place in history" is determined by the treaty, and with the contemporary quoters who seek to dislocate its terms, putting geographical *and* discursive place at issue. Without presuming to speak *for* "the Indians of Canada," Scott's quotation of the treaty, potentially, opens gaps in the dominant discourse that defines them as such; it is a disruptive gesture that may also tend to unsettle Scott's own positions as "expressive" poet, as Professor of Law.

Jonathan Culler writes that "in calling a text ironic we indicate our desire to avoid premature foreclosure, to allow the text to work on us as fully as it can, to give it the benefit of doubt by allowing it to contain whatever doubts come to mind in reading it" (157–58). Duncan Smith recognizes found poetry's claim to an extension of the "demystifying" procedure Culler describes with regard to

cultural signification. The reading strategies central to found poetry may help us "recognize the ambiguity in reality so that experimental analysis of reality may take place" (102). The found poem, then, like irony, draws attention to places where we habitually foreclose on signification, where meaning seems "obvious" or "natural" or "innocent," and asks us to look and think again.

THE WRITING ON THE WALL: THE IRONIES IN AND OF LOTHAR BAUMGARTEN'S "MONUMENT FOR THE NATIVE PEOPLES OF ONTARIO, 1984–85"
JULIE BEDDOES

· *University of Saskatchewan*

THE ONONDAGA MADONNA

She stands full-throated and with careless pose,
This woman of a weird and waning race,
The tragic savage lurking in her face,
Where all her pagan passion burns and glows;
Her blood is mingled with her ancient foes,
And thrills with war and wildness in her veins;
Her rebel lips are dabbled with the stains
Of feuds and forays and her father's woes.

And closer in the shawl about her breast,
The latest promise of her nation's doom,
Paler than she her baby clings and lies,
The primal warrior gleaming from his eyes;
He sulks, and burdened with his infant gloom,
He draws his heavy brows and will not rest.

— Duncan Campbell Scott, 1898

W RITERS ON IRONY (e.g., Lang) often talk about two general categories of irony: on the one hand, there is classic irony, marked by those rhetorical usages consciously inserted by a writer in order to warn her audience that what she says is not to be taken at face value; and on the other, interpretative possibilities which depend not on authorial intention but on the situation in which the work is presented or received. The two kinds may either reinforce or undermine each other, or be present in a way that makes them hard to distinguish.

This book (see Appendix 1, Introduction) proposes another dual classification of ironic functions or operations: the deconstructive, in which "marginality becomes the model for internal subversion of that which presumes to be central"; and the constructive, which "opens up new spaces, literally between opposing meanings, where new things can happen." Peter Dews (13) points out that Derrida's neologism *différance* implies not that there is an infinity of possible meanings of any text, but rather that to insist on any present meaning is always at the expense of something that is excluded by it, a notion that suggests that what is here called deconstructive irony is universally present. Classic irony might be read as the rhetorical marks which pretend that no such exclusion is taking place; but relocations of texts as political/historical, or even physical, context changes will reveal correspondingly changing varieties of excluded signification; both included and excluded significations are to some extent determined in any given situation. (To enter the monumental genre, I would merely remind you of what Shelley's "Ozymandias" says about the ironies brought about by the simultaneous presence of past and present, included and excluded significations.)

Lothar Baumgarten's work, *Monument for the Native Peoples of Ontario*, has been on my mind on and off since I first saw it five years

ago, as part of a huge exhibition at the Art Gallery of Ontario called *The European Iceberg: Creativity in Germany and Italy Today*, which showed from February to April, 1985. The two upper floors of the gallery were given over to paintings and sculpture by six German and six Italian artists. The lower floor showed the work of architects and designers of domestic and industrial objects. My first response to Baumgarten's work was delight in its beauty and elegance and regret at the obvious irony — that it took a German painter in an exhibit of European art to make a monument to the vanished people native to the ground the gallery stands on.

Second thoughts were in the deconstructive mode; I have come to feel that the work is one in which the marginal are explicitly pushed aside by those who believe that the history, geography and aesthetics of places like the AGO's Walker Court should occupy a central position in our culture. This marginalization is pushed into irony by the history that many are now trying to write, in which such places are central only to a particular and limited cultural group. This larger history insists we reinstate the marginalized, in an endlessly recurring return, if only as ghosts and memories.

I will first elaborate my "deconstructive" reading of the work, and then attempt to set this *explication de texte* against some of the many other texts that surround the installation, one of which is certainly my own history as an Anglo-Celt guilt-tripper.

In downtown Vancouver there is a building which contains objects made by immigrants from Europe, called an art gallery. On the campus of the University of British Columbia there is a building which contains objects made by native north Americans, called an anthropological museum. In downtown Toronto there is a building called the Art Gallery of Ontario. The central courtyard of the gallery, in front of the foyer, is the Walker

Court, square, tall, surrounded by a colonnade or cloister, semi-circular arches in the style of the Florentine Renaissance. The ceiling is a skylight. The space is occasionally used for concerts and can be rented for parties. (When the G7 conference was held in Toronto in summer 1988, the collected notables had lunch there.) On the walls of the court, at second-storey level, is this installation by a German painter, Lothar Baumgarten. It consists of the names of eight tribes once native to what is now called Ontario; four names are over the central arches of each side of the cloister and painted in red with black underlining, four more go around the corners and are painted in black with red underlining. On the wall in one corner, at eye level, is a plastic plaque with a description of the work and a map of Ontario on which are inscribed the names of the tribes at approximately the locations of the land they once held. The names are Neutral, Nipissing, Huron, Algonkin, Ojibwa, Iroquois, Petun, Ottawa. They are painted in a typeface designed by Eric Gill, developed from the letter forms on the monuments of ancient Rome, and called Perpetua.

In Rome there is a monument erected by the emperor Trajan to commemorate his victories over the Dacians and the Parthians.

The AGO installation's first doubleness is unironic: it is both a painting and a text. As text, it is a sound poem. The transliterated tribal names are lovely to say out loud. It is ravishingly beautiful to look at, if one is pleased by European neo-classicism, as I am; it is as severe and symmetrical as the cloistered court it adorns. The text is simply a list of names; predication, history, narrative are left to the viewer/reader. Gill's typeface, designed in 1925, is a monument to the austere aesthetic of high-modernism as well as a reminder of the

glories of Rome. The Walker Court is a monument to the fact that the burghers of Toronto and Ontario have not been such barbarians as to neglect the arts. The names of the tribes are a monument to the intention of those burghers to give credit where it is due: their wealth and our comfort depends in part on the deal that was struck for the land and they are willing to memorialize *in perpetuam* the existence of those they dealt with. This monument, like their cars and clothes, is expensive and European. I may be obtuse, but I can see no textual indications of intended irony, no suspicious exagger-ations, understatements, statements of the obvious, etc. The irony starts when one juxtaposes what one guesses to be the work's significance to the people who have paid to have it installed with how it looks to those of us who try not to share their ideology. It is ironic that Ontario native tribes are memorialized by a work whose Italianate references bring to mind Trajan's column: it becomes a monument to the imperialists. Its title becomes *antiphrasis*, the use of a phrase to mean its opposite: the tribes have in fact been written out of white history as they were physically destroyed, not memor-ialized at all.

The work attempts representation in its approximation of aborig-inal words, but of course both graphically and phonically, as painting and text, the names are translated and Europeanized. Algonkin, Nipissing, Ojibwa, etc. are not what the "Indians" called themselves but their names rewritten for European tongues to handle: there never were people with such names. The Petun language is not able to be perpetuated by a Gill typeface nor by English, Italian, or German sounds.

Thus a formal reading of this artifact (who ever said formalism must depoliticize?) leaves us with this ironic doubling: a sign whose first referent might seem to be the European tradition of monument building, which, by its very success in representing that tradition,

draws attention to all that is excluded by and that exceeds that representation: the multitudes who are dead, along with their languages, their monuments, their social organizations, their religions. And this is done in the form of what the *Oxford English Dictionary* offers as the third and fourth definitions of "monument": a written document, something marking a claim to land. But as Jacques Derrida points out in his *MEMOIRES: for Paul de Man*, to be a ghost or a memory is to occupy a place in the present of the rememberers, or deconstructive critics. "Memory projects itself toward the future, and it constitutes the presence of the present," says Derrida (57).

Thus, another cluster of ironies is in the co-presence of the ghosts of two histories and the future of a third. One of these histories is physically present in paint on concrete: it is the history of European imperialism synecdochally evoked in its monuments. The other is that of the unseen tribes, some of whom have had no living members for centuries, who are here simultaneously memorialized and demolished over and over again. The endlessly renewed presence of these ghosts operates here as a kind of *différance* in reverse: the triumph of European ethno-centrism that might seem to be celebrated here, rather than being deferred into some unattainable future of stable meanings, recedes instead into a past whose inhabitants celebrated too soon. Remember Ozymandias. But on these walls the ghostly presence is invisibly written; and whatever form that third ironizing text may take in future constitutional amendments or land claim settlements, the people I will, for the time being, assume to be the referents of the words Petun and Nipissing, are all dead and will never regain any material existence. But still, the overwhelming presence of European forms is ironized by its juxtaposition with a ghost-evoked past and the possibility of its own marginalized future.

I have offered here a reading of Baumgarten's work which evokes the post-modern problematizing of history: the uneasy juxtaposition of the notion of history as things which existed, events which happened, with our realization that these things and facts can never be present to us except through the medium of textuality. I know that I can never have knowledge of the Petun or the Neutrals except through texts as questionably representational as Baumgarten's translations of their names. Nonetheless, I know they did once exist as living beings and I grieve their loss. As a white, I am with others in the ironic situation of attempting to write the lost tribes back into history, but having no other languages in which to do so than those which are as irremovably situated in the European cultural tradition as is this installation.

But our situation in this tradition is not identical to that of our European cousins. To repeat from Appendix 1 of the Introduction here, perhaps we need to consider

the Canadian use of irony in relation to a series of self-defining self-positionings: that is, our position in response to our political pasts, both French and English, and our present (in terms of American culture); the positions taken by the regional in relation to the central; and 'minoritarian' (female; ethnic; visible minorities; native; gay, etc.) In the light of the general postmodern questioning of any notion of coherent, stable and autonomous identity (either individual or national), these positions are, almost by definition, provisional and tentative — not because they are weak, but because they stand ideologically opposed to the mastery (and presumption?) of dominant and dominating cultures. (21–22)

One irony of Canadianness is that most of us have dual citizenship;

we essentially lack essence. Baumgarten's work, which is European in form but Canadian in location, confers dual citizenship on the tribes whose essence its painter's tribal cousins attempted to obliterate. As well, as Canadians we partake particularly in Ozymandian irony: the conquering of the conquerors. The Romans once conquered the Germans; a German monumentalizes in Roman type the tribes who were conquered by the British who also conquered the Germans. Descendants of Romans, British, and Germans are now occupying the tribal territories as a colony of the empire established by the formerly British North Americans to the south. In all these variations of the pecking order it seems that only one group has consistently, for two hundred years, stayed at the bottom, and it is those whom their former enemies unite to monumentalize. (At that G7 lunch were Ozymandias's successors from Britain, Germany, the U.S.A, Japan, France, Italy, and Canada. What were *we* doing there? Read the writing on the wall.)

So far I have been avoiding the ironizing possibility that this installation's relationship to the monumental tradition is parodic. One reason for the failure of that penny to drop is the work's surroundings. On the walls of the official provincial art gallery which, to do it justice, has often exhibited parodic, playful, or satirical works, it still asks a viewer to bear in mind a different set of possibilities for meaning than if it was in an artist-run co-op gallery, far west on Adelaide St. The combination of the parodic possibility with the connotations of its surroundings makes the monument an example of that form of structural irony which is easier to define in a verbal narrative, where it is possible to indicate an implied authorial voice which, in complicity with the reader, knows more than the narrator. If there is a parodic intent behind this work, then there was an implied painter who wanted to use these parodic/ironic forms and also to suggest the possibility of a reading

that would allow the work to conform to our expectations of its surroundings.

Once this parodic reading has been performed, then the implied painter exists, whether or not his/her intentions have anything to do with those of Baumgarten. As Mieke Bal (120) points out, the implied author is the creation of the text, not its creator; some (Hutcheon, *A Theory* 85) prefer to call such authors "inferred." But we do have some indication of Baumgarten's intentions in painting his monument to juxtapose with those of an inferred painter and an inferred narrator, and that juxtaposition adds yet another layer of ironic possibilities to the interpretation of his work.

While I was thinking about how to structure this paper I was given an anecdote with which to make a transition to my next section. I turned the radio on for the news and got the last few minutes of an interview with a composer from Vancouver. I heard him say that all things Canadian are drenched in irony and he chose to write an opera to provide some needed emotional expression. Then was played an extract from the opera: a carefully stylized imitation of Japanese music. The question one asks is, of course, "Is he serious?" which leads to, "Is Baumgarten serious?" Is the meticulous neo-classical geometry of his work a way of winking at the Enlightenment's notion of the noble savage or of perpetuating it? Is he a disillusioned Romantic, ironically monumentalizing the wild nature that we often simplistically claim was destroyed by Enlightenment thinking by using the very forms of the tools of destruction? Can we seriously perpetuate the nineteenth-century opposition between craft and emotion? Or is Baumgarten not an ironist at all?

Since the work in Toronto did not exist prior to the exhibition, the catalogue shows pictures of an earlier work but contains no statement from the artist. The earlier work is, however, related to the one in Ontario. In 1982 Baumgarten completed work on an

installation in the Museum Fredericianum in his birthplace of Kassel, again as part of a large exhibition, *Documenta 7*. He had previously spent some time living in South America. The Kassel installation has been described as a "decorative frieze . . . in the dome of the Fredericianum," in which Baumgarten manages

> to poeticize both the form and the inspiration for the form. The frieze, conceived as a 'Monument for the Indian Nations of South America,' is a litany of tribal names painted on the architrave just below the museum's skylit dome. The names . . . [which] are spelled out in Eric Gill's Perpetua typeface in a red that simulates *urucu* (a dyestuff used for Amazonian body decoration), are instantly evocative of cultures wildly alien to the classicism of the Fredericianum. (Flood)

Baumgarten's statements in the *Documenta 7* exhibition catalogue seem similarly unquestioning of the inclusion of the native tribes in the European aesthetic tradition. Baumgarten claims: "The gulf between culture and nature . . . can be overcome if man succeeds in rediscovering those inherent laws that already exist in exemplary form in nature and have found expression in myth. It is essential to reconstruct this categorical unconscious. . . . In a way of thinking purged of ethnocentrism lies a key of this consciousness." The artist is apparently unaware of the ironic impossibility of representing "inherent laws" and a "categorical unconscious" in a universal sign system; or else he regards his Roman typeface as universal. In a paragraph specifically discussing the Fredericianum "Monument," he explains that the red paint refers to the use of urucu, derived from a plant which he identifies by its Latin name *(Bixa orellana)*. The description continues:

Yet Gill's beautiful letter forms and the sensuous *urucu* red conjoin so harmoniously with the architecture that all appears decoratively correct and emotionally inevitable. There is in the magical resonance of Baumgarten's contrived coincidences something akin to the theme expressed in Robinson Jeffers' poem "Hands," which tells of a visit to a cave in Tassajara where a nameless tribe once inscribed the ceiling with their hand-prints. The poem ends with the following epitaph, which, I think, gracefully parallels Baumgarten's program:

> Look, we also were human; we had hands not
> paws.
> All hail.
> You people with the cleverer hands, our sup-
> planters
> In the beautiful country; enjoy her a season,
> her beauty, and come down
> And be supplanted; for you also are human. (Flood)

This reviewer sees no irony in the fact that Jeffers's poem refers to an architectural artefact made by the people to whom it becomes a memorial, whereas in the work to which he finds it comparable, the translation of the tribal names by and into the medium of the European alphabet and monumental tradition consigns them to a ghostly perpetuity on the walls of what became the warehouses of the conquerors' artefacts. Baumgarten's intended purging of ethno-centrism is in fact a reminder of the way much of our senti-mentalizing and stereotyping of the native cultures we cannot understand (and perhaps, if we respect their difference, should not try to understand) results in a purging of elements that cannot be incorporated decoratively into (or made to "gracefully parallel")

our notions of the aesthetic. For D.C. Scott, to perceive the tragedy of the Onondaga woman he had to write her into the Mediterranean poetic form of the sonnet and the myth of the Christian Holy Family. But just as his poem turns back on this idea and ironizes it for the reader in a way that seems not to be present for the writer — the child is, after all, a half-breed — Baumgarten's installation, as time passes, is increasingly in dialogue with, and a commentary on, present struggles for recognition of native rights. It refuses the kind of sentimentality which, as much as the classical rigor that it hoped to replace, can be seen as responsible for their plight. As Robinson Jeffers's poem points out, both tribes and conquistadors eventually play the role of Ozymandias. At the AGO, the conquistadors' monument to their fantasy of the native peoples, that is, to themselves, is quite literally the writing on the wall.

A further ironizing situation is created when Baumgarten's work is juxtaposed with the essay by the curator of *The European Iceberg* in the exhibition catalogue. Germano Celant's reading of yet another history, that of art in Europe and America since the Second World War, makes the Canadian viewpoint seem highly eccentric, a point which is itself ironic since Celant, in the early pages of his essay, argues for the extreme heterogeneity, the elimination of notions of centre and ex-centre, in recent European art. "North America," he says, "has followed a straight line and fallen in love with the cube. These geometric notions indicate distance or the perimeter from the beginning to the end. Europe, in contrast, is attracted by crazy vectors that go in unprogrammed directions and take chaotic courses, upsetting any expectations and assumptions about confines" (15). Celant, like Baumgarten, is producing something for a Canadian market, but how many Canadian artists since the sixties would include themselves in the definition of North America he offers?

Celant asks: "How can we smash" the "perverse mechanism" by which Europe has recently succeeded the United States in proclaiming itself "the bearer of values" (16)? If I understand the paragraphs that follow, he says it will be achieved because "European culture remains aware of the enormous complexity of history; it also senses that it is moving forward and inward in order to find itself at the crossroads of eras, areas, and languages. This spiraling back and forth between the past and the present has guided us in selecting the elements of a jam session of the arts histories within History." And later: "Thus culture seems to come from a spoiled flesh and a deteriorated spirit. It lives on damnation and on the nightmare of a death that is unceasingly expiated and purged." In elaborating the intentions of the designers of the exhibition, the "jam session of the arts," he gives an account of recent art's questioning of history which is very different from that made by Canadian critics:

> This excursion into the images of the past . . . could be used to explain and revisit the archetypes. Instead, using a mattock and a rake, a burin and a plumb-line, the creators of Neo-Expressionism and Neo-Fauvism and the implementors of New Design and Post-modern Architecture have merely achieved a simple remixing of historical humus, almost a banal raid into the land of memory. Their collapse in ecstatic dreams about the past is excluded from our exhibition because it exemplifies a conservative retrogression. (20)

Thus, Celant claims to have excluded from the show precisely what I interpret Baumgarten's installation as being. But however much he may deny it, the irony of this work's inclusion under Celant's rubric points out that the "histories within History" he refers to must all be European histories; there is no place among

"the crazy vectors that go in unprogrammed directions" for inhabitants of other continents. The lack of any of the usual verbal clues to ironic intent in Celant's remarks about "spoiled flesh and a deteriorated spirit" is some proof of the invisibility to a European of the acts of cultural genocide memorialized in Baumgarten's work. If he were aware of their existence other than as fictional signifieds of translated signifiers painted on neo-classical walls, how could he assert that this work is not a "banal raid into the land of memory," a "collapse into ecstatic dreams about the past"? A Canadian reading of this writing on the wall must see the unrepresentable names of the native tribes as an endlessly ironizing palimpsest beneath Celant's words, especially those which suggest expiation and purgation of historical violence.

Celant attempts to write his exhibition into the chaotic history of Europeans slaughtering each other. His words, juxtaposed with Baumgarten's work, seem to be saying that Europe's "new cognitive perspectives of history" must exclude the colonialist past until its domestic atrocities have been dealt with, as if the two were separable, an opinion no Canadian could hold, whether or not we remember Trajan's column. Celant's essay, like the Walker Court itself, becomes a context in which Baumgarten's work becomes escapism, the conservative "collapse into ecstatic dreams" in which native peoples are sentimentalized into European fantasies, laundered into European notions of the universal aesthetic. Celant's excluding generalizations about European art and culture rebuild the monolith which he claims has crumbled. It is this installation's situation in the constantly revised history of the native peoples of this continent that ironizes what looks like a non-ironic use of traditional monumental forms and also the ethnocentrism inherent even in Romantic interpretations of the work. This recognition, possible perhaps only for Canadian viewers, becomes itself highly ironic if

we accept the work as a reminder that so far this new history is being written largely by the descendants of the Europeans responsible for much of the destruction of these tribes or their cultures, and, whatever our intentions in writing it, the only language available to us is the language of the heirs of the destroyers.

THE 'HOME TRUTH' ABOUT HOME TRUTHS: GALLANT'S IRONIC INTRODUCTION
KAREN SMYTHE

· *University of Regina*

MAVIS GALLANT has come to be known as one of the ironists supreme in Canadian letters. Her fiction is characterized by detached narrators and an ironic tone, producing the effect of what one critic has called "something rather chilling" (Rooke 267). I would argue, however, that Gallant uses irony not only as a distancing technique for her own voice or as a subversive strategy that challenges forms and values, but also as a strategy that invites readers to enter into a participatory relation with the text. It is these latter two uses of irony that make Gallant's writing both sophisticated and challenging to the reader of Canadian fiction, as critics are beginning to note. The study of irony in Gallant's fiction is fast becoming a commonplace. But rather than try to place Gallant's irony in a Canadian context, I would like to approach her ironic comments *about* the critical tendency toward contextualizing Canadian literature in a nationalistic framework.

Gallant included "An Introduction," twelve pages of paracritical

prose, in one of her more recent books, *Home Truths: Selected Canadian Stories*. I call this preface "paracritical" because it is written as commentary on the text, but is something other than criticism. Such prefaces seem to provide an introduction to the work, and when included in the text, especially when they precede the fiction (making them para*textual* as well), they provide tacit and/or explicit suggestions for interpreting that text. But Gallant's preface subverts this convention by refusing to offer specific interpretations; rather, she tells us, in introducing her "Canadian Stories," how **not** to read.

What is unusual about Gallant's preface is that instead of merely guiding our reading of her "Canadian" stories, she is defending her identity and her poetics from potential detractors. The introduction itself, then, is an example of "structural irony" defined as a sustained use of some structural feature in a text to produce "duplicity of meaning" (Appendix 2, 33). The preface stands structurally to suggest alternate readings of the proclaimed "Canadian Stories." Taken literally, the subtitle of the collection, "Selected Canadian Stories," would seem to suggest that Gallant adheres to a nationalistic aesthetic, one that she might explain in the introduction. Yet Gallant uses the forum of the preface ironically to declare that "where his work is concerned, the writer, like any other artist, owes no more and no less to his compatriots than to people at large" (xiii). Her remarks, then, ensure that the fiction they preface will not be reduced to a single reading as "Canadian Stories"; Gallant thereby discourages critics/readers from what Robert Kroetsch calls "recourse to an easy version of national definition" ("Beyond Nationalism" vii).

With the inclusion of the subtitle, it would seem that Gallant is guilty of "domestic embellishment" (xii), which is, she says, demanded of "Canadian writers, though only when their work is concerned with Canada and Canadians." The titular use (in both

senses) of nationality in the description of her fiction ensures not only that the market is targeted, but also that the critical reception and interpretation of the stories is at least partially predetermined as well. But it would appear that the subtitle was not Gallant's invention at all. In her limited discussion of it, Gallant implicitly refutes the idea that it reflects a nationalistic intention on *her* part. She raises the issue of nationalism explicitly, immediately after citing the phrase "Canadian stories," and in doing so she alerts us to the paradoxical use of the subtitle of her collection: "What I am calling, most clumsily, the national sense of self is quite separate from nationalism, which I distrust and reject absolutely, and even patriotism, so often used as a stick to beat people with" (xv). Her resistance to the nationalist label of literature is written into her preface, which indicates that the subtitle — the interpretive interference — is in her view a structurally ironic addition.

Assuming then that "Selected Canadian Stories" was a marketing idea that promised greater sales and wider readership (which would, no doubt, be welcomed by Gallant herself) the introduction Gallant provides serves to resist this label and to demonstrate the anti-nationalistic stance of the author.[1] Gallant's ironic preface allows her to play the publishing game and to criticize its political implications at the same time. She uses the example of Canadian painting (which is clearly a displacement for the art of writing) to indicate her feelings about nationalistically inclined Canadian criticism: "A Montreal collector once told me that he bought Canadian paintings in order to have a unifying theme in the decoration of his house. It means — if anything so silly can have a meaning — that art is neutral adornment, a slightly superior brand of chintz, and that Canadian painters, because they are Canadian, work from a single vision" (xi). She quickly adds that "To dissent would lead into hostile territory" (xi). Her vocabulary is telling: even as she with-

draws from a discussion of nationally oriented criticism, she has made her point.

The title itself, *Home Truths*, refers to an ironic type of idiom: "home truths" are painful facts, consisting of the contradiction between what *is* and what *should be* (Ross 86), between some kind of discomfort and the presumed comfort of "home." Gallant may have wanted this title to play against the subtitle ironically. The "truth" is that there is no consensus as to what constitutes, precisely, a "Canadian" story (much less a collection of stories). "Home" may be "Canada," but the only "Truths" are "Stories," Canadian or otherwise.

Gallant uses a subversive subtext to justify her stance as a Canadian "who has failed to 'paint Canadian' " (xii). While her preface might seem conventional on the surface — it seems briefly to describe the meaning of some of the stories ("Saturday," "Jorinda and Jorindel," "Up North," "Thank You for the Lovely Tea," and the Linnet Muir stories) — it is also inherently ironic, and as Gallant says of fiction in general, it "consists entirely of more than meets the eye" (xii). She uses the genre of the prefatory introduction to undercut its own intentions, and subtextually ridicules the very form that she employs, as well as the content expected of her: "[i]t is as if a reassuring interpretation, a list of characteristics — the more rigid and confining the better — needed to be drawn up and offered for ratification" (xiii), she says of the "national identity" crisis. But Gallant refuses to confine herself or her fiction to any such definition, and those readers of her introduction who seek reassuring interpretations of the stories of *Home Truths* from the author herself are disappointed.

In fact, Gallant works *against* both "domestic" readings of her fiction and autobiographical interpretations, as well as the privileging of authorial intention in criticism of her work. In the preface,

the *literal* reader — and Gallant claims that Canadians are indeed "very literal readers" (Hancock 51–52) — is directed to commit the biographical fallacy twice: once in reference to the life of the nation, and once in reference to the life of the author. For example, the kind of information Gallant includes in the preface might seem to promote biographical readings of the stories. Writing about the formal creative process, she divulges autobiographical information which has been included in the *content* of the stories:

> At the same time — I suppose about then — there began to be restored in some underground river of the mind a lost Montreal. An image of Sherbrooke Street, at night, with the soft gaslight and leaf shadows on the sidewalk — so far back in childhood that it is more a sensation than a picture — was the starting point. . . . The character I called Linnet Muir is not an exact reflection. I saw her as quite another person, but it would be untrue to say that I invented everything. I can vouch for the city: my Montreal is as accurate as memory can make it. (xxii)

Clearly the parallels between the author's life and the character in the quasi-autobiographical fiction exist and are even acknowledged openly by the writer. It would seem, then, that with the preface in place the biographical fallacy is encouraged.

However, it becomes obvious that the preface has a double meaning: it is being used ironically, as a tool to ward against such biographical readings. Gallant inserts an explicit disclaimer with respect to the autobiographical: "I am convinced that there is virtually no connection between mood and composition. 'How I've fooled them!' Colette once said of critics who saw in one of her novels the mirror of her own life" (xx). The tension between the "personal" surface content of the introduction and the explicit

rejection of that content works toward the development of a parodic preface, as does the tension between the expected explication of the stories and the defensive, political tone. These different intentions force the reader to interpret the introduction, to decipher the distance between what is said (or not said) and what is meant — to read it ironically, in other words. The double meaning is generated from a surface commentary on the creative process, which is played against a subtextual criticism of that self-commentary. This doubling first defines the preface paracritically, and then redefines and subverts it metacritically.

The use of an explicit disclaimer is one marker for this reading of the preface. If Gallant is the kind of writer Kroetsch typifies as "slightly uneasy, somewhat exhausted . . . reluctantly paying attention" to criticism of their texts ("Beyond Nationalism" v), she is also, ironically, uneasy in her role as self-critic. Her prefatorial persona is as complex as her fictional one(s): it also requires a reading, an analysis of roles, and a differentiation among voices. With one voice, Gallant interprets the stories, while with another she de-privileges her own opinions; she reluctantly offers an introduction, only to take it away from the reader, and thus prevent a reductive approach. She discredits her own paracritical comments by describing her poor memory of the origins of her own stories:

> Except for purely professional reasons, such as the writing of this introduction, I do not read my own work after it is in print. I had remembered "Jorinda and Jorindel" completely differently: I thought it was a story about a summer weekend party of adults and that the children were only incidental. . . . The span between the germ of an idea and its maturation can be very long indeed. . . . By the time I finally read the work in proof, its origin has sunk out of recollection. (xix–xx)

With the embedded disclaimer, Gallant is able to offer remarks about the stories which make us question both the validity of those comments, *and* the putative intention of the preface.

In 1981, Gallant was not as popular with Canadian audiences as she should have been, as she is at pains to point out in her introduction: "I often have the feeling with Canadian readers that I am on trial" (xii). This kind of language is prevalent in the entire piece: she refers to questions asked by Canadians as an "interrogation," the tone of which "suggests something more antagonistic than simple curiosity"; she feels she is accused of having "concealed intentions," of "perpetrat[ing] a fraud," of "committ[ing] an act of intellectual deception, evidence of which will turn up in the work itself" (xii). Ironically, *Home Truths: Selected Canadian Stories* won Gallant the 1981 Governor General's Award for fiction. Apparently the judges, too, were "very literal readers" of the qualified title of the collection. But if Gallant felt that she was on trial, then the subtitle, as well as her self-commentary in the introduction, can hardly be taken at face value.

Rather, Gallant's prefatory remarks constitute a form of "deconstructive [irony] . . . a kind of critical ironic stance that works to distance, undermine, unmask, relativize, destabilize. . . . This is primarily a form of critique which can at times border on the defensive . . ." (Appendix 1, 30). In effect, Gallant *has* been "on trial" for being a traitor to "Canadian Literature," since her work does not easily fall into what have become "Canadian" categories of theme and style. Gallant has not been as successful in terms of popularity and attention as other, perhaps less sophisticated writers (Margaret Atwood and Margaret Laurence, for example), writers whose work is easily recognizable as fitting the "Canadian" mould. Gallant's is in some ways "an alien sound" amongst other Canadian literature, to paraphrase her anecdote about feeling marginalized at

the age of ten by her classmates, who "hated" her because she was bilingual (xvii).

Consequently, a tone of resentfulness is evident in her comments about Canadian art and about questions (or "interrogations") that she has received about her own fiction. In this context her focus on the Dreyfus case, which might seem incongruous with the rest of the introduction (it is located in the midst of her explanation of the Linnet stories), is easily understood: she identifies with a man who, though patriotic (to a dangerous extreme), was labelled as a traitor and unfairly exiled for political reasons. Mentioning the case in the preface also serves to emphasize that Gallant's interests are not limited to those defined as "Canadian."

Gallant's prefatory introduction is defensive both of the integrity of her work and of her citizenship, as the epigraph indicates: "Only personal independence matters (Boris Pasternak)." Despite her surface silence on the subject, she is critical of the criteria apparently used for judging a "Canadian" work (namely that it be written in and/or about Canada, and contain pre-determined "Canadian" characteristics). The use of irony allows her to disseminate multiple messages (personal and political) to at least three separate audiences — the consumer market, the critical market, and the "unbiased" reader of irony — within a fairly conventional prefatorial form.

In order to interpret the preface, then, and uncover its ironic intent and content, the reader needs to place Gallant in the context of the Canadian literary scene — to locate "home," geographically and politically.[2] This raises the general question of whether or not irony is always intended, and is coded into a work, or if it is incorporated into the work by the reader whose ideas and biases are brought to it. If it is intended, if irony consists of speech coded for the *cognoscenti*, then it too is targeting an audience at the level of language, just as a preface might target an audience at the level of

content. In order to decode ironic discourse, the content must first be contextualized by the reader, and this turns irony into a collaborative effort.

Gallant's preface might be seen as an intimate exchange between reader and writer, and the inherent ironies would then be verbal and structural wedges that attempt to open up critical space rather than close it down. Clearly she could have used the introduction to "Canadianize" her work, to make her readers feel "at home" in a gesture of authorial good will. Instead, she makes her introduction ironic, unsettling reader expectation. Gallant writes that, while she has sometimes "felt more at odds in Canada than anywhere else . . .[,] no writer calls a truce" (xiv). And since irony is a tool used for defamiliarization, not reconciliation, the ironic introduction to *Home Truths* is the perfect vehicle for Gallant's resistance to a limited and limiting definition of herself as a Canadian writer.

NOTES

1 Gallant's *Overhead in a Balloon* is subtitled "Stories of Paris," but does not include an introduction, nor offer an explanation of the subtitle beyond the fact that the stories are *set* in Paris. Not all of the stories in *Home Truths* are set in Canada; nor do they deal with "Canadian" issues per se. This comparison would reinforce the interpretation that the preface in *Home Truths* is being put to ironic ends.

2 It should be noted that Gallant's manuscript as submitted to the editors (now with her other papers at the Thomas Fisher Rare Book Library, University of Toronto) does not differ greatly from the published introduction. Minor changes in syntax are marked in dark black ink, but there is little evidence that the author's ideas were either solicited or emended by the Canadian publisher. Thus while the subtitle may be attributable to Macmillan's staff, it would seem that the preface itself is a product of Gallant's intention.

IRONIC TRANSFORMATIONS: THE FEMININE GOTHIC IN ARITHA VAN HERK'S NO FIXED ADDRESS

SUSANNE BECKER

· *University of Mainz*

EFLECTING UPON the mythmaking of contemporary
women writers, Margaret Atwood once asked: "What about
that 'Madwife' left over from *Jane Eyre*? Are these our secret
plots?" (in Oates 7). The search for women's secret plots, for
feminine writing, has been a central concern of contemporary
feminisms, both outside and inside the literary establishment. Insist-
ing on the premise that "with a few rare exceptions, there has not
yet been any writing that inscribes femininity" (Cixous 248),
French feminist critics have proposed the concept of "l'écriture
féminine"— the inscription of the female body as text — OUTSIDE
the cultural codes for language and the body. On the inside, other,
mainly Anglo-American, critics have seized on the use and manipu-
lation of these codes in order to explore and rethink aspects of
convention: for example, by "re-vision," defined by Adrienne Rich

as "the act of looking back, of seeing with fresh eyes, of entering an old text from a new critical direction" ("When We Dead" 90). This process potentially uncovers not only the "secret plots" but also the means of re-writing them, marking difference. Difference can be situated "in the insistence of a certain thematic structuration, in the form of content" (Miller, "Emphasis" 341). The "gynocentric" lens is focused on and by both criticism and art: in open, communal phenomenological readings and collective writing, as women share, in Barbara Godard's words, "topoi, images, allusions, weaving a web of mutual quotations in their writing" (ix).

In this version of feminine intertextuality irony is one of the chief means of marking difference. Parody uses irony as a rhetorical strategy that is popular among women novelists today:

> I suspect this is because its ironic double-voicing allows a writer to speak *to* her culture, from *within* that culture, but without being totally recuperated by it. Parody is a weapon against marginalization: it literally works to incorporate that upon which it ironically comments. It can be both inside and outside the dominant discourse whose critique it embodies. (Hutcheon, "Shape Shifters" 226)

This structure parallels that of irony and it is due to this "structural similarity" that it can be seen as a preferred, privileged rhetorical mechanism of parody: "Both trope and genre . . . combine difference and synthesis, otherness and incorporation" (Hutcheon, *A Theory* 54). In feminist "re-visions" irony functions as a means of parody, which, along with other forms of quotation, works to subvert traditional claims for originality and greatness, by introducing multiplicity and ambivalence. It also functions as a renewal as well as critique of "old texts" — exploring their potential for

feminine "secret plots." Atwood's reference to the "Madwoman in the Attic" of Thornfield as a probable "secret plot" introduces what I would like to investigate in this essay: a feminine intertextualisation of the gothic and the possibilities that arise from it.

In feminist "re-visions" the gothic is a case in point: its canonical marginalization has paralleled that of women writers. Feminist literary "archeologists," challenging traditional assumptions about "great literature" and centre and margin, celebrating ex-centricity, have unearthed the gothic traces in the female tradition. In 1976 Ellen Moers coined the term "Female Gothic" for the "great" women writers of the mode (90). In a further challenge to hierarchies, Juliann Fleenor's 1983 anthology displayed the "critical and literary pluralism of the Female Gothic" by discussing popular contemporary authors (e.g., Phyllis Whitney and Victoria Holt) side by side with the likes of Ann Radcliffe and Mary Shelley. The term "female gothic," as used in these studies, refers only to works of female authorship. In a shift of interest to the text rather than author, the term "feminine gothic" seems more appropriate, for here the focus would be on the effects of the motivation and focalisation through the female subject, rather than on the gender of the author. It would, for example, contest the "Gothic's mesmerizing claim to present the truth of heterosexuality" and instead examine forms of homosocial desire (Sedgwick, *Coherence* vii) — foremost the *mise en abyme* of the mother-daughter relationship. It would also emphasize the implications of maternity, the process of creating with/of the body. Such a focus would investigate this mode's relationship with the "patriarchal paradigm": the potential as a traditionally non-realist narrative mode for "transcendence,"[1] for "subversion,"[2] for "transgression."[3] It would investigate the mode's connections with genres that are related to it: the romance, the picaresque, the fantastic.

The gothic has not been theorized to the same extent, for example, as the fantastic. "The definition of genres," Tzvetan Todorov writes, "will . . . be a continued oscillation between the description of phenomena and abstract theory" (21). The latter, for the gothic, seems to be lacking, and aesthetic/stylistic standards for "what is gothic" are rarely articulated, and when they are, they evoke differing associations. Gothic literary "phenomena" have been collected and interpreted extensively: the formulaic characters (villain, maiden-in-flight), the stock devices (haunted castle, mazes), the romantic period setting, the scenes of enclosure and horror, the overall effect to evoke physical fear (Moers 90) and to create an impression of "the nightmarish terrors that lie beneath the orderly surface of the civilized mind" (Abrams 69). Less frequently, the typical narrative strategies have been discussed: "the difficulty the story has in getting itself told" (the lost letter, the undecipherable manuscript, the housekeeper's tale), the structuring function of "the unspeakable," the live-burial not only of characters but also of language (Sedgwick, *Coherence* 37), and the fact that only language can be said to conceive of the unreal and the supernatural.

All these features have marked the gothic from its origins as rebellion against the neo-classicism of the English eighteenth century, with its hierarchical aesthetics and mimetic premises that allowed a legitimate "rise of the novel" only as "straightforward reporting of ordinary events" (Watt 11). Standard examples are Horace Walpole's *Castle of Otranto* (1764) and Ann Radcliffe's *Mysteries of Udolpho* (1794). Popular with both female writers AND readers, the mode quickly became a frame for intertextual references of women's writing, as in Jane Austen's parody, *Northanger Abbey* and Charlotte Brontë's *Shirley*. What has happened to the feminine gothic in a contemporary context, in a context marked not by fixed genre-concepts but by precisely the opposite, the blurring

of boundaries, the obfuscation of discrete genres, in a context that is concerned with feminist "re-visions"?

Studies of twentieth-century women's narrative and poetic strategies have referred to the gothic as remaining "to this day a major organizing grid for female consciousness" as Rachel Blau du Plessis puts it (44). She goes on to define the gothic as "sexual feudalism the masochistic powerlessness of the generic female confronted with the no-frills, cruel-but-tender male." Such is, indeed, the formula for the popular versions of the genre that marked the North American "gothic revival" with the romance-boom of the 1960s.[4] However, at the same time, the feminine gothic has reappeared in more "serious" writing as well, for example in Britain, Quebec, and the American South. Many of these texts turn out to be feminist re-visions of the generic traditional and popular conventions. For example, Margaret Atwood's *Lady Oracle* (1976) parodically incorporates the gothic romance formula to expose its destructive seduction of women's imagination and Angela Carter re-writes fairy-tales as feminine gothic texts.

Aritha van Herk's *No Fixed Address*, while not incorporating the gothic formula, transforms some conventions of the feminine gothic by ironic displacement. The novel does not, at first reading, display the gothic stock devices; there is, most importantly, no sense of the enclosed space traditionally so essential to the construction of horror. In contrast, the female protagonist, Arachne Manteia, "inhabits" almost the whole Canadian West: she is a travelling salesperson in Alberta and Saskatchewan selling ladies' underwear. Her occupation is important: the text opens with a reflection of underwear's age-old function "to aid physical attractiveness, a standard inevitably decided by men" (9) and the subsequent effect: imprisonment of the female body and the general discomfort of women (until recent, more androgynous fashions). The hidden

shapes the surface: the novel's double-layered opening functions as a double-edged device as the text unfolds. It structures the female hero's development as well as the narrative itself. It also suggests that other "double-layered" phenomenon: irony (Muecke, *Compass* 19).

Arachne wears no underwear; she is a female hero who defies being shaped by anyone but herself. However, her character too is double-layered: the present-tense travelling woman is shaped by a hidden past — an imprisoning mother-daughter relationship not discussed openly by her but ever-present. Her gothic doubleness is reflected in the typical narrative technique of the intrusive relationship of past and present. In the four sections titled "Notebook on a Missing Person," an all-inclusive "you" traces Arachne's travels, reconstructing causalities, mainly with "information" provided by mother Lanie and "confidante" Thena. The "notebook"[5] is, first of all, structurally reminiscent of gothic complications that typically include a mediated narrative (i.e., *Wuthering Heights* is told by Nelly Dean as well as by Lockwood), claiming authenticity (as the preface of *The Castle of Otranto*, which "reconstructs" details of the "manuscript's origin" as well as "translation"). Secondly, it also foreshadows mystery and doom: the "missing person" indicates Arachne's disappearance. Thus it exploits the convention's potential: it allows for the reader's inclusion, for a perspective beyond that of the third-person narration, and for an open ending, despite the implied tragedy, which fits the travel-motif. Present-tense Arachne is a "hero" on the road, a fact which evokes numerous intertexts. Some traditionally "masculine" versions of this convention are parodied by the feminist inversion of gender roles, for example the Western and the picaresque.[6] Some, at the same time, allow for "quotations" from the female tradition; the subtitle, "An Amourous Journey," most notably alludes to Erica Jong's *Fear of Flying* (1973).

The picaresque, moreover, is as intricately connected with the feminine gothic as is the sentimental romance: Moers has described Radcliffe's Emily in the *Mysteries* not only as Pamela's sensible sister but also as Moll Flanders's indestructible cousin:

> In Mrs. Radcliffe's hands, the Gothic novel became a feminine substitute for the picaresque, where heroines could enjoy all the adventures and alarms that masculine heroes had long experienced, far from home, in fiction. (126)

What becomes obvious here is one of the early twists in the feminization of the gothic, namely the reduction of the villain's power, which originally motivated the plot, to a mere functional device in the heroine's transcendence of her "proper sphere," the home. "In the power of villains," writes Moers, "heroines are forced to do what they could never do alone, whatever their ambitions: scurry up the top of pasteboard Alps, spy out exotic vistas, penetrate bandit-infested forests . . ." (126). This changed perspective on the liberation of the maiden-in-flight includes the "female space," the indoors, which is for Moers still the typical feminine gothic setting:

> For indoors, in the long, dark, twisting, haunted passageways of the Gothic castle, there is travel with danger, travel with exertion — a challenge to the heroine's enterprise, resolution, ingenuity, and physical strength. . . . It was *only indoors*, in Mrs. Radcliffe's day, that the heroine of a novel could travel brave and free, and stay respectable. (129)

Respectability! Myths of femininity have figured in feminine gothic texts ever since, revealed as yet another "imprisonment" of the female body. Arachne LIVES her body; her travels provoke sexual encounters with innumerable "road jockeys." Her aggressive sexu-

ality ironically alludes to the treatment of the female body in traditional as well as popular feminine gothic texts. The doctrine of sensibility in Radcliffe's *Mysteries* (adequately uttered by Emily's father), the prevailing presence of the Angel-in-the-House in Victorian versions, the "domestic test" of modern romance heroines: all these are juxtaposed with the "female foil," the "sexual woman," who is invariably doomed (to death, imprisonment and/or madness), and who functions to highlight the "power" of "respectability." The implied denial of female wholeness, the separation of body and spirit, and the suggestions of monstrosity have all marked stages in the feminine gothic quest: feelings of inadequacy/fragmentation and fear of identity-loss *vis-à-vis* yet another male standard. Arachne travels freely, hers is the (secret) plot of the sexual woman. There is no ideological punishment for her: Thomas, her "Apocryphal lover," loves her as she is because she saves him from a conventional marriage with a conventionally ideal heroine. This is another ironic inversion of popular gothic constellations where the female must be "rescued" by the male, a notion that Arachne explicitly detests (141).

This treatment of female sexuality suggests liberation. However, the notion of "respectability" is taken up in the novel in a different context: class-consciousness. Thomas's bourgeois world "displaces" Arachne who has a working-class background (she is working as a bus driver when they first meet) and, above all, a relative lack of education. The resulting feeling of inadequacy is resolved in an almost paradoxical treatment of another gothic motif: the traditional hero's attempt to make the heroine a product of his wealth and status by buying her new clothes. This motif is, for example, a decisive event in *Jane Eyre* and provokes one of her long monologues that express her demands to Rochester, the most famous of these ending:

"I am not talking to you now through the medium of custom, conventionalities, nor even of mortal flesh: it is my spirit that addresses your spirit; just as if both had passed through the grave, and we stood at God's feet, equal, as we are!" (281)

This is not the voice of a victimized maiden-in-flight but the language of a feminist hero, refusing submission, transgressing strictures. The "quotation" of this gothic motif in *No Fixed Address* underlines its importance in the struggle for stability of the female hero, even if at first seemingly undermining such strength: in an ironic inversion of the procedure, Arachne ASKS Thomas to "turn her into a respectable woman" (137). She can safely do so knowing that the "quiet transformation" is nothing but one of the "covers" she tries on throughout the plot, another "disguise," as the chapter's title "Disguise"⁷ aptly indicates. Thomas knows and understands: he is a hero, as glamorously idealized as his Byronic predecessors, characterized as "a man too good to be true"⁸ and the obviousness of this fact uncovers that former idealization of the gothic hero. Moreover, his ideal response to Arachne's wish of adapting to his world (as well as to her other wishes) underlines the new power of the gothic female hero facing the respectability-problem: if she chooses a commitment to traditional standards, she will determine the extent of that commitment herself, instead of reacting in self-defense against the hero's action. Arachne's "self" underneath the new clothes cannot be touched: it is inescapably bound to the past she rejects.

The uncanny presence of the past in the feminine gothic is related to the "savageries of girlhood" (Moers) that reverberate in the heroine. Most notably, it highlights the twistedness of the mother-daughter relationship. Arachne, ironically, feels like the generic orphan or motherless woman, denying her parents, calling her

mother "Lanie" and avoiding her presence. Lanie is characterized as a "pragmatist, without sentiment, although she likes movies where the right people kiss at the end" (40). Her relationship to her daughter — a child not wished for[9] — is influenced by this tendency towards a romantic happy ending: "Once [Lanie] discovered there was no romance in being Arachne's mother, she simply backed away" (39). She constantly has to cope with the discrepancy between romance plots and real life: "only in movies did characters long for adventure, follow it, seize it" (82). Mother and daughter wanted "the same thing," as Arachne realizes (41), yet only the daughter lives it. In a faithful treatment of the typical paradox at the centre of the feminine gothic, the mother, ironically, cannot imagine a different pattern for the daughter's life other than her own:

> "Why don't you marry [Thomas]? Sew him up?" "Marriage, *mother*, is not the heaven of refuge for me that it was for you." No — what she really said was, "I don't want no ring in exchange for screwing." (60)

Arachne's mobility defies convention, that is, the "reproduction of mothering."[10] She travels to travel, to get away from her past, which she invariably associates with imprisonment, and to get away from her future, which appears as the inevitable "happy ending" with Thomas. Such "happy endings," while still prominent in modern popular gothics, in earlier works in the mode — especially in those of Charlotte Brontë — were already shifted into ambiguity (the hero's questionable return in *Villette*), a surreal setting (Ferndean in *Jane Eyre*), a questionable achievement (voiced by Rose York in *Shirley*). What explicitly occurs in *No Fixed Address* is the association of such a "happy ending" with the horror of what Arachne calls "house arrest": domesticity. Needless to say, in Arachne's and

Thomas's household traditional roles are reversed: she is professionally absent, he tends to the home. The ultimate horror, the "unspeakable" in this feminine gothic text is stasis: the immobility as a child in the power of the mother, as much as the immobility as a wife in a house. In a complete inversion of the gothic, the traditional "happy ending," domestic bliss, here becomes the enclosure to be escaped.

For what then is her quest? The romance pattern, in which love dominates the quest, does not hold. Arachne's is a quest for quest's sake. Nancy Miller has found such seeming negativity, the absence of a stated cause or maxim, a marker for women's plots:

> To build a narrative around a heroine without a maxim is . . . to fly in the face of a certain ideology (of the text and its context), to violate a grammar of motives that describes while prescribing, in this instance, what . . . women should or should not do. (339)

Thus, Arachne's quest also subverts that of the "Faustian" gothic man: "a lonely, self-divided hero . . . on an insane pursuit of the Absolute" (Thompson 45). The female masochism and passivity of such male gothics (for example, Poe's[11]) in this text is transferred to the male characters: their hands (palms up) signal submission; they mostly react to her initiative; they are objects in her "brutally honest" reports to Thena; they become victimized by her sexuality and later by her violence, as she robs one and kills another man in self-defense.[12] In this reversal, men are relegated to the ultimate stasis: death. This is especially true of Joseph, Arachne's ninety-year-old lover who is romantically described as a man who has been alive for a long time. He appears not only as hyperbolic distortion of the traditionally somehow physically maimed Byronic hero but also provides the possibility of a reversed gothic elopement when

Arachne kidnaps him from an old-people's home — one of the truly nightmarish settings of the novel with its "endless white corridor that seems like an entrance to a dream where walls are terrifying and forever" (225). They meet early in the plot, in a graveyard, finding, guarding, burying a skull together; they share the feeling of displacement and the fascination with movement through his hammered copper disks figure dancers, "imprisoned in motion" (104), with which she identifies. "I should be dead," he says, and his subplot is only one of the elements that make the novel so obsessed with the basic gothic dread: the fear of the ultimate stasis, death.

There are traces of dread throughout the text, however paradoxical they might appear in a work set in the wild West with a travelling woman. They start out as almost comical ghostly optical illusions — "a disembodied head floating" (35) in a virtual ghost-town of dubious existence, or as "wild" paranoid visions of forgotten lovers' ghosts (29). These events virtually "quote" Joan Foster's early visions in the first part of Atwood's *Lady Oracle*. Another comic transformation and reversal of gothic dread occurs in the apt setting of the "castle-like hotel at the top of the hill" in Banff (242) where "five hundred women dressed in blue jeans and sweaters" — Women First, a feminist gathering — and "five hundred women in polyester dresses" — Women's Ministry, a religious gathering — clash in coinciding meetings:

> The women in dresses are standing in demure knots, nodding their permed heads and keeping their eyes fixed on each other's faces. The women in blue jeans are swinging from the banisters and luggage racks. One is doing leg raises off the horns of the buffalo head over the door. Women are balancing luggage on their heads, pinching the bums of bellhops; they are sprawled over the Gothic chairs, the courting chairs, the stately Queen

Anne wing chairs, the demure Princess Mary chairs, they are whistling at their friends on the mezzanine, dropping their suitcases and flinging coats and waving keys. They are booking massages and whipping out their business cards and demanding suites with jacuzzis and the location of the swimming pool.

The presentation of both groups in the most grotesque colours with weird individuals carefully described and monstrous impressions of masses of women crowded in "their" indoor space evoked with satiric distance aptly culminates in the enclosure of a sauna from which Arachne escapes (247).[13]

The outdoors, the "male West" as van Herk has called it elsewhere ("Women Writers" 18), is no less gothic but much less comic: coming from the B.C. panorama, the first sight of the prairie fills Arachne with "cautious horror," ironically recalling Emily's first encounter of Alpine sublime. Yet it is exactly this bare landscape, perceived as "mournfully gothic" world (164), that she is magically drawn to explore. Such gothic traces thicken throughout the text, as indicated by chapter titles and other allusions. They point towards the last section, where "report" and nightmare are blurred together into the surrealistic, sinister construction of Arachne moving towards her former paradox, "arrival,"[14] which is yet another motion: in a helicopter, beyond the metaphorical spiderweb of roads. Has she transcended what turned out to be yet another imprisonment, the maze of the "ghostly curled world of maps"?

This last part is the most obviously gothic. Arachne is *Angst*-ridden, thinks she is dead: "I died, she thinks. I'm dead" (285) which parallels the last part of *Lady Oracle* in which Joan Foster questions whether she is alive ("Maybe I really did drown, I thought" [341]). The setting is the Burkean sublime: it is characterized by the attributes of what he has called "terrible privations: Vacuity, Dark-

ness, Solitude and Silence" (71)[15] — the West coast mountains, the blue glacier. Even Burke's shipwreck-theme is depicted: in an imagined encounter with a drowned man (294). Driving West for Arachne means going back to the past, back to "her own escaped history" (278). It becomes a self-destructive movement marked by the conscious pain of returning *to* the repressed[16] and by a record of her various selves, "dying" one after the other: "She has been back to Vancouver and died there, one of her lives certainly over" (301); "Perhaps they would let her stay here . . . sleep her last life away" (309). She also encounters her *Doppelgänger* — a woman with a bear whom she picks up on the road with a strange sense of *déjà vu*. In the gothic tradition the uncanny closeness of the same indicates disintegration (Trautwein 46). Arachne's *Doppelgänger* is yet another grotesque female figure, a "bearwoman." Allusions arise to numerous "affairs with bears" (Atwood, "Canadian Monsters" 108) in Canadian folk tales as well as women's writing, most notably Marian Engel's *Bear* and Aritha van Herk's own *The Tent Peg*. In the feminine gothic context, the "bearwomen" recalls other images of "incomplete" femininity; it might be the Canadian version of the Danish "fishwoman," the mermaid, who figures in other feminine gothic texts.[17] In *No Fixed Address* this uncanny scene sounds almost comic; yet, it has a tragic indication: Arachne is only half human now. Her movement north, on the edge, is marked by her simultaneous physical and mental disintegration.

In this section we find the gothic *locus classicus*: Arachne's "liveburial" among two sleeping drunks, in a pitch-black coalminer's shack, a place that has irresistibly drawn her towards its darkness (261). This dark scene again depicts the gothic motif with a twist: she is awakened, not by her own scream but by her own snoring! Claustrophobia quickly changes the tone: "Constricted more and more, she feels herself rising in a scream, a cry beyond darkness and

death, rising" (263). Besides paralleling the movement of her final helicopter scene, this points to the function of self-expression for survival. As Arachne BECOMES the cry, she can rise from the "shared grave." As in all subsequent chapters she loses language and communication remembering "her tongue as dead wood in her mouth" (286). Her passivity inevitably grows and with it her movement towards "arrival."

The importance of language for the construction of experiences is expressed throughout the text by Arachne's consciousness of speaking ungrammatically, by her stubborn silence about her past, as if she could "erase" it this way, and by Thena's role in her adventures: "Only Thena gets the whole truth. For what is a traveler without a confidante? It is impossible to fictionalize a life without someone to oversee the journey" (154). Her life in this fiction, indeed, is fictionalized again and again; for example, in the exchange of stories between Lanie and Thena, each "enjoying the other's version." The multiplicity and fragmentation of the gothic heroine are here not represented by the gothic mirrors, cameos, photographs, paintings, but — self-consciously — by the fictionmaking about her. This process parallels the (multiple) possibilities for reading her special quest.

Arachne's quest, it seems, characterizes a feminine plot, which is, in Nancy Miller's words, "about the plot of literature itself, about the constraints the maxim places on rendering a female life in fiction" ("Emphasis" 356) — exactly through the absence of such a maxim. The quest's structure is not linear towards some kind of prescribed ending but more like a spiral, moving virtually into space. The novel participates in the feminist explosion of traditional genre, avoiding both of the two possibilities love or death for gothic closure. Aritha van Herk re-writes the traditional heroine's plot into that of a liberated female hero; the sexual woman's story can finally

be told. The ironic double voice allows for such a "re-vised" renewal without discontinuing the feminine gothic tradition; on the contrary, through the displaced "quotation" of decisive gothic motifs and allusions, *No Fixed Address* contributes to the intertextualisation of the feminine gothic. It displays complicity with the secret plots of the "gothic foremothers" and responds to their desire for liberation, expanding it beyond the ending.

NOTES

1 The potential for transcendence, for example, has been denied by Fleenor: "The Female Gothic is not a transcendent form as the Romantic novel has been described. Transcendence is not possible. The Female Gothic is historically defined by the culture in which it has existed and continues to exist. The thread of continuity established in all gothics is that they all represent an androcentric culture" (16). "Although the Gothic is not transcendent for either females or males, in the Female Gothic it is even more limited It is a metaphor for female experience" (27).

2 As emphasized by Rosemary Jackson: "[Mary Shelley's] writings open an alternative 'tradition,' of 'female Gothic.' They fantasize a violent attack upon the symbolic order and it is no accident that so many writers of a Gothic tradition are women: Charlotte and Emily Bronte, Elizabeth Gaskell, Christina Rossetti, Isak Dinesen, Carson McCullers, Sylvia Plath, Angela Carter, all of whom have employed the fantastic to subvert *patriarchal* society — the symbolic order of modern culture" (in Mary Eagleton 118).

3 Allison Light has used the term transgression to characterize the possibilities of the related romance plot by the example of the feminine gothic *Rebecca* (in Mary Eagleton 143). Applied to the concept of the feminine gothic, the term has the potential to extend the inherent gothic "transgressions" of the natural, the real, the rational in such a way that they include the feminist critique and subsequent "transgression" of the limitations of the patriarchal paradigm with its related cultural codes for language and the body.

4 This phenomenon, usually tied to the publishers "Mills & Boon" in London and "Harlequin" in Toronto, and interpreted as result of the "Feminine Mystique"

(Betty Friedan) in Western societies of the 1950s, has been analyzed by Mussell, Radway, and Modleski.

5 The intertext that comes to mind is Doris Lessing's *The Golden Notebook* (1962), a self-conscious example of the ultra-realism that dominated feminist writing in the 1960s in connection with the consciousness-raising of the time. While its combination with the gothic in *No Fixed Address* might at first seem like a paradox, it demonstrates the scope of the intertextualisation of the feminine gothic, including a variety of feminist literary forms.

6 In *The Canadian Postmodern* Hutcheon writes: "Arachne and her Mercedes can be interpreted as a parody of the cowboy and his horse as much as of Don Quijote and Rocinante. Her relation to the land she travels is not that of the male tradition of mastering and controlling nature, perhaps most obviously because the male tradition had usually seen the land as gendered female" (124). At the same time, van Herk re-writes the picaresque genre with a female hero at the centre: "In formal, structural terms, this novel also follows and yet ironizes many of the conventions of the picaresque narrative" (129). Hutcheon also explores the parallels of such a treatment of the picaresque with the postmodern on the levels of socio-economic and politico-historical contexts, of the female picaro's (postmodern) ex-centricity, of literary history: both genre and period are a "critical response to that realist reaction" (129). These points signal the affiliation of the picaresque and the gothic and the alliances of both types with the postmodern.

7 Titles throughout the novel signal double meanings, for example "Routes of passage," a chapter about Arachne's "rites of passage" on her routes as bus driver, or "Swath" meaning "the movement of a blade" as well as "a great stir" in the chapter in which Arachne and Joseph first make love in the field, or "Ferryman," the chapter in which Arachne first thinks she is dead and then murders a man on a ferry. Titles also frequently point to gothic references, for example "The Disinterred," in which Arachne flees with Joseph from the old-people's home and "Live-Burial" indicating the gothic *locus classicus* to be discussed in the following pages.

8 This is van Herk's phrase for critics' responses to (as well as for her intention in creating) the character of Thomas. See Liam Lacey, "Gods of Literature Smile on van Herk," *Globe and Mail* 22 Sept. 1986: C11.

9 This fact ironically undermines the archetypical fairy-tale scene of naming the unborn child: like the queen in Grimms' *Schneewittchen*, Lanie sits at the window

in winter, "strangely content, caught in a web of quiet" (81), waiting for the birth, and like the queen, she names her child after what she sees at that time within the window-frame: what in the fairy-tale is the combination of blood, snow and ebony, for Lanie is a spider with which she identifies: "It was a large spider with a belly as rotund as Lanie's. . . . Lanie saw that the spider had been injured; it had only seven legs. But that did not hinder her design or ambition" (82). The actual naming, with all its very unromantic implications, then occurs with Gabriel's reflections on " 'Arachnid . . . Spiders are rogues' " (83).

10 In *The Reproduction of Mothering*, Nancy Chodorow explores the dynamics of the mother-daughter relationship in a patriarchal context, the family conventions of which leave the regulation of childhood to the mother, thus repeating the same gender structures over and over again: "From the retention of preoedipal attachments to their mother, growing girls come to define and experience themselves as continuous with others: their experience of self contains more flexible or permeable ego boundaries. Boys come to define themselves as more separate and distinct, with a greater sense of rigid ego boundaries and differentiation. Women's mothering, then, produces asymmetries in the relational experiences of girls and boys as they grow up, which account for crucial differences in feminine and masculine personality" (169). The mother-daughter relationships in feminine gothic texts often represent or comment upon such constellations.

11 Poe stated in "The Philosophy of Composition" that "the most poetical topic [was] the death of a beautiful woman" (197) and explored this topic to the fullest in his own gothic tales and poems, such as "Ligeia" and "The Raven."

12 This murder occurs in the typically gothic situation in which immobility of the subject evokes violence: see, for example, Sedgwick's discussion of *Wuthering Heights* (*Coherence* 99). The expected pattern of violence triggering horror is here extended into a reversal where now violence is triggered by horror. This extension may be another means of the feminine gothic's turn against the patriarchal paradigm's violations of women's liberty/mobility which in turn provokes violent reactions.

13 The scene evokes Atwood's party scene in *The Edible Woman* as much as Munro's portrayal of Flats Road women in *Lives of Girls and Women* or in "Dance of the Happy Shades." The grotesque, the monstrous in femininity is distorted to demonstrate its social construction. Van Herk emphasizes this artificiality: Arachne doubts her eyes, "overlooking what must surely be a backdrop — there is no real

scenery like that in the world" (243).

14 That no static ending for this female hero is possible is indicated throughout the novel, for example: "Arachne travels to travel. Her only paradox is arriving somewhere, her only solution is to leave for somewhere else" (164). The final sentence of her story, then, can only be set in movement — the helicopter: "She watches the roadless world below her, knowing she has arrived."

15 The physical perception of the sublime, too, is Burkean, for example, Arachne's "pupils dilating" in utter darkness (262), resulting in pain and fear, the terrors of darkness (Burke 145).

16 The movement here reverses the Freudian "return *of* the repressed" that haunts, for example Joan Foster in *Lady Oracle* in the shape of the "Fat Lady."

17 For example in the last section of *Lady Oracle*, where paranoid Joan Foster's imagines herself as "female monster": "The Little Mermaid rides again, I thought, the big mermaid rides again. . . . A female monster, larger than life, larger than most life around here anyway, striding down the hill . . . her green eyes behind her dark tourist's glasses, her dark mafia glasses, lit up and glowing like a cat's . . ." (370). The image of the mermaid as indicating incomplete femininity has also been used by Dorothy Dinnerstein in *The Mermaid and the Minotaur: Sexual Arrangements and the Human Malaise*.

IRONING OUT THE DIFFERENCES: FEMALE ICONOGRAPHY IN THE PAINTINGS OF JOANNE TOD
KAREN BERNARD

· *York University*

THE POWERFUL POTENTIAL of irony as a strategy of feminist critique can be seen in the paintings of Joanne Tod. In analyzing how her irony functions, I will be using predominantly metaphors of speech in order to conceptualize her work on the general model of painting as a mode of cultural communication which signifies, or "speaks," on a number of levels at once. At stake in these discursive events is the social constitution of subjects, and it is because of her careful disruptions in and of this realm that I want to focus attention on the works of this contemporary Canadian painter. The ironic edge to her representations and arrangements of female forms is what gives them their force.

The overlappings of speech and subject-formation were articulated clearly in Benveniste's influential formulation of the speech utterance, in which a split subject emerges: the speaking subject is distinct from the subject of speech. The speaking subject is, most commonly, the speaker or writer of the discourse, while the subject

of speech is the first-person pronoun or its equivalent, "the discursive element with which that discoursing individual identifies, and in so doing finds his or her subjectivity" (Silverman 46). Kaja Silverman, whose film analysis owes much to Benveniste, has posited a third category in the utterance, one which is valuable to feminist critiques of ideology: that of the spoken subject. She defines the spoken subject as the subject who is constituted through identification with the subject of speech, novel, film, or any other medium of representation. The interplay of these three dimensions of subjectivity in cultural production proves very useful in articulating the ironic forces at play in politicized art like that of Tod.

We know that ironic discourse is a double speech on the most elementary level: saying one thing and meaning another. It is possible, then, to think of ironic speech as one type of Bakhtin's "double-voiced discourse," in which, like its cousin parody, "speech becomes a battlefield for opposing intentions" (Bakhtin 184, 185). In the three paintings to be discussed here, the referent is, in a general sense, the female person. The conflict of opposing intentions towards and understandings of this referent can be explicated in terms of what Bakhtin calls "hidden polemic":

> In hidden polemic the author's discourse is oriented toward its referential object, as is any discourse, but at the same time each assertion about that object is constructed in such a way that, besides its referential meaning, the author's discourse brings a polemical attack to bear against another speech act, another assertion on the same topic. Here one utterance focused on its referential object clashes with another utterance on the grounds of the referent itself. (187)

In Tod's paintings, irony is used to advance a polemic against culturally dominant and naturalized representations of women. The

essential doubleness of her work is in its reiteration of these dominant representations in one voice, and its contradiction of (or "speaking against") them in another.

The doubleness of Tod's painting technique is located, initially, in her loyalty to a high realist tradition. One critic describes precisely this quality in Tod's work, and some ensuing implications for the viewer:

> These surfaces are rich, elegant, painterly in the tradition of the Enlightenment painters, epitomized by Jean-Honoré Fragonard. In keeping with the objectivity of rationalism, viewers expect a representation of truth. But Tod's visual discourse is ambiguous. One representation breaks through another, destroying the unity of the image and its power. (Andreae 62)

The traditional or inherited aspect of Tod's visual vocabulary is the realm of the "spoken subject" — the established, culturally coded representations of women which appear natural. In the meta-narrative of realism throughout art history, women are continually and already inscribed on the surface of the canvas in particular shapes and forms. The most familiar of these is the reclining odalisque, and the most omnipresent characteristic of gendered representations is the frozen positioning of women as magnet of the male gaze. The colours of Tod's palette, the eminently recognizable forms which represent people and objects in her work, and the relatively refined brush strokes derive from a long-standing mimetic impulse in figurative painting. However, Tod appropriates the conventions of pictorial realism only in order to counteract them, by means of incongruous and unsettling arrangements of elements within the painting.

Her well-known *Self-Portrait* was proclaimed as an emblem of the New Figurative or Neo-Expressionist art when first displayed at the watershed *Monumenta* exhibition at YYZ Gallery in September 1982. The immediate irony of this piece is that its title does not accurately describe it; that is, the artist herself does not resemble the image in the "self-portrait." The speaking subject cannot possibly match the subject of speech. One need not be acquainted with the artist's appearance to affirm this discrepancy, for the female image in the painting is clearly marked as being from somewhere else. The image is, in fact, copied from a photo which Tod found in a 1920s' *Harper's Bazaar* magazine, and bears the unmistakable features of an icon from the netherworld of fashion photography. The woman is arranged against a decorative, urbane, and loudly American land-scape (on the steps of the Lincoln Memorial, with the Washington monument behind her.) She is motionless, like a plastic mannequin, in the requisite pose for optimal display of clothing to the consumer. She embodies the relative bodily proportions demanded of fashion models, and wears the benignly discreet facial expression of woman as spectacle.

Tod has borrowed from the visual discourse of fashion photography for deliberate reasons: there is perhaps no mode of cultural representation which so clearly shows the abject situation of the female subject as produced, "spoken," through discourse. Fashion magazines, published and sold in millions of copies every month, are packed with photographs of fashion models designed to say to the female reader: "you should aspire to look like me." The fashion magazine is perhaps the vehicle par excellence of the ideology of gender, the handbook of one's own feminine self-production. Tod's first move to interfere with the inundation of these magazines is to transfer one of their images into oil paint, effectively blocking its naturalness and easy assimilation.

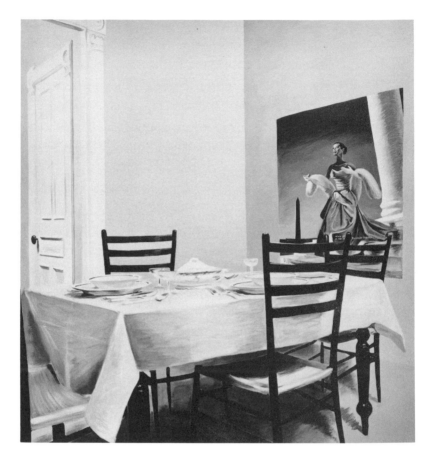

Joanne Tod, Self-Portrait as Prostitute *(1983; acrylic on canvas,*
55 x 60 in.). Private collection. Photo by Peter MacCallum.

The irony of this work is generated by the tension between what the title "says" and what the image "says" — two different things. Drawing from a feminist development of cultural discourse theory in Teresa de Lauretis's work, we can elaborate the social process from which this tension springs. De Lauretis tracks the process of the cultural construction of the gendered subject, in which male and female are solicited differently by social institutions:

> the discrepancy, the tension, and the constant slippage between Woman as representation, as the object and the very condition of representation, and, on the other hand, women as historical beings, subjects of "real relations," are motivated and sustained by a logical contradiction in our culture and an irreconcilable one: women are both inside and outside gender, at once within and without representation. That women continue to become Woman, continue to be caught in gender as Althusser's subject in ideology, and that we persist in that imaginary relation even as we know, as feminists, that we are not *that*, but we are historical subjects governed by real social relations, which centrally include gender — such is the contradiction that feminist theory must be built on, and its very condition of possibility. (10)

This process of the cultural construction of women is pictured in Tod's *Self-Portrait* — and at the same moment disrupted. If gender is ideological in Althusser's sense, as de Lauretis claims, then it must function unnoticed to be most effective. While a reader of a fashion magazine may unconsciously recognize herself, or her desired self, in its photographs, Tod's displacement and estrangement of the same image disrupt this seamless flow of the daily and shifting constitution of women's identities. Tod's choice of title emphasizes that it is her

self at stake in the seemingly anonymous and artificial image of a fashion-clad female.

The image is displaced from the glossy pages of its original milieu onto the less likely scene of the canvas of contemporary postmodern painting, where it is no longer subjugated in quite the same way to an apparent socio-economic purpose — that of commodity circulation. Another element adding to the estrangement of the image is the legend which runs across the centre of the canvas. A convention of fashion magazines, as Barthes noted in *Système de la Mode*, is to accompany the photo with a line of text which describes the article purveyed in the image. Ostensibly, this is why the model's gown in the painting is traversed by a line of text; however, the content of this text is startlingly inappropriate for the genre of fashion commentary. It reads: " 'neath my arm is the color of Russell's Subaru" an oddly personal remark, which highlights the artist's personal investment in this image. Again, this comment underscores the nature of the piece as a self-portrait, as the possessive pronoun "my" can only refer to Benveniste's "speaking subject" — the artist or producer of the speech. The irony of this heavily personal fragment of text juxtaposed with the public image of a fashion model reflects the complicity of the female artist and all women in what de Lauretis calls the "technologies of gender."

In a later use of this painting, Tod incorporates *Self-Portrait* into a larger canvas called *Self-Portrait as Prostitute*. The gesture of engulfing the first painting within the second shows that Tod continues to be concerned with the problem of self-representation, so that the first self-portrait requires the later supplement of a sequel. The title of the second one also points to an awareness of the inevitable role-playing involved in identity by bringing in the "as if" dimension of self-ness. The encapsulation of the earlier painting within the later emphasizes that a work of art (in this case, the first *Self-Portrait*) is

never closed or finished, even when it has hung in a public exhibition. In this way, the processes of identity formation and artistic production can be seen as analogous in their interminability.

In the second painting, the self-portrait hangs on the wall of an empty, ordinary dining room. The table is set, and the door is invitingly open. Tod has remarked that this painting serves as a warning to herself of the possible commodification of her work, which may be consumed as quickly and thoughtlessly as the pot of soup depicted on the table. There is another ironic effect of the painting, though, one which is not necessarily linked to the artist's intention. The only human figure in this second painting is off to the side, that is, in the reproduction of the first picture which overlooks the table. According to the conventions of realistic painting, the most important image in the painting, especially in the case of a portrait, should be centred. Perhaps the self-depiction here is not the image on the wall, but rather the implied image of the person whose absence in the painting is centrally notable; according to the codes of narrative realism, within which this painting can operate, the open door signals the imminent entrance of the housewife, the protagonist who would complete this scenario. The titular prostitution would then work as a trope which criticizes the exploitation of women in a bourgeois domestic arrangement. On this level, as well, the picture serves as a warning to the artist and other women: to allow oneself to follow the most conventional roles which society offers women is equivalent to the subjugation more dramatically played out in literal prostitution. The roles which are written for women, their subjectivity as it is "spoken" by social pressures, must be noted and resisted.

The last painting to be discussed is Tod's *Magic at Sao Paulo*. Knowledge of the context is crucial in all of her work, and especially in this piece. The painting responds to an incident which occurred

in the inner circles of the Canadian art world in 1985. That year, the male editor of a prominent Canadian art magazine, *C*, was responsible for selecting the Canadian participants in a Biennial Celebration in Sao Paulo, Brazil. Neither Tod nor her friend Elizabeth MacKenzie — both pictured recognizably on this canvas — were invited to attend. At the same time, factions within the Toronto arts community hotly contested the selection of participants in the biennial, and suspicions of nepotism were voiced.

Tod's reply to this controversy is to paint herself and friend into the very locale from which they were excluded, working from an actual photograph of a nightclub in Sao Paulo. She copied the photo faithfully, simply replacing the heads of strangers with hers and MacKenzie's. This forbidden location is at the same time the front cover of an issue of *C*, as indicated by the edge of its logo at the top of the canvas. The ironic doubleness of this piece emerges in its capacity to speak presence and absence simultaneously. Tod's literal banishment from both places is contradicted by the solidity and apparent verisimilitude of this visual depiction of herself there. In the art world, as in other spheres of social life, women are "the underdog," in Tod's own words. Their exclusion from glorified events is not accidental but systematic, and *C* undermines its apparent progressiveness, as an institution linked to the parallel gallery network, by seeming to perpetuate sexual inequity.

At the same time, it seems that Tod is questioning her own desire for the prestige which patriarchy has to offer, by picturing herself and her friend as somewhat ill at ease in the glamorous Brazilian night life. The two women appear less integrated into the crowd than the others present, and their bodies appear constrained within rigid garments of a type obligatory to the formal-occasion fancy gowns which sculpt the female body forcibly into uniform contours. The artist here is a subject both speaking and spoken, both the agent

which conceived and executed this painting and the figure con-
strained by the ball gown and the scene of the fiesta. In this painting,
Tod captures the tension which de Lauretis theorizes, the slippage
between Woman as the concept and its continual representation and
women as historical subjects governed by real social relations —
here, the international relations of the commercial art world. The
socio-economic relations are suggested here too by the form of the
reflected diving board in the swimming pool: the shape repeats the
logo of the Canadian Imperial Bank of Commerce, thus pointing to
the subtlety of corporate sponsorship.

The ambivalence of the female figures in this circumstance is
clear: the gazing away from the rest of the crowd marks their
ignoring of the festivities, and the very presence of the two women
in this scenario has an air of improbability, almost to the extent of
producing a surreal or magical quality. The word "magic" in the title
speaks a double resonance. It may sardonically refer to the natural-
izing of a male monopoly of society's power, the exercise of which
can seem mysterious and of obscure origin. On another level, it may
refer to Tod's capabilities as an artist, her ability magically to
represent herself in a scene from which she is excluded.

The necessity to counteract exclusion is, of course, predicated on
the marginality of women, that is, on their placement on the
outskirts of the circles of power. This is the predicament which Tod
recognizes and in which these paintings intervene. The doubled
vision of irony facilitates this critique, as it can both speak the
marginality of women in our historical moment and speak against
it. Thus irony works as a destabilizing force from within the pres-
ently existing social order, Canadian as well as global, in which it is
necessary to wrest gendered images from patriarchal control. As
part of a feminist cultural politics, irony may be one of the earlier
stages in a lengthy process which will be reformulated along the

way. Feminist strategies are complicated and changing, and at moments flourish on the sustenance of irony's potential for both humour and aggressiveness.

"MOTHER(S) OF CONFUSION": END BRACKET

WENDY WARING

. *University of Toronto*

M ANY CRITICS have argued that irony is a possible organizing trope for women's artistic production. The question is, however, does such a notion not risk circumscribing the subversive projects of women in Canada, as elsewhere? Is irony the "mother" or perhaps mother(s) of confusion, as Wayne Booth has claimed (ix)? It has been suggested that irony is a fertile mode of "speech" used by marginalized or minoritarian cultures in their positionings with respect to mainstream culture (see Appendix I of Introduction). In the company of ethnic, visible minorities, native, gay, and other minoritarians, "female minoritarians" would use irony to combat the ideologies of dominant cultural discourse. The framework for this ironic "speaking Canadian" is one which uses a figure of a simultaneous double margin and centre; opposition from within and without. By this view, a forked tongue is how we can best typify the particular ironies of Canadian culture. Irony would be a hinge that swings positive and negative. It is negative: "a form of critique which can at times border on the defensive, but

which is always concerned with internally oppositional positions" (Appendix 1, 30). It is also positive: another "more constructive kind of irony works to assert difference as a positive and does so through double-talking, doubled discourses" (30). The process of deconstruction and reconstruction that ironic discourse initiates is not limited solely to the individual ironic voice of the artist but could be seen as characterizing a more general mode of discourse, a speech rooted in the collectivity, in history. This didacticism and historical rootedness would seem to make it particularly interesting for politicized literatures. I would like to address these possibilities using a few short texts by women in Canada.

Given that the productions of marginalized cultures do not have the same kind of institutional clout as do an English Department's canonical texts, I cannot assume the same kind of familiarity with my corpus as I could for works by Shakespeare or T.S. Eliot. Moreover, because the very desire for canon seeps into the most radical of university departments (even Women's Studies), I have taken a somewhat unusual approach to the first part of my textual corpus. I want to speak about the titles, only the titles, of two fairly well-known recent Canadian feminist postmodern texts. Then I will take a look at a few texts which may be less familiar to some, and which certainly, for various ideological reasons, haven't received the same kind of canonical attention as my first two title-texts.

Two novels, *L'Amer*, by Québécois lesbian feminist Nicole Brossard, and *Heroine*, by lapsed lefty and feminist Gail Scott, have titles which provide us with thumbnail sketches of ironic discourse in a feminist mode. The generation of language play in Brossard's *L'Amer* offers from the very outset a critique of motherhood as mythologized in Western societies. Received patriarchal notions of motherhood are rendered negative, through an ironic recontextualization of the verbal mother "la mère" into a visible bitterness "l'amer."

Through this ironic linguistic recontextualization is born the liminal space of the sea, "la mer." The ironic turn which produces this positive space would seem to follow the very pattern of deconstruction and reconstruction which has been identified with the potency of ironic discourse. In *L'Amer*, a positive space is born through the recuperation of matriarchal traces and the projection of lesbian women mothering one another without the patriarchal mother: a new species emerges from "la mer." In the title, we can both see and hear the ironic hinge swinging back and forth, doubling up and then working into a new space.

In her novel *Heroine*, Montreal anglophone writer Gail Scott creates an irony which is bathetic, both literally and figuratively. The novel is a series of flashbacks of a political Montreal of the seventies by a woman who is contemplating the problem of how to write a heroine in 1980. She contemplates this difficulty from the warmth and security of her bathtub. The novel is fictional, autobiographical, and self-referential. Astride the tragic and the melodramatic, this heroine disappoints the literary antecedents on a number of fronts: she does not provide a positive role model in response to the desires of a certain kind of feminist literary criticism; nor does she follow the stereotypical expectations for heroines of nineteenth-century romance novels (although she may 'shadow' them). The authoritarian discourses challenged in *Heroine* are fairly easy to spot in the narrative (however fragmented it may be): the patriarchal discourse of the romance, the masterful discourse of the left in the late 1960s, and the discourse of white middle-class second-wave feminism. The doubling doubles here; the irony turns on itself. It deconstructs the notion of the heroine, while at the same time envisioning the creation of one, and while writing one in the present. The heroine of this novel wrestles with what it means to *be* a heroine in the 1970s and 1980s and what it means to *write* one. For both these texts,

liminality, the space of reconstruction, is represented by the emergence from water, a rebirth of the subject, when our heroine finally gets out of the bath, or in Brossard's text, a species is reborn.

I want to look now at an ironic moment in a short poem by Lenore Keeshig-Tobias, founding editor of the magazine *Sweetgrass* and an Ontario Ojibway poet. It is entitled: "(A found poem)." In it, sections 11 and 12(1)(b) of Chapter 149 of the "Act Respecting Indians" are quoted and reworked with repetition to create a subtle yet powerful poem and political commentary:

> Section 12 (1) (b)
> The following persons are not
> not allowed to be registered
> registered namely, (b) a woman who married
> married a person who is not an Indian,
> Indian, unless that woman is subsequently
> subsequently the wife or widow of a person
> person described in section 11.

The irony in this poem hinges on the doubling meaning of single words such as "respecting" and "person," and is actualized through the recontextualization of a piece of legislation into the body of this found poem. This poem uses an altered context to create an irony which comments on both the sexual oppression produced by a white European state and the complicity of male Indian band chiefs who condoned and policed this state's intervention in reservation sexual politics.

"Where are the Women?" the woman's and the poet's voice asks:

> we reach out into the mist
> to women you refuse to see
> to strength you cannot give

and will not give to emotion
you cannot feel to the other
half of our beginnings

we have ourselves and our daughters
and you my fathers have
sons and sons and sons

and section 12 (1) (b)
in the Act Respecting Indians

The shifting irony works around the words "respecting Indians." For one, there is no respect, for the culture and the sexual/gender structure of native life was dismantled and disrupted for all Indians with the coming of white conquest, but as well, the exclusion of native women renders this phrase doubly ironic. This poem is for women, those female minoritarians, but it is also for men, native men. And it is most obviously addressed to native women. At this point, categories like "female minoritarian" or even "feminist" falter in their attempts to erect a metadiscursive stance on the use of irony. Is this a native minoritarian use of irony or a female minoritarian one? The title of bell hooks's book on black women and feminism puts this succinctly: "Ain't I a woman?" The native woman could reiterate this question that a white middle-class feminist discourse has scarcely begun to address. Who is the "we" in whose voice that discourse often speaks? There is irony in this poem, but is it "female minoritarian"?

The third text I want to discuss is a performance piece by Robin Endres. She is a local Toronto feminist who "left 'the left' to write" about ten years ago.[1] In terms of irony, this text is a borderline case, or rather a revealing one in that it takes the ironies possible in a

certain kind of feminism and makes that structure the very point of "Talkin' Marxist-Feminist Blues."

> SISTERS!
> Hear me now, sisters!
> Well if you call yourself a Marxist and a feminist too,
> It might be more accurate to characterise your inner
> theoretical life as anarchist
> or at the very least
> highly contradictory, yeah coooooooontradictory
> 'cause in the first place, you'll want to distinguish *your*self
> from
> radical feminism
> socialist feminism
> & even national feminism
> national feminism? what the hell is that?
> well what do you call Margaret Atwood/she sure ain't no
> national socialist no sir (82)

Later in the piece, the speaker finds herself at a party embroiled in a difficult conversation with "some nice male marxist" who's "sympathetic to the feminist cause/hell he's probably married to one of us/does the dishes . . ." She struggles to articulate how the specificities of being a woman and a feminist temper her Marxism:

> why even bourgeois women get menstrual cramps
> fear rape
> ain't no woman ever made noooooo missile

To which her comrade replies, "Well what about Margaret Thatcher?" Again, the irony of the piece depends on this phrase

reappearing later in the text in an altered context. We hear the question a second time repeated "maybe even at that same party" by the Marxist-feminist in conversation with a radical feminist:

> she's beautiful and her paintings are gorgeous outrageous
> she's got a lot of class sisters but no
> claaaaaaaass analysis
> for her class struggle means who does the dishes
> and all woman are beautiful
> there's no recognition of the oppression of
> Black men
> Indian men
> and even some white working class men who never had her
> education or her freedom to be an artist
> and you turn to her and you say
> yes sisters, you know you're gonna say
>
> But what about Margaret Thatcher? (84, 85)

What is deconstructed in this piece are the discourses of radical feminism and the left; they are reconstructed into some only difficultly theorizable space called Marxist-feminism, the space of the hyphen familiar to many of us. Endres's final word on the situation, "theoretical schizophrenia," is a re-emergence point, perhaps a liminality, a kind of madness before a new understanding. The irony in this text works for an audience who understands what divided loyalties mean, and what they involve, how a kind of mythical solidarity has as its underbelly the shifting of political positions, theoretical questionings and new alliances.[2] This performance piece itself enacts the doubled structure of an ironic political discourse.

The final text to be considered is by Suniti Namjoshi, who was born in India, lived in Toronto and is now living in England. Her feminist fable "The Fox and the Stork" was reprinted in *Fireweed: A Feminist Quarterly* from the book *Feminist Fables* published by Sheba, a collectively-run press of women of colour and white women in Britain.

> One day a fox invited a stork for a visit. As soon as Stork arrived, Fox started saying that she, herself, was a very progressive fox and intended fully to respect Stork and Stork's individuality. "Thank you," said Stork. "Now," said Fox, "I do not wish to make any assumptions, and so I must ask you: do Storks, in fact, eat?" (65)

Stork patiently answers a few of these mindless questions from Fox, of the kind that remind one of those produced by researchers who view "their subjects" (be they working class, native, or "ghetto kids") as exotic curiosities. Now the irony in this fable begins early in the text with the Stork's quiet "Thank you" and is generally directed at that scientistic empiricist urge that sometimes characterizes the social sciences within research institutions. When asked if Storks were "fluent in ordinary language," Stork cuts short her interview with:

> "No," said Stork shaking her head sadly, "we ration words, and I've used mine up for at least three centuries. I must be leaving," and left abruptly. (65)

Fox, painfully stereotypical, drafts the conclusions to her research: "[T]he average stork utters seventeen words, exactly seventeen, in every century."

The irony in this fable is not directed solely at the more scientistic urges of researchers. The "conversation" with the progressive Fox represents the kind of residual "exotification" that is often present in white feminist organizations, a by-product of tokenism. This exotification is another variation on the racism that post-colonial societies continue to produce long after imperial forces have withdrawn. The important thing for us to note here is that the irony is directed from within at the within, or from the without at the without, or directed at female minoritarians by female minoritarians. In fact, if we look at Endres's piece, "Talkin' Marxist-Feminist Blues," or at *Heroine*, we could come to similar conclusions. This is the point where that word "feminist" is going to create problems.

The difficult moment in this analysis comes when we attempt to outline what female minoritarian discourse is, and what the nature of dominant culture is, that presumed and presumptuous centre which is deconstructed by a female irony. According to the *Oxford English Dictionary*, "irony entails a judgement and always has a victim." One must have faith in what the twenty-volume *Oxford* can reveal of the truth. The victim of feminist irony would be, I suppose, something called patriarchy, or male-stream traditions, or even the capitalist-patriarchal state. And yet I see difficulties in reconciling this "target" with the "victims" of the ironic texts read here.

To begin with, many feminists can (and do) maintain an ironic stance in relation to more than one "mainstream." A feminist could use irony in her texts certainly against patriarchy, against capitalism, against Marxism, against empiricism, against racism, but against feminist as well: role-model feminism, Marxist-feminism, institutionalized, middle-class feminism. Can we say that we are still discussing irony when the target of the text is doubled, sometimes tripled, and sometimes self-directed? Can a text be first black, then

feminist, then lesbian? Can the ironic trope as a general mode account for these simultaneous ironic uses? And is it Canadian? The anglophone and colonial mainstream would have no problems having problems with Namjoshi's fables: they could be excluded by virtue of their exoticism. What about Lenore Keeshig-Tobias's poem? What does "Canadian" mean in a native context? Is it not the oppressor's name? And for Gail Scott, is the question of being "Canadian" not made acute and thorny by writing in a Québécois context as an anglophone?

The first difficulty, then, is one of homogenization: it becomes impossible to circumscribe a female position which would stand in opposition to an equally homogenous dominant victim of irony. If irony's discourse is one of doubling, of opposition, of the confrontation of two sides, we would need a replication of that doubling oppositionality to feel justified in isolating irony as a general discursive figure that rules aspects of feminist or even female minoritarian speech. I think we can see from the assortment of works chosen here that whatever irony emerges from a feminist discursive space would have to be articulated as multiple.

Going back to irony's hinge, the ironic text says one thing; it means something else. If the function of a political irony is to question the construction of master meaning, can we go back to "meaning something else" without re-writing the status of that production of meaning? And if we attempt critically to place the variety of such subversion in the mainstream under the banner of irony, does this not defeat their effect, their production of numerous locations for interference and critique? If the discursive production of minoritarian discourses not only fractures the monolith of dominant culture and ideology, but as well, breaks through the very figure of centre and margin that that monolith institutes in a gesture of containment, the figure of the double, the "forked tongue,"

becomes inadequate. When the proliferation of meanings — produced by those whom dominant culture would like to thrust back into the margin — refuses to stop, we no longer need a hinge, but a revolving door.

We can see this burgeoning heterogeneity in all the texts discussed here. The critique that the irony of "(A found poem)" offers relates to both a patriarchal state and to native political issues. Keeshig-Tobias's text is directed against two things at once, at two different degrees, although they are obviously interrelated. Brossard's text challenges the fatherly mother, and in its radical feminism seems closest to a popularly received notion of feminist critique, but its lesbian separatism is an added feature of the irony which not all female minoritarian speakers would be comfortable with. Similarly, Namjoshi's fable uses irony to critique a certain kind of patriarchal reification, but also to critique other feminists. Endres's performance piece may make ironic comments against the industrial-militarist capitalist complex, but the sharpest edge of the irony in "Marxist-Feminist Blues" is self-directed.

The degree to which self-referentiality undoes the work of irony is also worth contemplation. If we take *Heroine* as an example, where a certain kind of feminist criticism and positive role modelling are being toyed with, or if we look at "Talkin' Marxist-Feminist Blues," where various ideological versions of feminism are jostling about, or if we take finally "The Fox and the Stork," where again, feminism is being challenged by feminism, we do run into a difficulty with mastery. If we assume that irony needs a clearly articulated authoritative voice as its victim, is the self-referential political irony of feminists still ironic? Is what Endres dubbed "theoretical schizophrenia" a step beyond what we can meaningfully call irony?

The advantage of looking at irony as a discursive function which controls the cultural interplay between centre and margin can be

seen in its ability to embrace both literary productions and works of non-fiction. As well, it locates language in both a political and cultural sphere, thus dispensing with the need to draw boundaries between where feminist literary irony would begin and feminist didactic irony would take over. This refusal to confine the creative use of language for political ends seems to me to be the most exciting part of the proposition of irony as a feminist rhetorical tool. Nonetheless, using irony as a generalized discursive principle in feminist speech raises some problems for us, especially if we want to reflect the very power of the women's movement, its ability to work on several fronts at once, and the emergence into primacy of a feminist analysis that takes sexual preference, race, class, and gender into account. And if we turn from irony as discourse to individual incidences of ironic play in texts, we increasingly come up against that troublesome self-referentiality which undoes the masterful premise of irony. And that ironic self-critique seems to me to rub up against a new trope, thus transforming irony with its opposing of authority into a figure which would question the establishment of authority. Even when we are ironic, we feminists are not quite ironic, and even when we are "we" we are not quite "we." There is no position from which to unite the various discourses which make up what we persist in throwing under the single banner of "feminism." Nor are all these differences "merely" contextual, questions of different referents, or different speech situations. Texts by a native woman, a working-class woman, a black nationalist woman, written from these perspectives, are not variations on a theme. Each of these cases comes with its own baggage, a baggage over which we stumble in attempting to board the train to somewhere called "female minoritarian discourse." Let's take mother out of the closet, off the back of the bus, out of the kitchen, off the reserve. Let's put all those mothers on the platform, watch-

ing the train pull away. Then comes babble, Babel, more discussion, more strategies. Mothers of confusion. End bracket.

NOTES

1 See her essay, "Why I Left 'The Left' to Write," in Silvera 13–20 for an ironic, incisive, anecdotal look at the problems facing a Marxist-feminist artist in Canada.

2 See the essay by Arun Mukherjee which follows in this volume.

IRONIES OF COLOUR IN THE GREAT WHITE NORTH: THE DISCURSIVE STRATEGIES OF SOME HYPHENATED CANADIANS

ARUN P. MUKHERJEE

· *York University*

M Y TITLE, by juxtaposing the word "colour" with the phrase "the Great White North," an affectionate appellation used by Canadians to denote the long, wintry face of Canada, creates ironic speech about race. As any perceptive user of language can see, the title is really a tongue-in-cheek description of race relations in Canada. By appropriating a popularly used metaphor about Canadian geography and weather and bending it to suit my own purposes, I want to create a racial "difference," a racialized discourse. By echoing several non-white Canadian writers who also use this popular metaphor in similar ways, I have created another level of irony which will only be evident to my readers if they are familiar with the characteristics of non-white discourse in Canada, both literary and non-literary. And since irony is generally a denoter of dissonance, discord, disrespect, and difference, the metaphors

suggest that I am not speaking about the officially sanctioned version of difference which elides the issues related to race by speaking of Caravans and multiculturalism but about tensions and disaffections based on race.

The official definitions of Canada, whether they be by Northrop Frye or Margaret Atwood or by those in Ottawa, suggest that we have one national outlook and one cultural theme. They assume that, although we Canadians do come in more than one colour, it does not really matter. This rhetoric of identification claims that we are all immigrants to this land and, therefore, all Canadian literature can be classified as immigrant literature, "a mourning of homes left and things lost" (Atwood, "Introduction" xxxi). A cosmic irony is claimed for both the Canadian psyche and Canadian literature, an irony which emerges from "man"'s unsatisfactory relation with the universe. This viewpoint, of course, suggests that the irony is directed outside the inclusionary community called Canadian society. It also implies that the problem is at the level of "man" versus universe something that cannot be helped and not at the level of "man" versus "man."

For me numerous ironies, therefore, emerge when I come across the discourse produced by the non-white Canadians. For they, it seems, by highlighting the conflicts between Canadians of different colours, belie the claims of unity and homogeneity made by the custodians of Canadian culture. In their discourse, irony is racialized speech, emerging from the social, economic, historical, and cultural differences and disjunctions between whites and non-whites. Their ironic speech is based on the ironies non-white Canadians experience in their real life as members of a society which has given them the appellation "visible minorities." While the official cultural and political discourse claims that the visible minorities and the invisible majority lead a harmonious life, the ironic speech created by the

non-white Canadians belies that. The simultaneous denial and demarcation of difference by the invisible majority creates the possibilities of ironic manipulation, the ones exploited in this passage of Himani Bannerji's "Paki, Go Home!," from her collection *doing time*:

> And a grenade explodes
> in the sunless afternoon
> and words run down
> like frothy white spit
> down her bent head
> down the serene parting of her dark hair
> as she stands too visible
> from home to bus stop to home
> raucous, hyena laughter (15)

It is the two words "too visible" that make the poem parodic, a critique of the subterfuges of Canada's official discourse. If only they had called us racial minorities, the non-white poet would not have been able to ridicule them.

I am trying to suggest that the ironies created by the non-white Canadians are based on ironies experienced by them. They create parodies of the dominant discourse to indicate that its tonalities of glory, or patriotism, or moral superiority rub them the wrong way. The ironic voices of non-white Canadians are, then, not directed to God or universe, but to white Canadians.

In discursive terms, it means that the ironic mode used by non-white Canadians is parodic and juxtapositional: it echoes and mocks the acts and words of dominant Canadians. For example, July 1, the erstwhile "Dominion Day" and present "Canada Day" has been called "Humiliation Day" by Chinese Canadians —

because to them the day is the anniversary of the infamous Chinese Immigration Act. By naming "Canada Day" "Humiliation Day," the Chinese Canadians desacralize the dominant discourse of patriotism. Native Canadians create a similar parodic dissonance when they rewrite the national anthem by changing "our home and native land" to "our stolen native land."

Such discursive strategies create ironies that are experienced in a race specific way by non-white Canadians. They may, of course, be experienced by informed white Canadians too, but the modes of experience will be race-specific for them as well. The Chinese Canadians who respond to the irony implied in "Humiliation Day" will do so as victims of an injustice, while the sympathetically disposed white Canadians may respond with the guilt of the victimizer. The race-specific irony, then, insists on dividing Canadians into whites and non-whites, as opposed to dividing them according to their ethnicity. The major marker is colour, as opposed to ethnocultural diversity. It is so because colour, at least from the perspective of non-white Canadians, is a codification of privilege. Therefore, colour and colour coding become major carriers of ironies in the literature of non-white Canadians. The following passage from Krisantha Sri Bhaggiyadatta's poem called "Big Mac Attack!" from *The Only Minority Is the Bourgeoisie* is a good example of how colour becomes a carrier of ironic meanings in non-white writing:

The paper said
The paper said
An american man

This side of the mexican border
Shot 20 children and others
in a McDonalds Restaurant

We knew immediately
he wasn't black
There was no large photo (n.pag.)

Another poem in the same collection points out another aspect of
this representational racism:

in the last two months
all the black people on
television cop shows
have been criminals (n.pag.)

In both cases irony arises from the fact that non-whites can read
between the lines and foil the strategies of the dominant discourse.
Thus, when we non-white Canadians watch beer commercials, we
never fail to notice our absence there. The happy scene of convi-
viality, then, is interpreted by us as that of racist exclusion. It is in
this context that all descriptions of a non-white skin, as in "black is
beautiful," become ironic.

It is ironic to ponder on the fact that non-white writers are always
identified on the back page of their books by their racial difference.
"Dionne Brand is a Toronto Black Poet," we are told on the last page
of her poetry collection *Winter Epigrams*. White Canadian artists, of
course, do not need to be defined racially. Does it mean that the
white writers are writing for every-body, regardless of race? If so,
then it is interesting to speculate on why writing the body is so
important for non-white writers.

This self-identification by race *is* an important piece of contextual
knowledge for understanding the work of the non-white writers.
For example, when Dionne Brand entitles her poems *Primitive
Offensive*, and the poems happen to be about her journey back to her

African ancestry, about slavery, about South Africa, about black heroes such as Frantz Fanon and Toussaint, one cannot but be struck by the multiple meanings of "primitive" — especially its use by Europeans to denote Africans as savage and uncivilized. The title, therefore, is colour-coded, and parodic.

Brand uses African chants, African symbolism, African referents in the poem. It is, however, divided into Cantos. Insofar as she appropriates a Western European art form to do entirely different things with it, she creates a parodic text. However, the degree and level of appropriation imply more of a rejection than an allegiance. These Cantos differ greatly in form and content from the ones we are familiar with. There is not a single reference to European art forms. On the other hand, the Cantos *do* present the oppressive nature of relationship between Europeans and Africans:

> but I stayed clear
> of Bordeaux and Nantes,
> no more trading me
> for wine and dried turtles,
> oh yes
> I could feel their breath
> on my neck,
> the lords of trade and plantations.
> not me
> not Bordeaux
> not Marseilles
> not for sugar
> not for indigo
> not for cotton.
> I went to Paris
> to where shortarsed Napoleon said,

'get that nigger Toussaint,'
Toussaint, who was too gentle,
He should have met Dessalines,
I went there to start a war
for the wars we never started
to burn the Code Noir
on the Champs Elysees. (32)

This Canto is, like Ezra Pound's cantos, about education, but a totally different kind of education. It mocks Europe's postures of cultural and moral superiority from a "primitive" perspective. And insofar as the European metropolis is a symbol of cultural sophistication for white Canadians, a cultural mecca where many of them have gone in their desire to drink from the fountain, Brand's "primitive offensive" mocks the values of the Canadian cultural establishment as well.

Different interpretations of the world and different experiences of history are, then, at the heart of ironies based on racial differences. What promotes awe and reverence in the Canadians of one colour, arouses ridicule and contempt in those of another. What seems appropriate and normal to one group, appears dark and sinister to the other. Feminists here may recall the new readings of fairy tales to bring out their misogynistic content. The non-white writers, on the other hand, appropriate fairy tales to comment on the experience of racism. In *Obasan*, Joy Kogawa provides a racialized version of the classic fairy tale of "Goldilocks and the Three Bears":

In one of Stephen's books, there is a story of a child with long golden ringlets called Goldilocks who one day comes to a quaint house in the woods lived in by a family of bears. Clearly,

we are that bear family in this strange house in the middle of
the woods. I am Baby Bear, whose chair Goldilocks breaks,
whose porridge Goldilocks eats, whose bed Goldilocks sleeps
in. (126)

In Kogawa's version, the fairy tale becomes a myth about the last
five centuries of the history of imperialism. The incarceration of
Naomi's family at Slocan can now be read as part of a larger story of
racism. Kogawa's appropriative act is similar to the one whereby
many Third World writers have turned traditional interpretations of
The Tempest upside down and appropriated Caliban as the heroic
figure. It is also similar to the appropriative act of native Canadians
when they destroy the proprieties of the Hollywood westerns by
cheering for the Indians.

The non-white writers' texts persistently draw our attention to
these cultural representations of non-whites produced by the domi-
nant culture. Maria Campbell in *Half-Breed* describes the movie
about the Northwest Rebellion from her perspective as a Métis
viewer:

The movie was a comedy and it was awful: the Half-breeds
were made to look like such fools that it left you wondering
how they ever organized a rebellion. Gabriel Dumont looked
filthy and gross. In one scene his suspenders broke and his pants
fell down, and he went galloping away on a scabby horse in his
long red underwear. Louis Riel was portrayed as a real lunatic
who believed he was god, and his followers were real "three
stooges" types. Of course the NWMP and General Middleton
did all the heroic things. Everyone around us was laughing
hysterically, including Half-breeds, but Cheechum walked out
in disgust. (111)

Those who produced the movie and those who participated in the proprieties of its form do not see or experience any irony. The irony is experienced by those who bring a different perspective on history. I, as a non-white reader, for example, wince under the non-ironic "normalized" racism of such texts as Nellie McClung's *In Times Like These*, Charlotte Perkins Gilman's *Herland* and Charlotte Brontë's *Jane Eyre*. And the celebratory tone of some feminist critics *vis-à-vis* these texts becomes ironic for me since I can't pay my allegiance to them as a non-white woman. Similarly, I feel that my race-specific experience has led me to experience several highly appreciated works of Canadian literature rather differently from the mainstream Canadian experience. (See Mukherjee, *Towards an Aesthetic of Opposition*.)

It seems to me that ironies based on racial difference are always a reactive response to the dominant, white society. In that sense, the parodic forms created by the non-white writers are not "complicit" with those of the past in the same way as the ones created by the postmodern art of Euro-America. Instead of complicity, we see ceremonial acts of rejection. Marlene Philip's "Oliver Twist," from her collection, *Thorns*, is a good example:

man we was black
an' we was proud
we had we independence
an' massa day done,
we goin' to wear dat uniform
perch dat hat
'pon we hot comb head
jus' like all dem school girls
roun' de empire

learning about odes to nightingales
forget hummingbirds,
a king that forgot
Harriet Tubman, Sojourner Truth
and burnt his cakes,
about princes shut in towers
not smelly holds of stinking ships
and pied piper to our blackest dreams
a bastard mother, from her weaned
on silent names of stranger lands. (6)

There is no complicity in the poem with the romantic ethos of Keats' "Ode to a Nightingale." It is part of the imperial baggage that the poet must reject along with "Hector and Lysander / and such great names as these" (5). Philip's use of children's rhymes along with the island dialect are part of her ironic strategy of ridicule and rejection of an arrogant, imperial culture. Further, its juxtaposition with "smelly holds of stinking ships" makes one wonder how an English poet could have delved in such exquisite "romanticisms" when his society was profiting by trading in human cargo.

The use of African chants, children's game songs and nursery rhymes, dialect, evocation of place names associated with African, Caribbean and South Asian history, naming of non-white heroes (especially ones like Angela Davis who happen to be villains in the discourse of the dominant media), all these become freighted with irony when we know that they are a strategic and ideological rejection of a Western European cultural ethos. The non-white writers in Canada have been deeply influenced by the writings and other art forms of the Caribbean, Africa, Latin America, and parts of Asia, and in their establishments of intertextuality with artists like

Derek Walcott, Martin Carter, Pablo Neruda, Nicholas Guillén, J.P. Clarke, and Bob Marley, they step outside the postmodern tradition of Euro-America.

This artistic alliance is itself fraught with ironies when we realize that the Canadian critical theory is entirely Eurocentric. Canada's geographic location is in the Americas, but we do not hear white Canadian literary theorists or artists quoting Derek Walcott or Frantz Fanon, C.L.R. James or Aimé Cesaire. We have French imports like Derrida or Lacan or Foucault, but we seldom hear Achebe or Soyinka or N'Gugi being quoted. And because its evaluative criteria are exclusionary of the cultural currents of most Third World societies, it cannot, therefore, perceive the ironies of those non-white Canadian artists who draw their inspiration from these currents.

Irony, thus, is a way of speaking that creates exclusionary communities. On the one hand, there is the exclusion practised by those in the cultural establishment, and, on the other, there is the creation of a community created out of a sense of solidarity with victims of similar cultural and racial oppression. For the non-whites in Canada share many similar experiences despite their diverse cultures and ethnicities. First, there is the history of their colonial oppression, regardless of whether they experienced it in the Caribbean or South Asia or, in the case of native Canadians, Canada. Secondly, there is the common experience of racism faced by them in Canada.

It is this community which may be considered the target audience of the non-white Canadian writers. It is they who share the writers' world view and experience and, hence, "get" their ironies. The relationship of a non-white author to her or his audience is an ironic one. Very often, in this discourse, the writer uses "we" to stand for a particular racial/ethnic group, whereas "you" or "they" very often stands for a white person or persons. This marking out of difference,

as I mentioned earlier, is ironic because the writers belonging to the dominant community seem to speak to an undifferentiated audience, unless they address themselves to gender and/or class divisions. For example, Maria Campbell uses "we" to stand for the Métis and "Your people" (9) for the white community. The relationship here is not that of an "author"-ity with its racially undifferentiated pupil listeners, but a more problematic one of a member of an oppressed group speaking to the oppressors. Feminist critics have tried to appropriate some of these voices for the metanarrative of feminism. However, it remains problematic and unappropriated because "your people" creates a racial divide instead of a gender one.

Since the voice of the oppressed, Fanon's "the wretched of the earth," has been a muted one throughout history, only allowed to speak within the constraining parameters set by the oppressors, one can only speculate how they would have spoken without these constraints. However, since that possibility has emerged only recently, the discourse of the oppressed is full of cautions, understatements, as well as silences. And because the relationship between the victim and the victimizer is so conflictual, the discourse addressed to the victimizer may range any where from persuasion to total condemnation.

Claire Harris's "Policeman Cleared in Jaywalking Case" in her *Fables from the Women's Quarters* is a long poem about a fifteen-year-old black girl who was arrested by the Calgary police and strip searched for the crime of jaywalking. The poet begins the poem by quoting the *Edmonton Journal*'s headline (which forms the title of the poem) and its pro-police reporting. Then she provides the items that the newspaper and the Alberta law enforcement appeal board neglected to consider. It is only then that she can speak of her rage and we understand it:

Look you, child, I signify three hundred years in swarm around me
this thing I must this uneasy thing myself the other stripped
down to skin and sex to stand to stand and say to stand and say
before you all the child was black and female and therefore mine
listen you walk the edge of this cliff with me at your peril do not hope
to set off safely to brush stray words off your face to flick an idea off with
thumb and forefinger to have a coffee and go home comfortably
Recognize this edge and this air carved with her silent invisible cries
Observe now this harsh world full of white works or so you see us
and it is white white washed male and dangerous even to you full of
white fire white heavens white words and it swings in small circles
around you so you see it and here I stand black and female
bright black on the edge of this white world and I will not blend in
nor will I fade into the midget shades peopling your dream (38)

Harris's poem enacts the drama of race relations in full. First we see the hypocrisy of the media and the government bodies when it comes to providing equal treatment to black Canadians. Then we see Harris's interpretation of these discourses and their juxtaposition with her own, where black signifies the physical body, the spirit, as well as the experience of victimization. White, on the other hand, refers to a patriarchal power structure, in the control of white males. There are ironies in the "whitewash" performed by the people in power and their inability to control the black poet's rage. However, I feel that white women readers will experience an ambiguity here. Are they completely spared the poet's rage against "white works" because they are women?

Frantz Fanon declared that "I have one right alone: That of demanding human behaviour from the other" (229). The ironies of non-white discourse emerge when this basic expectation is not met. This discourse, therefore, is obsessively centred on exploring the racial difference, attacking the racism of Eurocentric discourse and forging a positive racial identity that is grounded in the memory of the historical struggle of the community. As long as the right of

non-white people to get "human behaviour from the other" is not granted, as long as non-white skin is a caste marker, as long as Canadian society's image of the norm remains "white," the ironies of non-white Canadians will continue to parody the assumptions of "Canadian" culture, literature, and social order.

BECOMING-HOMOSEXUAL/ BECOMING-CANADIAN: IRONIC VOICE AND THE POLITICS OF LOCATION IN TIMOTHY FINDLEY'S FAMOUS LAST WORDS

RICHARD DELLAMORA*

· *Trent University*

J AMES BALDWIN has remarked: "Any real change implies the breakup of the world as one has always known it, the loss of all that gave one an identity, the end of safety."[1] In a series of novels that deal with the two World Wars: *The Wars* (1977), *Famous Last Words* (1981), and *The Telling of Lies* (1986), Timothy Findley has returned obsessively to moments of crisis that put in question central values in Western culture. In *Famous Last Words* he focuses on the fears of social catastrophe that prompt Hugh Selwyn Mauberley, the leading protagonist of the novel, to invest in the myth of a strong leader who will rescue the West in the face of challenges both from the Communists and from "the raucous and wilful repudiation of civilization by industrified America" (67). Although Mauberley, writing in

England in 1936, the year of the Duke of Windsor's brief reign as Edward VIII, does not support the expansionist policies of Hitler's and Mussolini's governments, the political intrigues that begin to gather around the King inexorably draw him and men like Mauberley into the orbit of Nazi Germany. This process shows the novel to be, in part, a meditation on how anxiety can provoke a need for order that operates at the expense of the very "civilization" with which Mauberley so earnestly identifies himself.

Expressed in these terms, Findley's meditation might well be a humanist reflection on the dangers of cultural elitism. Precisely by situating his text at the margin of humanism, however, Findley shifts the critique to new ground and makes it available, in prophetic fashion, to ongoing processes in cultural politics. In part he does so by writing from a position of difference within the dominant sexual economy, a location that permits him to consider the ideological work of gender within representation in ways that humanism fails to take into account.[2] In part he does so by writing from a highly specific national location, namely as a Canadian who grew up in Rosedale, a section of Toronto synonymous with anglo-Canadian hegemony within Canada. From both locations, the Duke of Windsor is a telling figure: from the first, because, in a gay imaginary, the erotic tenor of his appeal to men is evident; from the second, because, during his trip to Canada after World War I as Prince of Wales, he became the cynosure of the anglo-Canadian establishment and a focal point of Canadian post-colonial identity. The particular "safety" that has to be yielded in face of "change" in this novel is the safety of identifying with English "civilization" — and English manliness. By yielding, the novel opens new possibilities for writing both as a gay and a Canadian. These new locations, however, are imaginative not literal; for reasons evident in the narrative, Findley posits no univocal representation of either gay or Canadian

identity. Rather, he emphasizes self-reflexive change: becoming conscious of and responsible for one's sexuality, becoming conscious of oneself as the subject of a national experience which is not contained within the limits of relations to imperial powers.

In the guise of Mauberley, Findley also addresses the allegation that middle-class homosexuals are prey to an aesthetic irony which makes them susceptible to the seductive power of the exercise of political violence, an allegation whose partial truth Mauberley acknowledges at the time of the fall of Addis Ababa. In this context, homosexuality and fascism are both removed to the margin of "civilization." Yet the danger of succumbing has a specific meaning within the history of homosexual existence. During the nineteenth century, it has been argued, a close connection existed between male-male desire and military devotion to state-building projects, including the work of "civilization" that was often confused with the pursuit of a particular national interest.[3] However, the emergence of "homosexuality" as a category in late nineteenth-century sexology — through marginalizing — sundered this productive use of desire — at the very same time that "civilization" began to come into disrepute, as the processes of monopoly capitalism undermined the moral coherence of the unitary subject.[4] For Mauberley, however, not only the most debased but also the most generous experience of desire is directed toward men in uniform.

Findley takes a risk in enunciating these contradictory desires in direct relation to fascism. He takes another risk in drawing a connection between Anglo-American high culture and subjection to fascist ideology. Mauberley is both a practitioner of and, in his subordination to Ezra Pound, in subjection to literary modernism.[5] Findley describes the strongly homophobic character of the relationship, which is bound within the conventions of male homosocial mentoring and discipleship. Not too surprisingly, for most of the

novel, Mauberley suffers from writer's block. Only when he is forced beyond his flirtation with fascism into individual extremity does he find a subject about which he is able to write. In critiquing the sexual politics of male literary modernism, Findley again signals an anglo-Canadian location since, for over a generation now, high modernism has remained the badge of anglo-Canadian academic culture. By challenging the politics of race and gender within this movement, Findley shows implicitly his resistance to the household gods — ironically, at the very moment when Canadian academics are making room for him among the *penates*.

By naming Hugh Selwyn Mauberley after Ezra Pound's poem of the same name, Findley proffers *Famous Last Words* as a kind of homage to an earlier generation of modernists who lived and worked outside Canada. This homage, however, provides the occasion for drawing into question the anglo-Canadian patrimony and, in particular, for rewriting Mauberley's final testament. Pound in his poem describes Mauberley's last words as

> . . . maudlin confession,
> Irresponse to human aggression,
> amid the precipitation, down-float
> Of insubstantial manna,
> Lifting the faint susurrus
> Of his subjective hosannah.
>
> Ultimate affronts to
> Human redundancies. (Pound, *Selected Poems* 110)

The events of the Holocaust, unanticipated by Pound when he wrote, have lent an unexpected but not fortuitous irony to these lines, in which he associates the effeminate Mauberley with the

Chosen People in exile. A prophet in spite of himself, Pound speaks of "the precipitation, down-float / Of insubstantial manna," demonically literalized during the 1940s by the release of gas from showerheads in the death camps. Ironically too, he directs against Mauberley, the 'Jew' homosexual, accusations of an "irresponse to human aggression" which form the "Ultimate affronts to / Human redundancies." And yet it is less Mauberley than his creator, Pound, who helped make Jews literally redundant by excluding them from the human.

Turning quotation into apostrophe, Findley addresses to Pound and other exponents of this facet of modernism the question of *their* "irresponse to human aggression," of *their* part in precipitating "human redundancies." These are apt issues to raise in relation to a text that indulges a modish revulsion against Jews, against the "insubstantial manna" of money earned as interest, "usury age-old and age-thick" (100) or, in one of Pound's neologisms, Jewsury (Parker 77).[6] If the Holocaust that looms prophetically over the novel is that of the destruction of European Jews, then, there is also the matter of the death of large numbers of homosexuals in Nazi concentration camps. Findley alludes to this calamity by giving utterance to Mauberley's subjectivity as homosexual, something that Pound implies without naming. The mixture of racism and homophobia in Pound is mirrored in Nazi thinking. In the concentration camps, members of "both categories found themselves at the bottom of the current hierarchy below the non-Jew or racially defined groups of prisoners" (Lautmann 83). Because even after World War II homosexuals in Germany were regarded as criminals ("the anti-homosexual Paragraph 175, ratified in 1871 and sharpened under Hitler, remained on the books until 1969" [Wright 32]), their ordeal was passed over in silence, and homosexuals "withdrew into the closet" (Lautmann 85).

Silence and closeti y also figure in *Famous Last Words*, though in
other ways, given the different history of homosexuals in English-
speaking countries. The novel suggests a three-generation model of
male homosexual existence.[7] Mauberley is the type of a generation
of closeted homosexuals born shortly after the Wilde trials of 1895.
He is subject to a panic so extreme that his sexuality is blocked at
the site of the genitals. Lieutenant Quinn, the secondary protagonist
of the novel, who is in his twenties during the War, uses silence
differently from survivors in Germany, where silence was interpre-
ted during the 1950s as a sign of "extreme [self-] devaluation"
(Lautmann 85). To the contrary, Quinn succeeds in turning the
silence of the closet against his antagonists. Since the 1960s, men
have been able publicly to express a range of gay subjectivities,
absent from a historical novel like *Famous Last Words* but which is
necessary if the resistance registered in the novel is to become
something that can be spoken today. Findley's novel conciliates
contemporary gays with closeted homosexuals of the interwar years
by providing a possibility of witness — figured in the text by Quinn's
reading of Mauberley's last words.

I. A Resourceful Irony

Writing from a minority subject-position has provided a location
from which, without expatriating himself, Findley can contest the
cultural and sexual politics of anglo-Canadian hegemony, a politics
which as an adolescent and young man he found severely disabling
("My Final Hour"). Since this hegemony is as outmoded and
damaging of national existence today as it has been in relation to the
lives of lesbians and gay men in the past, Findley's critique has

implications for the Canadian post-colonial subject, nudging him or her to another space that is as yet in the making. In *Famous Last Words*, Lieutenant Quinn is assigned to decipher the writing that Mauberley has left on the walls of his final hiding place at war's end in Austria. Mauberley's text, in turn, focuses on the relation between Wallis Simpson and Edward Prince of Wales, a relation in which sexual politics is intimately related to a politics of the far Right. The choice of Edward as focal point in a novel by a Canadian writer permits Findley to pose the relation between national identity and post-colonial identity as that subordinate relation showed itself in the fixation of anglo-Canadians on the glamorous figure of the Prince.

Since both Mauberley and, likely, Quinn (Queen/Queer/Quill) are consciously homosexual, sexual politics in the novel is homosexual politics.[8] Within the context of Findley's historicizing fiction, such self-awareness is expressed primarily in the mode of irony, a silent negation of the dominant pieties — whether these be those of vanguard literary culture, of filial loyalty to the Crown or of highly conservative political thinking. Within history, however, for members of despised minorities affirmation is likewise reached by way of irony — at least that is how I interpret the moment when Quinn refuses to select for himself one of the identifying badges used by Nazi prison officials and offered him by his commanding officer, Captain Freyberg (218–21). In the preliminary days of the Cold War, such silence is saving — a way of being able to *be* by *choosing silence*, by refusing, paradoxically, to name oneself. Quinn's position, moreover, marks a step beyond Mauberley's, which is one of continually attempting to disentangle homosexual difference from a phallic idolization that both mimics and repeats the gender-bound patterns of asymmetrical power in personal and public life. In Venice at the time of the fall of Addis Ababa, Mauberley imagines

how much he would like to fellate a young Blackshirt sitting at
another table (91). Mauberley also finds himself admiring the
"damned beauty" (360) of Harry Reinhardt, a hired gun for the
fascist Right, who eventually tracks and kills Mauberley himself. Yet
another, explicitly acknowledged desire for other men gives worth
to Mauberley's existence. As he waits for Reinhardt at night in a
square at Nassau where prostitutes ply their trade, Mauberley
watches the men in uniform:

> . . . in spite of all the years I might still have to live as me,
> despised as I was by people I admired, and looked down upon
> as I was by all, or nearly all, of my peers, . . . I smiled. I smiled
> because I was alive. I still had that. I could smell the bougain-
> villaea still, and smoke my cigarette and feel the cool white
> cloth of my suit against my legs — and I could watch the
> Airmen, still, in the marvel of their youth, the brevity of which
> they had no inkling of; and I could see them cross the street and
> pass into the dark and I could feel their fear, their marvellous,
> sensual fear as they went their way to whatever beds they would
> find. I still had that. (359–60)

The doubleness of Mauberley's experience permits Findley to pur-
sue irony in terms that are far more extreme than those which
"allow speakers to address and at the same time confront any
'official' discourse, that is, to work *within* a dominant tradition, but
also to challenge it" (Appendix 1 to Introduction, 29).

In this further sense, irony is "a self-conscious use of Metaphor in
the interests of verbal self-negation":

> The basic figurative tactic of Irony is catachresis (literally
> "misuse"), the manifestly absurd Metaphor designed to inspire

Ironic second thoughts about the nature of the thing character-
ized or the inadequacy of the characterization itself. The rhe-
torical figure of *aporia* (literally "doubt"), in which the author
signals in advance a real or feigned disbelief in the truth of his
own statements, could be considered the favored stylistic
device of Ironic language. (White 37)

Irony in this sense is crucial to Findley because, beginning from the
premise that the events of the period 1924–45 mark "the final hours
of Western Civilization" ("My Final Hour" 14), he negates the
humanist ideal of "being-human," an ideal that, in more theoretical
terms, may be described as "the unified subject . . . integral to
contemporary bourgeois ideology" (Dollimore 36).

 Findley's negation of "being-human" takes the form of "being-
mad" or "being-monstrous," a possibility inherent in Mauberley's
wayward attractions and familiar in representations of history in the
mode of irony. As Hayden White has remarked: "In its apprehension
of the essential folly or absurdity of the human condition, it [i.e.,
irony] tends to engender belief in the 'madness' of civilization itself"
(38), a stance that, at least in the imagination of White, comes home
in turn to aesthetes, effete and possibly homosexual, like Mauberley,
like Quinn or like Findley himself, who was a young man during the
1950s. White continues: irony "inspire[s] a Mandarin-like disdain
for those seeking to grasp the nature of social reality in either science
or art" (38). Moreover, "as the basis of a world view, Irony tends to
dissolve all belief in the possibility of positive political actions" (38).
This last dissolvent is close to being the novel's primary concern,
voiced by Quinn, who in the face of Dachau wonders "how these
things had been accomplished by the race of which he was a part"
(47). *Famous Last Words* is a meditation on what happens when irony,
in this last sense, overtakes the guardians of Western culture

whether they be bourgeois, aristocratic, royal or a literary modernist scribbling anti-Semitic squibs.

Anger, ambition, and/or indifference turn characters like Pound and Mauberley and others like Charles Lindbergh and the Duchess of Windsor into instruments and objects of the anarchy that they react against. Findley, the structure of whose novel is located both inside and outside their paranoia, is complicit in an erotics of apocalypse that is both homophobic and homosexual. Mauberley's fantasy of fellating a Blackshirt, cited earlier, is only one such moment of ethical/political failure. There are others too. By registering Mauberley's incapacity for intimacy, his fascination with Reinhardt, and his complicity in the conspiracy around which the novel turns, Findley faces the allegation (and the temptation) that to be homosexual is to lose one's humanity. Doing so, he aligns the negation of humanity in the politics of the extreme Right with the negation of humanity in a sexuality that coincides at times with its most homophobic representations. At its most ironic, the novel poses the experience of being not-human, of being-monstrous, in both political and sexual terms. Yet the aporia thus encountered poses the possibility of recovery, again through irony but now in a third sense as "double talking, doubled discourses," which create the imaginative possibility of "*liminality*, a term used to refer to the open space 'whence novel configurations of ideas and relations may arise.' Irony opens up new spaces, literally between opposing meanings, where new things can happen" (Appendix 1 to Introduction, 30–31).

This process occurs in the terms by which the moral "enigma" of Mauberley's identity "can be distinguished, suggested, formulated, held in suspense, and finally disclosed" (Barthes, *S/Z* 19). Who is Mauberley? Is he a monster? Can Mauberley, who has long been unable to write, recover his voice? And if so what does he have to

say? As one expects in an ironic text, there are two answers to this question. In the eyes of the Nazi hunter, Captain Freyberg, Mauberley's last words precisely are "maudlin confession," a pornographic opportunity to lick someone's boots; but to Lieutenant Quinn, who is charged with reading what Mauberley has incised with a silver pencil on the walls of his last refuge, the writer is "trying to . . . [t]ell the truth" (154). But for Mauberley there is no escape from the *aporia*: he writes in the epigraph of his text: "*All I have written here . . . is true; except the lies*" (59).

If Findley puts in doubt the stereotypes of homosexual identity, he also inverts a number of the self-flattering clichés of anglo-Canadian culture. Mauberley's one clear crime is to order Reinhardt to dispose of the novel's sole Canadian character, Sir Harry Oakes. Oakes is a violent boor who made his money in the Kirkland Lake gold strike of 1912. Further, like many other Canadians, he hails originally from the United States. Since anglo-Canadian post-colonial identity depends on contrasting stereotypes of "being-Canadian" and "being-American," Findley's reminder that the American exists *within* the Canadian mosaic is not flattering. Similarly, when Oakes first plants, then bulldozes, hundreds of trees, he inverts Canadians' environmentally-friendly self-image. In the words of Mauberley, Oakes is "a walking summary of all that is crude, contemptible and mean" (332). In a final gratuitous humiliation, he becomes unhinged when his son Sydney becomes an intimate of his French, possibly bisexual, brother-in-law. Yet Oakes does share with fellow Canadians an ability to turn raw materials into money. He aspires to gentility, and like other well-placed anglo-Canadians of his generation, he hopes to borrow it by rubbing shoulders with the Duke of Windsor, a man who as Prince of Wales was not only a focus of anglo-Canadian sentiment but whose extended visit immediately after World War 1 gave the anglo-

Canadian upper crust a way of distinguishing themselves from their racially suspect American cousins and from the new migrants of Southern, Central, and Eastern Europe. Hence Edward, in Mauberley's words "the epitome of all that is civilized, genteel, and respected" (332), provided a focal point of national, ethnic, and class identity. Though Oakes wants to make money out of the Duke, he is prepared to bankroll him — and he idolizes him.

Mauberley too worships at this shrine. In a series of articles published in the *Daily Mail* in 1936, he writes about "the success of Fascism" (81) and calls for "a new kind of leader" (93) in Britain. Although Quinn defends Mauberley by saying that he was only a messenger in the right-wing plotting woven around the Duke, Mauberley plays a key role by persuading Wallis, whom he names the *Penelope* of the cabal (182), to marry the Duke after his abdication (144). Mauberley is both in love with Wallis and a secret sharer of her romantic investments. And Wallis's royal lover, whose Christian name is David, a name redolent of sentiment in homoerotic tradition, functions in Mauberley's homosexual imaginary as a Dionysus-figure — though one liable to pale:

The King had a charming smile and his colouring was vivid and exquisite under the sun, which he revelled in — though his lips, I noted, tended to pale if he stayed too long in the heat. He was otherwise tanned and golden and he wore the briefest khaki shorts I have ever seen on a grown-up man and an open shirt with a brace of crucifixes round his neck on silver chains. He literally shone from head to toe, so you could pick him out a mile away in any crowd and this *shining* was so pronounced and unique that I ultimately found myself believing in the magic "inner lights" of which one hears superior beings are possessed. (95)

In view of Mauberley's fascination, the scene in which he persuades Wallis to marry "the King" (but he isn't; he is now the Duke of Windsor) is redolent of the triangulated male desire that Eve Kosofsky Sedgwick ("The Beast") has shown to be basic to English male homosocial culture — and which Findley here signals as an aspect of pre-War Canadian and American adulation of that culture.

When Mauberley speaks of "the legendary Prince of Wales, the idol of a whole generation — the Boy King of England, Edward viii" (64), he echoes the press coverage of the 1919 tour:

> We met a young man in a rather light grey lounge suit, whose boyish figure is thickening into the outlines of manhood. I have heard him described as frail; and a Canadian girl called him "a little bit of a feller" in my hearing. But one has only to note an excellent pair of shoulders and the strength of his long body to understand how he can put in a twenty-hour day of unresting strenuousity in running, riding, walking and dancing without turning a hair.
>
> It is the neat, small features, the nose a little inclined to tilt, a soft and almost girlish fairness of complexion, and the smooth and remarkable gold hair that give him the suggestion of extreme boyishness — these things and his nervousness.
>
> His nervousness is part of his naturalness and lack of poise. It showed itself then, and always, in characteristic gestures, a tugging at the tie, the smoothing-down of the hair with the flat of the hand, the furious digging of fists into pockets, a clutching at coat lapels, and a touch of hesitance before he speaks.
>
> He comes at you with a sort of impulsive friendliness, his body hitched a little sideways by the nervous drag of a leg. His grip is a good one; he meets your eyes squarely in a long glance to which the darkness about his eyes adds intensity, as though

he is getting your features into his memory for all time, in the
resolve to keep you as a friend (Newton 9–10)

The Prince is the focus of a male homosocial gaze directed at the
male body poised between youth and manhood, at rest but capable
of vigorous exercise. The object of this gaze is a young man of neat
features and an "almost" girlishly fair complexion whose handshake
is firm and whose glance takes: "there are no barriers or reticences
in intercourse with him" (Newton 11). This is the House of Windsor
as Apollo Belvedere. The subject of this gaze, however, is also
observant of the slightest flaws of masculine representation, ration-
alized in the text as signs of sincerity and responsiveness but
registering too an anxiety evident in the need to correct the voice,
evidently not girlish enough, that finds the Prince "a little bit of a
feller."

The trajectory of *Famous Last Words* makes Mauberley a figure of
abandonment, both by his parents, in the outermost frame of the
novel, and by a number of women whom he loves and who love him:
Dorothy Pound, Isabella Loverso, and Wallis herself. After the Duke
and Duchess miss their rendezvous with a German submarine,
however, Mauberley is forced to relinquish his connection with her.
What he has regained, however, is the ability to write, in Findley's
terms to say "*I am*" (173) — even if, again, to say so means to confess
to complicity. Nonetheless, complicity gives him the new subject
that he has hitherto sought in vain. Moreover, his ability to thread
the labyrinth chastely, without either an Ariadne or a Dionysus at
his elbow, is the measure of his recovery. Indeed this ability becomes
his voice and text despite the fact that he dies with both arms
broken.

After the embarrassing prophecies of his pre-War journalism,
Mauberley attaches to his final text an epigraph from Daniel 5.5 that

signifies an attempt to prophesy differently. In the biblical verse, a hand appears whose writing upon the wall foretells the fall of Baltasar's kingdom at the hands of Darius. Since Mauberley writes on a wall in 1945, his prophecy becomes in part his readers' past, in part an as yet unrealized future. The kingdom of Baltasar is, by analogy, the British imperium. With specific reference to anglo-Canadians, the prophecy of 1945 is reflected in the Duke's eyes near the end of the novel when he watches a Bahamian sunset: "When the breezes stirred the brim of his hat, the reflections could be seen of an Empire going out and setting in his eyes" (384). In witnessing this humiliation, Findley marks the need that anglo-Canadians of that era had to disinvest in Prince, Crown, and Empire. Since World War II this group has had to learn, as the Duke does as he sits bobbing in a rowboat off Nassau, to "Let go" (383). For those whom Findley especially addresses, the sunset is a moment of negation that preludes the aporia of "becoming-Canadian."

II. In the Labyrinth

In considering the post-colonial subject, Findley has recourse to a tradition of myth-analysis by subjects of male-male desire that precedes the advent of literary modernism. For writers like Walter Pater, the myth of Dionysus was especially helpful in analyzing masculine desire.[9] E.M. Forster structures *The Longest Journey* (1907) around the myth, which also provides a major element, thematic and historicizing, of Findley's World War I novel, *The Wars* (1977). The myth of Dionysus has recurred prominently in recent years in the critical theory of J. Hillis Miller, who describes deconstructive reading as the pursuit of "Ariadne's Thread." Miller

refers to the legend of Theseus, the Athenian hero, who was charged with the task of slaying the Minotaur in the labyrinth ordered built for him by King Minos of Crete. Minos's daughter Ariadne gives Theseus a ball of thread with which to thread the labyrinth. In exchange, he promises to marry her; but, after successfully killing the monster and returning, he abandons her on the island of Naxos, where Dionysus discovers her and takes her as his lover. Miller's use of the figure has been interpreted by another Miller, Nancy K., as a sign of neurotic fixation among heterosexual males. Referring to what she terms the Ariadne complex, Miller contends that "domesticated female desire becomes the enabling fiction of a male need for mastery" (*Subject* 94). Miller argues the importance of the Ariadne complex in structuring masculine identity, including the stabilizing of male-male desire: "like Theseus rising to the challenge of the minotaur, the masculist [writer] uses Ariadne to negotiate his encounter with the woman, perhaps in himself, the monstrous self the male . . . might meet at the heart of the maze of heterosexuality" (100, 121). Overdependence on a woman enables the man to cope with the spectre of an internal femininity that has frequently been characterized as homosexual. The Ariadne complex, then, is a defense against male sexual panic.

Gay critical theory reads the myth more equivocally. Most recently, Arthur Evans has argued that Dionysus conflates a number of deities deriving from different periods of early culture. Dionysus is a life-affirming, bisexual deity conflated with an earlier Cretan "god in the form of a bull-man" (46) that existed in a matri-equal culture widespread in Europe and Western Asia during the Old Stone Age (46, 84). Secondly, however, Dionysus is also the Minotaur itself, whose myth refers to a later time "when Athens was a tributary subject of Crete and when human sacrifices were performed, that is, when criminals and war captives were executed in

a ritual context" (46). This avatar dates from after the incursions of Northern invaders, who brought patriarchal culture with them. The composite myth of Dionysus includes antagonistic elements of both sorts of culture. In Evans's speculative mythography, then, the bull-man/minotaur is a figure, an encounter with whom might be either enabling or murderous. This two-fold aspect is congruent with Pater's late Victorian evocations of Dionysus as both a subject of desire and an object of violence.

In *Hugh Selwyn Mauberley* Pound, exploiting the same myth, associates Mauberley with the figure of Ariadne's thread in a way that emphasizes the context of homosocial desire. In the final poem of the sequence, "Medallion," Pound describes the female por-traiture of Mauberley's finest poem:

> Honey-red, closing the face-oval,
> a basket-work of braids which seem as if they were
> Spun in King Minos' hall
> From metal, or intractable amber. (112)

Pound re-imagines Ariadne's thread as "a basket-work of braids" as fascinating as "the elegance of Circe's hair" which is the object of "E.P.'s" (i.e., "Ezra Pound's") attention in the first poem of the sequence. This sexual context is, however, complicated by another comparison in which the "Medallion" is described as a "Luini in porcelain." This allusion is to a portrait by a Milanese painter, Bernardino Luini (1480?–1532), who imitated Leonardo's man-ner.[10] The Leonardo connection, especially with Pater's essay on the painter in mind, signifies bisexuality or, more likely, homosexuality. The dissonant allusion invokes just that suspicion of deviance that is necessary to spark the engine of male sexual panic.[11] While the "E.P." of the first part of the poem celebrates "Dionysos, / Phallic

and ambrosial" (99), Mauberley "drank ambrosia" (107). The absent member tells.

These details seem to distance "E.P." from Mauberley as the quintessential type of the effete artist. Yet Pound also ties "E.P." and Mauberley together so that commentators like K.K. Ruthven have argued that in Mauberley Pound exorcises aspects of an earlier self (124–27). Masculinist critics scent the taint of sexual nonconformity in "E.P." himself. A.L. French, for instance, cites for its "Rupert Brookery" the line, "fair cheeks, and fine bodies," from "E.P.'s" elegy for the soldiers of World War I. (Brooke was bisexual.) And F.R. Leavis, who terms Pound "an aesthete," albeit "in the most serious sense of the word" (117), makes the castrating gestures of denying Pound both greatness as a poet and the crucial role that he played as T.S. Eliot's editor in revising *The Waste Land*. Leavis opens his chapter on Pound by quoting Eliot's acknowledgement of Pound's influence ("I am never sure that I can call my verse my own") only to deny the fact: "whatever [Eliot] and others may owe to Mr Pound," says Leavis, "the influence of Mr Pound that can be observed from outside is secondary to Mr Eliot's" (111). Yet *Hugh Selwyn Mauberley*, published two years before *The Waste Land*, is uncannily akin to Leavis's preferred poem. And though the manuscript of *The Waste Land* with Pound's emendations was published only in the 1970s, the words of Eliot that Leavis cites make clear the extent of the younger poet's obligation.

To be secondary, to be an aesthete (even of the most serious kind) is, for a critic like Leavis, to be *not man enough*. While Pound in Findley's text compensates to a fault, the actual Pound shared traits with Mauberley that Pound makes manifest in "E.P.": the thirst for "Beauty" (106), the hatred for contemporary life, the attraction to military men, and the need for an Apollonian great man. "E.P.'s" apostrophe to Apollo might well be the germ of the novel since the

course from divinity to tin man is precisely the downward curve of Mauberley's estimate of Edward/David:

O bright Apollo,

What god, man, or hero
Shall I place a tin wreath upon! (100; qtd. in Findley 59)

In *Famous Last Words*, an exaggeratedly masculine Pound plays the role of the intellectual or artistic male who has nurtured the talent of the ephebe, Mauberley. This connection brings to mind the role of collaborator that Pound played for Eliot in writing *The Waste Land* (Koestenbaum ch. 4). Findley associates Mauberley with Eliot in a number of ways. The novel opens at Cambridge, Mass., where Eliot studied and briefly taught and where Mauberley's father was a professor at Harvard. As well, Mauberley and Eliot both approach Pound while suffering from writer's block. And the lives of both men are marked by the loss of young men: for Mauberley, of Dmitri Karaskavin among others, for Eliot — as James Miller has shown — of Jean Verdenal, the French medical student with whom Eliot shared a pension in Paris in 1910–11 and who died in service at Gallipoli in 1915. Verdenal might be described as the absent referent of *The Waste Land*, the lover, actual or wished for or about whom Eliot's feelings were blocked, whose gender remains undisclosed and of whom the speaker says in the final section of the poem:

. . . what have we given?
My friend, blood shaking my heart
The awful daring of a moment's surrender
Which an age of prudence can never retract
By this, and this only, we have existed

Which is not to be found in our obituaries
Or in memories draped by the beneficent spider
Or under seals broken by the lean solicitor
In our empty rooms. (ll. 401–09)

Teasing Eliot for his effeminacy, Pound writes to him during their work together:

SAGE HOMME
These are the Poems of Eliot
By the Uranian Muse begot;
A Man their Mother was,
A Muse their sire.[12]

Whether Pound has Verdenal in mind as the "Uranian Muse" of *The Waste Land* or whether he refers, as Wayne Koestenbaum argues, to his own ministrations to the poem, "Uranian" was a term, current at the time, for male homosexual verse.[13]

Pound's lines cast a comic slur on Eliot. In their scatological continuation, which D.D. Paige excludes from the *Selected Letters of Ezra Pound*, Pound pokes comic fun at himself by claiming to be the object of both homosexual desire and Jewish praise:

. . . holy hosts of hellenists
Have numbed and honied his cervic cysts,
Despite his hebrew eulogists.
 (Koestenbaum 122)

The confession is ironic; as editor, Pound strikes a hectoring note, "queerying" (the term is his) "instances of linguistic effeminacy" (Koestenbaum 124) in Eliot's draft. Effeminacy is to be excised from

The Waste Land. The action of "queerying," however, works in both directions so that, like the "E.P." of *Hugh Selwyn Mauberley*, the "E.P." of the lines to Eliot is haunted by a sense of sexual inadequacy. In lines that Koestenbaum published for the first time in 1988, the "E.P." who is "Sire" to *The Waste Land* also characterizes himself as an onanist (a code word for homosexual):

> His foaming and abundant cream
> Has coated his world. The coat of a dream;
> Or say that the upjut of his sperm
> Has rendered his senses pachyderm.
> (Koestenbaum 122)

Insemination in male literary collaboration is a rhetorical figure inscribed with a sexual anxiety that infects both partners. In *Famous Last Words*, Findley characterizes the post-collaborative phase of such a relationship. Pound, although unable to let Mauberley go, must also reject him: "Mauberley cannot bear the world of men at arms, and I cannot bear the world of men in white linen suits" (82).[14] The latter are Mauberley's trademark. Pound's love-hate and the younger man's prolonged subordination are synecdochic of the intimate place of homophobia within the literary tradition that Findley both inhabits and critiques. He is altogether aware that neurotic symptoms such as Pound's anger over a lost cultural coherence and Mauberley's nostalgia for order are accompanied with an erotics of which male homosocial desire is a major element.

In the course of *Famous Last Words*, Findley often alludes to the castration complex, for instance in the posture of Harry Oakes's body after death: "One arm was caught underneath his body and the other was flung between his legs in that gesture so often made by boys in their sleep against the atavistic fear that Lilith will come in

the dark with her scissors" (379). Here Lilith, however, is in drag since the man who arranged Oakes's murder is the same man whose dead body, if touched, Sergeant Rudecki fears will blow his balls off (39). At the wedding of Wallis and "the King" (145), Mauberley fears that the marriage is a prelude to suicide. This fear, however, is fear of the Ariadne complex not the castration complex. Findley sees the King as undone by his inability to find his voice in the presence of Queen Mary and to say no to Wallis's will to become Queen. Abject need of a woman is the self-destructive flaw in the King as in others in the novel, such as Mauberley's father, who, on page 2, commits suicide after having been abandoned by his wife. Mauberley says: "What my father had wanted was to have her and to hold her all the rest of his life. And after the refusal to be joined — the leap into space and the fallen mind So this was all I could see as I stood there watching the King and Wallis take their vows" (145). In mythic terms, this tendency in male heterosexual psychology is suggested by allusions to Icarus, son of Dedalus, fashioner of the Labyrinth, who fell from the sky. For Mauberley, the former King is a Dionysus-figure during his days as Prince of Wales but becomes lost in a labyrinth when, after his marriage, he is renamed Duke of Windsor. Duke signifies not-King.

Negated as cynosure, the Duke/David becomes lost in darkness. At one point, Wallis observes:

His eyes — somehow — had gone out. As if they had been disconnected. The Duchess was — and she knew it — the centre of his life. Her wisdom, her advice, her presence were the food on which he fed: *feasted* whenever the tide of public opinion flowed against them. But now, his back was turned — and what she saw was just his clothes — with no one inside. A shell. (191)

At another moment, the Duke has a dream in which the labyrinth seems to fuse, in the image-repertoire of Hollywood (where Findley once went to make his name) with the image from *Vertigo* of Jimmy Stewart, paralyzed with fear on the bell tower steps to which he has been drawn by a duplicitous woman:

> Everytime he dreamt, the dream was edgeless and the bottom of the stairs on which he sat could not be seen or imagined. Perhaps there was no bottom. Maybe there was nothing there but a drop into space. Sometimes in the dream there was a sudden tilting of the stairs and the Duke was forced to cling to the railings, fighting gravity and dizziness in order not to fall. And he would hang there with his eyes closed sometimes it seemed for hours, until the stairs were righted again and he could breathe He was alone. (244)

In the final description of the Duke after the débacle of his attempted escape, Findley writes: "All the rest of his life he was faithful to Wallis. All the rest of his life he found his comfort in her shadow" (384).

As for Mauberley, he encounters the Minotaur in various guises — in the young Blackshirt whom he "wanted so desperately to follow" (91), in Reinhardt, but also in the darkness of the square at Nassau, which also belongs to the Minotaur. This creature is, however, another animal-man-god, or rather, he is the same but different, within the economy of phallicized power yet exceeding it and gracing existence.

III. Pillow Talk

In an address presented at Trent University in 1987, Findley remarks that his "sexual orientation . . . is something to which I have been peacefully reconciled since I could think; perhaps since I was three" ("My Final Hour" 7). He has also, however, suffered the indignity of seeing himself characterized as Other: "When I was fifteen or sixteen years old . . . I was being informed by other people — and, sometimes, very harshly — that I was not like them; that I was not, or so it seemed, like anyone. This part of me that others would not accept and could not cope with was called — by them — an *aberration*." In reaction, Findley writes: "I felt the sorrow of the leper and the rage of the outcast" (7). Findley's exclusion prompted an inwardly directed homophobia that made him see himself as a "monster" (9). Not surprisingly, his difference, represented thus to himself, had a deforming effect:

> I was very good at keeping my distance Yes — I was very good at that. I was so alarmed by the thought of love that I only slept with strangers. And if I fell in love — and I did that twice with a mighty fall before I was twenty-eight . . . I would find some way to unleash the monster and let the monster do its work of driving love away. (9)

In these lines, Findley testifies to his own Icarian fall not into the sea but into a labyrinth in which, in a dreamlike conflation of images, he became his own Minotaur. It would be a mistake to underestimate the extent to which the indictment of humanism in *Famous Last Words* is based on Findley's lifelong, justified anger against the culture in relation to which he found himself termed "an *aberration*."

Since 1964 Findley and Bill Whitehead have lived just outside the

town of Cannington, self-styled as *The Heart of Ontario* ("A Sense of Place" 4). Although Findley calls this place "my town," he also says that he lives "beyond" it (5). The dual location marks both the sense of belonging and the internal distance. In the Trent address, Findley says that it was Shakespeare's Richard III that helped him understand how one could turn the contempt of others into an active will: " '*I am myself alone*' " ("My Final Hour" 8). In this way, Findley has drawn strength from aspects of the very culture that had *othered* him. What Findley leaves unstated are the years of struggle during the 1950s and 1960s to achieve the capacity to love and be loved by another man. If, as Michael Peterman has pointed out, *Famous Last Words* "constitutes a kind of signature" (160), then it is that of a gay subject, whom Findley represents in the Trent address as simultaneously natural, marred by the violence directed against him, resistant, and, at last, self-expressive.

Residence at Cannington locates Findley and his companion outside the gay ghetto of Toronto but inside the process whereby gay communities have constituted themselves over the past twenty years. Among gays in Canada, 1969 is remembered as the year of passage of the Canadian Criminal Code Reform bill that in part decriminalized sexual activity between men (Kinsman ch. 9). Without the passage of this or similar legislation, the Trent address would have been literally not possible.[15] Passage of the bill was immediately followed by the emergence of visible gay subcultures in Toronto, Montreal, and Vancouver. During the period prior to publication of Findley's novel, however, gay groups found themselves subject to an unusually high level of harassment. In the mid-1970s and in particular after the slaying of a young boy on Toronto's Yonge Street strip in July, 1977, police and politicians attempted a "clean up" which included a December, 1977, raid on the offices of *The Body Politic*, the leading organ of gay opinion in

Canada. Reaction against the emergence of gay visibility poisoned the atmosphere during the following municipal election. Shortly after the defeat of the incumbent mayor, "a supporter of gay civil rights" (Kinsman 207), police launched a major raid on a number of gay bathhouses. The scale of the operation (286 men were arrested in a single night) and the difficulty that prosecutors met in establishing the offenses for which the men had been arrested, resulted in widespread revulsion. Police had miscalculated: what they had perceived as an effort to affirm their authority by reasserting the social consensus against a marginal group was instead widely represented and understood as an attack on a specific minority. The police were compelled to back down, redirecting subsequent efforts towards arrests of random individuals and towards prosecutions directed at gay publications and bookstores.[16]

In the Trent address, Findley, emphasizing the need for "reconciliation" (7), cites *Famous Last Words* as affirming an essential humanity. This recourse is risky, however, since gay subjectivity like other marginal positions is tolerable only insofar as its representation is already included within the expressions of the dominant culture. Even at Trent, where openmindedness long benefitted from the relative homogeneity of the University's constituencies, the President has recently found it necessary to convene a Task Force to respond to growing "evidence of sexism, homophobia and racism" on campus. Despite Findley's recourse to humanism, the novel subverts the doxa of anglo-Canadian culture while passionately affirming homosexual difference. And the ending of the novel, which juxtaposes vacationers dozing on a beach while something ominous "rises to the surface" (395) at the horizon, is an image of citizens like ourselves whose sloth and indifference make possible the emergence of real monsters. In an interview, Findley has remarked of Mauberley that he "gave in to safety, to wanting to be

safe" ("Masks" 35). In its apocalyptic aspect the novel warns of the as-yet-unknown "affronts to /Human redundancies" (Pound, *Selected Poems* 110) that lie just off shore of our complacencies.

If Mauberley achieves selfhood by acknowledging his own non-humanity, Quinn achieves selfhood, in another ironic way, by reading Mauberley and by refusing to speak the "truth" about himself. While statements by Findley, such as the Trent address, specify both a humanist and an explicitly gay subject-position, in *Famous Last Words* the possibility exists in supplement to the text, as a third, affirmative irony in contrast to the chill reminder with which the novel ends. The emergence of gay communities in recent years is a necessary condition for making Quinn's silence audible. Without that reality, the reader would remain oblivious to this space in Findley's text or would be, at best, the silent sharer of Quinn's (and Findley's) resistance. The engagement of a range of gay groups in contemporary politics likewise contextualizes by contrast the demonic vision of a homosexual aesthetic irony that gathers around the character of Mauberley in the novel. These activities bear witness against the stigma of irresponsibility that many, including Pound, have wielded against homosexuals. The work of gay men and lesbians today bears witness to the value of the attempts that closeted homosexuals made earlier in the century to take responsibility for their consciousness and actions. In return, texts like *Famous Last Words* are equally necessary in sustaining the struggle for gay existence by the witness that they provide to the worth and necessity of that struggle.

At the present moment, at end of summer 1991, when Canadian politics are in danger of breaking down amid conflicting ethnic claims over, literally, the ground under foot, Findley's novel may also serve as a reminder that self-assertion by minority groups need not lead to apocalypse. For Findley, the affirmation of sexual difference has provided a means of raising to the level of conscious analysis

the sexual and ethnic biases of Canadian post-colonial identity. Affirming himself as gay has been necessary in his own coming to voice. In the renewed emphasis on ethnicity in Canadian politics there exists a similar potential to fashion a future that will be not the reduced sum of our differences but a sum larger than the figures that the anglo-Canadian elites offer us today.

N O T E S

* For her reflections on the politics of location, I am indebted to Adrienne Rich. I owe a further obligation to Stephen Barber and Tom Hastings, conversations with whom have contributed to my understanding of Findley's work.

1 Quoted in Rich, *Blood* 176.

2 I adapt the phrase, "ideological work of gender," from Mary Poovey, who comments: "I give the phrase *ideological work* two different emphases. In one sense, it means 'the work of ideology': representations of gender . . . were part of the system of interdependent images in which various ideologies became accessible to individual men and women. In another sense, however, the phrase means 'the work of making ideology': representations of gender constituted one of the sites on which ideological systems were simultaneously constructed and contested" (2).

3 I discuss the connection in "Dorianism," a full-length paper delivered at McGill University in Montréal, Québec, in January, 1991.

4 Joseph Conrad's *Heart of Darkness* (1899) is only one literary instance of this loss of confidence, which is a prime element of literary modernism (Eagleton, *Ideology*, 316–19).

5 I do not mean the modernism of writers like Virginia Woolf, Gertrude Stein or H.D. or of the Hart Crane of *The Bridge*, for reasons which shall be clear shortly.

6 The poem also contains the anti-Semitic section, "Brennbaum" (103).

7 This chronology should not be taken literally. Some homosexuals of Mauberley's generation were not as confused as Mauberley is; similarly, the closeted homosexual is not, as of 1992, a thing of the past. Many gay men are sometimes in, sometimes out of the closet.

8 John Quinn was the name of Pound's literary agent. Notable for his misogyny,

he was also the recipient of the original manuscript of T.S. Eliot's *The Waste Land* (Koestenbaum 120).

9 Walter Pater revives the myth in the context of analyses of homophobia in a number of studies published between 1876 and 1893: "A Study of Dionysus" (1876); "Denys l'Auxerrois" (1886); and "Apollo in Picardy" (1893). For a detailed discussion, see Dellamora ch. 9.

10 On Luini, see Freedberg (264–65). Pater associates Luini with drawings of Salome and John the Baptist, images of male-male desire in Pater's perverse reading of Leonardo (93).

11 In a similar slur, Pound speaks of Mauberley's inability to respond to the sexual invitation of a beautiful woman (107–08).

12 Quoted in Koestenbaum 121 and published in Pound's *Letters*, no. 181. The letter bears more than a trace of *ressentiment*.

13 Timothy d'Arch Smith writes at length about "Uranian" poetry.

14 Wearing white suits is a semiotic sign of Mauberley's love for Karaskavin — and of his attempts to win independence from his father and Pound (69).

15 Stephen Epstein argues that gays in North America are increasingly regarded as one among a number of ethnic groups. This development has gained gay males a measure of protection against police "sweeps."

16 Information in this paragraph is from Kinsman ch. 11.

WORKS CITED

Abrams, M.H. *A Glossary of Literary Terms*. 4th ed. New York: Holt, Rinehart, 1981.

Alexander, Lawrence. "Moral Rights and the Visual Artist." *Vanguard* 17.3 (1988): 14–17.

Andreae, Janice. "Joanne Tod." *Parachute* Sept.–Nov. 1988: 62.

Atwood, Margaret. "Canadian Monsters: Some Aspects of the Supernatural in Canadian Fiction." In *The Canadian Imagination*. Ed. David Staines. Cambridge: Harvard UP, 1977. 91–109.

——— . "Introduction." *The New Oxford Book of Canadian Verse in English*. Ed. Margaret Atwood. Toronto: Oxford UP, 1982.

——— . *Lady Oracle*. New York: Avon, 1976.

——— . *Survival*. Toronto: Anansi, 1972.

Bailey, Alfred G. "Evidences of Culture Considered as Colonial." *Culture and Nationality: Essays*. Toronto: McClelland, 1972. 178–99.

Bakhtin, Mikhail. "Discourse Typology in Prose." In Ladislav Matejka and Krystjna Pomorska, eds. *Readings in Russian Poetics*. London: Cambridge UP, 1971.

Bal, Mieke. *Narratology: Introduction to the Theory of Narrative*. Toronto: U of Toronto P, 1985.

Bannerji, Himani. "Paki Go Home." In *Doing Time*. Toronto: Sister Vision, 1986. 15.

Barbour, Douglas. "Transformations of (the Language of) the Ordinary: Innovation in Recent Canadian Poetry." *Essays on Canadian Writing* 37 (1989): 30–64.

Barthes, Roland. "The Death of the Author." *Image Music Text*. New York: Hill and Wang, 1977. 142–47.

——— . "From Work to Text." In *Textual Strategies: Perspectives in Post-Structuralist Criticism*. Ed. Josué V. Harari. Ithaca, NY: Cornell UP, 1979. 73–81.

——— . *S/Z*. Trans. Richard Miller. New York: Hill and Wang, 1974.

Behler, Ernst. *Klassische Ironie, Romantische Ironie, Tragische Ironie*. Darmstadt: Wissenschaftliche Buchgesellschaft, 1972.

Benveniste, Emile. *Problems in General Linguistics*. Trans. Mary Elizabeth Meek. Coral Gables: U of Miami P, 1971.

Berg, Wolfgang. *Uneigentliches Sprechen: zur Pragmatik und Semantik von Metapher, Metonymie, Ironie, Litotes und rhetorischer Frage*. Tübingen: TBL Verlag Günter Narr, 1978.

Bhaggiyadatta, Krisantha Sri. "Big Mac Attack!" In *The Only Minority Is the Bourgeoisie*. Toronto: Black Moon, 1985.

Blodgett, E.D. "After Pierre Berton What? In Search of a Canadian Literature." *Essays on Canadian Writing* 30 (1984–85): 60–80.

Bolen, Frances E. *Irony and Self-Knowledge in the Creation of Tragedy*. Salzburg: Institut für Englische Sprache und Literatur, 1973.

Booth, Wayne C. *A Rhetoric of Irony*. Chicago: U of Chicago P, 1974.

Brand, Dionne. *Primitive Offensive*. Toronto: Williams-Wallace, 1982.

Brontë, Charlotte. *Jane Eyre*. Ed. Q.D. Leavis. Harmondsworth, Eng.: Penguin, 1985.

Brooks, Cleanth. "Irony as a Principle of Structure." In *Critical Theory Since Plato*. Ed. Hazard Adams. New York: Harcourt, 1971. 1041–48.

Brossard, Nicole. *L'Amer, ou le chapitre effitré*. Montréal: Quinze, 1977.

Büchner, Wilhelm. "Uber den Begriff der Eironeia." *Hermes* 76 (1941): 339–58.

Burke, Edmund. *A Philosophical Enquiry into the Origin of Our Ideas of the Sublime and the Beautiful*. Ed. James T. Boulton. London: U of Notre Dame P, 1968.

Burnham, Jack. *The Structure of Art*. New York: Braziller, 1971.

Calvino, Italo. *Six Memos for the Next Millennium*. Cambridge, MA: Harvard UP, 1988.

Campbell, James D. *Mnemosyne or the Art of Memory: Gerhard Merz*. Toronto: Art Gallery of Ontario, 1988.

Campbell, Maria. *Half-Breed*. Toronto: McClelland, 1973.

Carter, Angela. *The Bloody Chamber*. New York: Harper, 1979.

Celant, Germano. "The European Concert and the Festival of the Arts." Introduction to *The European Iceberg: Creativity in Germany and Italy Today*. Toronto: Art Gallery of Ontario; Milan: Mazzotta, 1985.

Cheetham, Mark. "Purity of Danger: Mondrian's Exclusion of the Feminine and the Gender of Abstract Painting." In *Women and Reason*. Ed. E. Harvey and K. Okruhlik. Ann Arbor: U of Michigan P, 1991.

———. *Remembering Postmodernism: Trends in Recent Canadian Art*. Toronto: Oxford UP, 1991.

———. *The Rhetoric of Purity: Essentialist Theory and the Advent of Abstract Painting*. Cambridge: Cambridge UP, 1990.

Chodorow, Nancy. *The Reproduction of Mothering: Psychoanalysis and the Sociology of Gender*. Berkeley: U of California P, 1978.

Cixous, Hélène. "The Laugh of the Medusa." In *New French Feminisms*. Ed. Elaine Marks and Isabelle de Courtivron. New York: Schocken, 1981. 245–64.

Colombo, John Robert. *ABRACADABRA*. Toronto: McClelland, 1967.

———. "A Found Introduction." *The Avant-Garde Tradition in Literature*. Ed. Richard Kostelanetz. Buffalo: Prometheus, 1982. 304–09. Rpt. from *Open Poetry: Four Anthologies of Expanded Poems*. New York: Simon and Shuster, 1973.

———. "Introduction." *The Mackenzie Poems*. Toronto: Swan, 1966. 7–25.

———. "A Note on the Composition of Some of These Poems." *ABRACADABRA*.

———. *The Sad Truths: New Poems*. Toronto: Peter Martin, 1974.

———. *Translations from the English: Found Poems*. Toronto: Peter Martin, 1974.

Conrad, Peter. *Shandyism: The Character of Romantic Irony*. Oxford: Blackwell, 1978.

Culler, Jonathan. *Structuralist Poetics: Structuralism, Linguistics and the Study of Literature*. London: Routledge, 1975.

Davey, Frank. "Surviving the Paraphrase." *Surviving the Paraphrase: Eleven Essays on Canadian Literature*. Winnipeg: Turnstone, 1983. 1–12.

de Lauretis, Teresa. *Technologies of Gender*. Bloomington: Indiana UP, 1987.

Dellamora, Richard. *Masculine Desire: The Sexual Politics of Victorian Aestheticism*. Chapel Hill: U of North Carolina P, 1990.

Derrida, Jacques. *MEMOIRES: for Paul de Man*. New York: Columbia UP, 1986.

———. "Signature Event Context." Trans. Samuel Weber and Jeffrey

Mehlman. *Glyph 1*. Baltimore: Johns Hopkins UP, 1977. 172–97.

———. "Structure, Sign and Play in the Discourse of the Human Sciences." *Writing and Difference*. Trans. Alan Bass. Chicago: U of Chicago P, 1978. 278–93.

Dews, Peter. *Logics of Disintegration: Post-Structuralist Thought and the Claims of Critical Theory*. London: Verso, 1987.

Dikkers, S.J.E. *Ironie als Vorm van Communicatie*. Den Haag: Kruseman, 1970.

Dinnerstein, Dorothy. *The Mermaid and the Minotaur: Sexual Arrangements and the Human Malaise*. New York: Harper, 1976.

Dollimore, Jonathan. "Different Desires: Subjectivity and Transgression in Wilde and Gide." *Genders* 2 (1988): 24–41.

du Plessis, Rachel Blau. *Writing Beyond the Ending: Narrative Strategies of Twentieth-Century Women Writers*. Bloomington: Indiana UP, 1985.

Duchamp, Marcel. "Apropos of Readymades." *The Essential Writings of Marcel Duchamp, Salt Seller-marchand du sel*. Ed. Michel Sanouillet and Elmer Peters. London: Thames, 1975. 141–42.

Dudek, Louis. "Introduction." *Trouvailles: poems from prose*. By F.R. Scott. Montreal: Delta, 1967. 1–3.

DuVernet, Sylvia. *Egyptian Themes in Canadian Literature: A Review*. Toronto: Blue Chip Publications, 1987.

Eagleton, Mary, ed. *Feminist Literary Theory: A Reader*. Oxford: Blackwell, 1986.

Eagleton, Terry. "Capitalism, Modernism and Postmodernism." *New Left Review* 152 (1985): 60–73.

———. *Criticism and Ideology: A Study in Marxist Literary Theory*. London: New Left Books, 1976.

———. *The Ideology of the Aesthetic*. Oxford: Blackwell, 1990.

Eco, Umberto. "Postmodernism, Irony, the Enjoyable." In *Postscript to The Name of the Rose*. Trans. William Weaver. New York: Harcourt, 1983, 1984.

Ehrmann, Jacques. "The Death of Literature." Trans. A. James Arnold. *Surfiction: Fiction Now and Tomorrow*. Ed. Raymond Federman. 1975; 2nd ed. Athens, OH: Ohio UP, 1981. 229–53.

———. "What Is an Author?" *Textual Strategies: Perspectives in Post-Structuralist Criticism*. Ed. Josué V. Harari. Ithaca, NY: Cornell UP, 1979. 141–60.

Eliot, T S. *Selected Poems*. London: Faber, 1963.

Elliott, Robert G. *The Power of Satire*. Princeton: Princeton UP, 1960.

Empson, William. *Seven Types of Ambiguity: A Study of Its Effects in English Verse*. 3rd ed. New York: Meridien Books-Noonday, 1955.

Endres, Robin. "Talkin' Marxist-Feminist Blues." *Fireweed: A Feminist Quarterly* 19 (Sept. 1984): 82–85.

Epstein, Steven. "Gay Politics, Ethnic Identity: The Limits of Social Constructionism." *Socialist Review* 93/94 (1987): 6–54.

Evans, Arthur. *The God of Ecstasy: Sex-Roles and the Madness of Dionysos*. New York: St. Martin's, 1988.

Fanon, Frantz. *Black Skin, White Masks*. New York: Grove, 1967.

Ferraz, Maria de Lourdes A. *A Ironie romântica: estudo de um processo comunicatovo*. np: Imprensa Nacional-Casa da Moeda, 1988.

Findley, Timothy. *Famous Last Words: A Novel*. Markham: Penguin, 1987.

——— . "Masks and Icons." Interview with Barbara Gabriel. *The Canadian Forum* Feb. 1986: 31–36.

——— . "My Final Hour: An Address to the Philosophy Society, Trent University." *Journal of Canadian Studies* 22 (1987): 5–16.

——— . "A Sense of Place." Unpublished transcript of program produced for State of the Arts, CBC, 1987.

Fleenor, Juliann, ed. *The Female Gothic*. Montreal: Eden, 1983.

Flood, Richard. Rev. of "Monument for the Native Peoples of Ontario, 1984–85." By Lothar Baumgarten. *Artforum* Oct. 1982: 81.

Freedberg, S.J. *Painting in Italy: 1500 to 1600*. Harmondsworth: Penguin, 1971.

Frye, Northrop. "Conclusion to *A Literary History of Canada*." *The Bush Garden: Essays on the Canadian Imagination*. Toronto: Anansi, 1971. 213–51.

——— . *Divisions on a Ground: Essays on Canadian Culture*. Ed. James Polk. Toronto: Anansi, 1982.

Furst, Lilian R. *Fictions of Romantic Irony*. Cambridge, MA: Harvard UP, 1984.

Gallant, Mavis. "An Introduction." *Home Truths: Selected Canadian Stories*. Toronto: Macmillan, 1981. xi–xxii.

——— . *Overhead in a Balloon: Stories of Paris*. Toronto: Macmillan, 1986.

Garber, Frederick, ed. *Romantic Irony*. Budapest: Akademiai Kiado, 1988.

Gaunt, Simon. *Troubadours and Irony*. Cambridge: Cambridge UP, 1989.

Glicksberg, Charles I. *The Ironic Vision in Modern Literature*. The Hague: Martinus Nijhoff, 1969.

Godard, Barbara. "Introduction." *Gynocritics/La Gynocritique*. Ed. Barbara Godard. Toronto: ECW, 1987. i–xi.

Good, Edwin M. *Irony in the Old Testament*. Philadelphia: Westminster, 1965.

Green, D. H. *Irony in the Medieval Romance*. Cambridge: Cambridge UP, 1979.

Groeben, Norbert, and Brigitte Scheele. *Produktion und Rezeption von Ironie*. 2 vols. Tübingen: Günter Narr Verlag, 1984.

Hancock, Geoff. "An Interview with Mavis Gallant." *Canadian Fiction Magazine* 28 (1978): 19–67.

Handwerk, Gary J. *Irony and Ethics in Narrative: From Schlegel to Lacan*. New Haven: Yale UP, 1985.

Hansen, Tom. "Letting Language Do: Some Speculations on Finding Found Poems." *College English* 42 (1980): 271–82.

Harris, Claire. "Policeman Cleared in Jaywalking Case." *Fables from the Women's Quarters*. Toronto: Williams-Wallace, 1984. 37–38.

Hass, Hans-Egon, and Gustav-Adolf Mohrlüder, eds. *Ironie als literarisches Phänomen*. Cologne: Kiepenheuer & Witsch, 1973.

Hassan, Ihab. "Pluralism in Postmodern Perspective." *Critical Inquiry* 12.3 (1986): 503–20.

———. "The Question of Postmodernism." In *Romanticism, Modernism, Postmodernism*. Ed. Harry R. Garvin. Lewisburg, PA: Bucknell UP, 1980.

Holman, C. Hugh. *A Handbook to Literature*. Indianapolis: Odyssey, 1972.

hooks, bell. *Ain't I a woman? black women and feminism*. Boston: South End, 1981.

Howells, Coral Ann. *Private and Fictional Words: Canadian Women Novelists of the 1970s and 1980s*. London: Methuen, 1987.

Hutcheon, Linda. *As Canadian as ... Possible ... Under the Circumstances!* Toronto: ECW and York U, 1990.

———. *The Canadian Postmodern: A Study of Contemporary English-Canadian Fiction*. Toronto: Oxford UP, 1988.

———. *A Poetics of Postmodernism: History, Theory, Fiction*. New York: Routledge, 1988.

———. *The Politics of Postmodernism*. New York: Routledge, 1989.

——— . "Shape Shifters: Canadian Women Novelists and the Challenge to Tradition." In *A Mazing Space: Writing Canadian Women Writing*. Ed. Shirley Neuman and Smaro Kamboureli. Edmonton: Longspoon/NeWest, 1987. 219–27.

——— . *A Theory of Parody: The Teachings of Twentieth-Century Art Forms*. London: Methuen, 1985.

Huyssen, Andreas. *After the Great Divide: Modernism, Mass Culture, Postmodernism*. Bloomington: Indiana UP, 1986.

Immerwahr, R. "The Subjectivity or Objectivity of Friedrich Schlegel's Poetic Irony." *Germanic Review* 26 (1951): 773–91.

Irvine, Lorna. *Sub/version: Canadian Fictions by Women*. Toronto: ECW, 1986.

Jameson, Fredric. "Postmodernism, or the Cultural Logic of Late Capitalism." *New Left Review* 146 (1984): 53–92.

Japp, Uwe. *Theorie der Ironie*. Frankfurt am Main: Klostermann, 1983.

Jardine, Alice A. *Gynesis: Configurations of Women and Modernity*. Ithaca, NY: Cornell UP, 1985.

Jones, Douglas G. *Butterfly on Rock: A Study of Themes and Images in Canadian Literature*. Toronto: U of Toronto P, 1970.

Keeshig-Tobias, Lenore. "(A found poem)." In *A Gathering of Spirit: A Collection by North American Indian Women*. Ed. Beth Brant. Toronto: Women's, 1988.

Kerbrat-Orecchioni, Catherine. "Problèmes de l'ironie." *Linguistique et sémiologie* 2 (1976): 9–46.

Kierkegaard, Soren. *The Concept of Irony, with Constant Reference to Socrates*. Trans. Lee M. Capel. Bloomington: U of Indiana P, 1971.

Kinsman, Gary. *The Regulation of Desire: Sexuality in Canada*. Montreal: Black Rose, 1987.

Knox, Norman. "Irony." In *Dictionary of the History of Ideas: Studies of Selective Pivotal Ideas*. Vol. 2. Ed. Philip P. Wiener. New York: Scribner, 1973. 626–34.

——— . "On the Classification of Ironies." *Modern Philology* 70 (1972): 53–62.

——— . *The Word 'Irony' and Its Context, 1500–1755*. Durham, NC: Duke UP, 1961.

Koestenbaum, Wayne. "*The Waste Land*: T.S. Eliot's and Ezra Pound's Collaboration on Hysteria." *Twentieth Century Literature* 34.2 (1988): 113–39.

Kogawa, Joy. *Obasan*. Markham: Penguin, 1983.

Kroetsch, Robert. "Beyond Nationalism: A Prologue." *Mosaic* 14.2 (1981): v-xi.

———. "Disunity as Unity: A Canadian Strategy." In *Canadian Story and History: 1885–1985: Papers Presented at the Tenth Annual Conference of the British Association for Canadian Studies*. Ed. Colin Nicholson and Peter Easingwood. Edinburgh: U of Edinburgh P, 1985. 1–11.

———. *Essays*. Special Issue of *Open Letter*, fifth series, 4 (Spring 1983). Ed. Frank Davey and bpNichol.

———. *Labyrinths of Voice*. Ed. Shirley Neuman and Robert Wilson. Edmonton: NeWest, 1982.

———. and Diane Bessai. "Death Is a Happy Ending: A Dialogue in Thirteen Parts." *Figures in a Ground: Canadian Essays on Modern Literature Collected in Honour of Sheila Watson*. Ed. Diane Bessai and David Jackel. Saskatoon: Western Producer Prairie, 1978.

Kundera, Milan. *The Book of Laughter and Forgetting*. Trans. Michael Henry Heim. London: Penguin, 1981.

Lang, Candace D. *Irony / Humor: Critical Paradigms*. Baltimore: Johns Hopkins UP, 1988.

Latimer, Dan. "Jameson and Post-Modernism." *New Left Review* 148 (1984): 116–28.

Lautmann, Rüdiger. "Categorization in Concentration Camps as a Collective Fate: A Comparison of Homosexuals, Jehovah's Witnesses and Political Prisoners." *Journal of Homosexuality* 19.1 (1990): 67–88.

Leavis, F.R. *New Bearings in English Poetry: A Study of the Contemporary Situation*. Harmondsworth: Penguin, 1967.

Lipsitz, George. "Cruising Around the Historic Bloc — Postmodernism and Popular Music in East Los Angeles." *Cultural Critique* 5 (1986–87): 157–77.

Mandel, Eli. *Crusoe: Poems Selected and New*. Toronto: Anansi, 1973.

Martin, Graham Dunstan. "The Bridge and the River: Or the Ironies of Communication." *Poetics Today* 4.3 (1983): 415–35.

Mathews, Robin. "Survival and Struggle in Canadian Literature." *This Maga-zine* 6.4 (1972–73): 109–24.

McGregor, Gaile. *The Wacousta Syndrome: Explorations in the Canadian Land-scape*. Toronto: U of Toronto P, 1985.

McKee, John B. *Literary Irony and the Literary Audience: Studies in the Victimization of the Reader in Augustan Fiction*. Amsterdam: Rodopi, N.V., 1974.

Mellor, Anne K. *English Romantic Irony*. Cambridge, MA: Harvard UP, 1980.

Merleau-Ponty, Maurice. "Eye and Mind." Trans. Carleton Dallery. *The Primacy of Perception*. Evanston: Northwestern UP, 1964. 159–90.

Miller, J. Hillis. "Ariadne's Thread: Repetition and the Narrative Line." In *Interpretation of Narrative*. Ed. Mario J. Valdés and Owen J. Miller. Toronto: U of Toronto P, 1978.

Miller, James F., Jr. *T.S. Eliot's Personal Waste Land: Exorcism of the Demons*. University Park: Pennsylvania State UP, 1977.

Miller, Nancy K. "Emphasis Added: Plots and Plausibilities in Women's Fiction." *The New Feminist Criticism*. Ed. Elaine Showalter. New York: Random, 1985. 339–60.

———. *Subject to Change: Reading Feminist Writing*. New York: Columbia UP, 1988.

Modleski, Tania. *Loving with a Vengeance: Mass-Produced Fantasies for Women*. London: Methuen, 1985.

Moers, Ellen. *Literary Women*. Ed. Helen Taylor. London: Women's, 1986.

Muecke, D.C. *The Compass of Irony*. London: Methuen, 1969.

———. *Irony and the Ironic*. London: Methuen, 1982.

Mukherjee, Arun. *Towards an Aesthetic of Opposition: Essays on Literature, Criti-cism, and Cultural Imperialism*. Stratford, ON: Williams-Wallace, 1988.

Mussell, Kay. *Women's Gothic and Romantic Fiction*. Westport: Greenwood, 1981.

Nadaner, Dan. "Intervention and Irony." *Vanguard* 13 (1984): 13–14.

Namjoshi, Suniti. "The Fox and the Stork." *Fireweed: A Feminist Quarterly* 16 (May 1983): 65.

Nesselroth, Peter. "Lautréamont's Plagiarisms; or, the Poeticization of Prose Texts." In *Pretext / Text / Context: Essays on Nineteenth-Century French Literature*. Ed. Robert L. Mitchell. Columbus: Ohio State UP, 1980. 186–95.

Newton, W. Douglas. *Westward with the Prince of Wales*. New York: Appleton, 1920.

Oates, Joyce Carol. "A Conversation with Margaret Atwood." *Ontario Review* 9 (1978): 757–78.

O'Hara, Daniel. Rev. of *On Grammatology*. By Jacques Derrida. *Journal of Aesthetics and Art Criticism* 36 (1978): 361–65.

Pacey, Desmond. *Essays, Canadian Literature in English*. Mysore: Centre for Commonwealth Literature and Research, U of Mysore, 1979.

Parker, Andrew. "Ezra Pound and the 'Economy' of Anti-Semitism." In *Postmodernism and Politics*. Ed. Jonathan Arac. Minneapolis: U of Minnesota P, 1986.

Pater, Walter. *The Renaissance: Studies in Art and Poetry: The 1893 Text*. Ed. Donald L. Hill. Berkeley: U of California P, 1980.

Peterman, Michael A. "Passing Observations upon the Canadian Literary Scene, 1985–1987." *Journal of Canadian Studies* 22 (1987): 3–4, 160.

Philip, Marlene Nourbese. "Oliver Twist." In *Thorns*. Toronto: Williams-Wallace, 1980. 6.

Poe, Edgar Allan. *The Works of Edgar Allan Poe*. Ed. Brimley Johnson. London: Oxford UP, 1927.

Pontbriand, Chantal. "The Historical Factor: A Fundamental Theme in Canadian Contemporary Art." *Parachute* 47 (1987): 50–52.

Poovey, Mary. *Uneven Developments: The Ideological Work of Gender in Mid-Victorian England*. Chicago: U of Chicago P, 1988.

Pound, Ezra. *The Letters of Ezra Pound: 1907–1941*. Ed. D.D. Paige. London: Faber, 1951.

———. *Selected Poems: 1908–1959*. London: Faber, 1975.

Prang, Helmut. *Die Romantische Ironie*. Darmstadt: Wissenschaftliche Buchgesellschaft, 1972.

Princeton Encyclopedia of Poetry and Poetics. Ed. Alex Preminger. Enlarged ed. Princeton: Princeton UP, 1974.

Purdy, Al. "Permanently Canadian." *Globe and Mail* 14 Nov. 1987: D6.

Quintilian. *The Istitutio Oratoria*. Trans. H.E. Butler. Cambridge, MA: Harvard UP, 1921.

Radway, Janice. *Reading the Romance: Women, Patriarchy and Popular Literature*. Chapel Hill: U of North Carolina P, 1984.

Rich, Adrienne. "When We Dead Awaken: Writing as Re-Vision." *Adrienne Rich's Poetry*. Ed. B.C. and A. Gelpi. New York: Norton, 1975. 90–98.

———. *Blood, Bread, and Poetry: Selected Prose 1979–1985*. New York: Norton, 1986.

Richards, I.A. *Principles of Literary Criticism*. New York: Harcourt, 1925.

Richter, David H. "The Reader as Ironic Victim." *Novel* 14 (1981): 135–51.

Rodway, Allan. "Terms for Comedy." *Renaissance and Modern Studies* 6 (1962): 102–25.

Rooke, Constance. "Fear of the Open Heart." In *A Mazing Space: Writing Canadian Women Writing*. Ed. Smaro Kamboureli and Shirley Neuman. Edmonton: Longspoon/NeWest, 1986. 256–69.

Rosler, Martha. "Notes on Quotes." *Open Letter* 5th ser. 5–6 (1983): 194–205.

Ross, Robert. "Mavis Gallant and Thea Astley on Home Truths, Home Folk." *Ariel* 19.1 (1988): 83 89.

Ruthven, K.K. *A Guide to Ezra Pound's Personae (1926)*. Berkeley: U of California P, 1969.

Schlegel, Friedrich. *Friedrich Schlegel's Lucinde and the Fragments*. Trans. Peter Firchow. Minneapolis: U of Minnesota P, 1971.

———. *Kritische Friedrich-Schlegel-Ausgabe*. 22 vols. Ed. Ernst Behler, et al. Münich: Verlag Ferdinand Schöningh, 1958–80.

Scott, F.R. *Trouvailles: poems from prose*. Montreal: Delta, 1967.

Scott, Gail. *Heroine*. Toronto: Coach House, 1987.

Sedgewick, G.G. *Of Irony, Especially in Drama*. 2nd ed. Toronto: U of Toronto P, 1948.

Sedgwick, Eve Kosofsky. "The Beast in the Closet: James and the Writing of Homosexual Panic." In *Sex, Politics, and Science in the Nineteenth-Century Novel*. Selected Papers from the English Institute 1983–1984. New Series 10. Ed. Ruth Bernard Yeazell. Baltimore: Johns Hopkins UP, 1986.

———. *The Coherence of Gothic Conventions*. New York: Methuen, 1986.

Sharpe, Robert Boies. *Irony in the Drama: An Essay on Impersonation, Shock, and Catharsis*. Chapel Hill: U of North Carolina P, 1959.

Siegle, Robert. *The Politics of Reflexivity: Narrative and the Constitutive Poetics of Culture*. Baltimore: Johns Hopkins UP, 1986.

Silvera, Makeda, ed. *Fireworks: The Best of Fireweed*. Toronto: Women's, 1986.

Silverman, Kaja. *The Subject of Semiotics*. New York: Oxford UP, 1983.

Smith, Duncan. "Prose and Found Poetry and Anti-Modernist Aesthetics: A Modernist Response to Capitalist and Socialistic Aesthetic Neutralization." *The Minnesota Review* 15 (1980): 98–111.

Smith, Timothy d'Arch. *Love in Earnest: Some Notes on the Lives and Writings of English 'Uranian' Poets from 1889 to 1930*. London: Routledge, 1970.

Smyth, John Vignaux. *A Question of Eros: Irony in Sterne, Kierkegaard, and Barthes*. Tallahassee: Florida State UP, 1986.

Spanos, William V. *Repetitions: The Postmodern Occasion in Literature and Culture*. Baton Rouge: Louisiana State UP, 1987.

Sperber, Dan. "Verbal Irony: Pretense or Echoic Mention." *Journal of Experimental Psychology: General* 113.1 (1984): 130–36.

——— , and Deirdre Wilson. "Irony and the Use-Mention Distinction." In *Radical Pragmatics*. Ed. P. Cole. New York: Academic, 1981. 295–318.

Stanzel, Franz. "Texts Recycled: Found Poems Found in Canada." *Gaining Ground: European Critics on Canadian Literature*. Edmonton: NeWest, 1985. 91–106.

States, Bert O. *Irony and Drama: A Poetics*. Ithaca, NY: Cornell UP, 1971.

Stempel, Wolf-Dieter. "Ironie als Sprechhandlung." In *Das Komische*. Ed. Wolfgang Preisendanz and Rainer Warning. Poetik und Hermeneutik 7. Münich: Wilhelm Fink, 1976. 205–35.

Strohschneider-Kohrs, Ingrid. *Die romantische Ironie in Theorie und Gestaltung*. Tübingen: Max Niemeyer Verlag, 1960.

Sutherland, Ronald. *The New Hero: Essays in Comparative Quebec/Canadian Literature*. Toronto: Macmillan, 1977.

T[hirwall]., C[onnop]. "On the Irony of Sophocles." *Philological Museum* 2 (1833): 483–537.

Thompson, Alan Reynolds. *The Dry Mock: A Study of Irony in Drama*. Berkeley: U of California P, 1948.

Thompson, G.R. *The Gothic Imagination: Essays in Dark Romanticism*. New York: Oxford UP, 1974.

Thomson, J.A.K. *Irony: An Historical Introduction*. London: Allen, 1926.

Todorov, Tzvetan. *The Fantastic: A Structural Approach to a Literary Genre*. Trans. Richard Howard. Ithaca, NY: Cornell UP, 1970.

Trautwein, Wolfgang. *Erlesene Angst: Schauerliteratur im 18. und 19. Jahrhundert.* Münich: Hanser, 1980.

Turner, Victor. *The Forest of Symbols: Aspects of Ndembu Ritual.* Ithaca, NY: Cornell UP, 1967.

van Herk, Aritha. *No Fixed Address: An Amorous Journey.* Toronto: Seal, 1986.

——. "Women Writers and the Prairie: Spies in an Indifferent Landscape." *Kunapipi* 6 (1984).

Waddington, Miriam. *Collected Poems.* Toronto: Oxford UP, 1986.

Waterston, Elizabeth. "Bogle Corbet and the Annals of New World Parishes." *John Galt: Reappraisals.* Ed. Elizabeth Waterston. Guelph, ON: U of Guelph P, 1985. 57–62.

Watt, Ian. *The Rise of the Novel.* Berkeley: U of California P, 1957.

Weinzweig, John. Interview. "The Radical Romantic." On *Adrienne Clarkson Presents.* CBC Television. 11 July 1990.

White, Hayden. *Metahistory: The Historical Imagination in Nineteenth-Century Europe.* Baltimore: Johns Hopkins UP, 1973.

Wilde, Alan. *Horizons of Assent: Modernism, Postmodernism, and the Ironic Imagination.* Baltimore: Johns Hopkins UP, 1981.

Worcester, David. *The Art of Satire.* 1940; New York: Russell, 1960.

Wright, Les. "Gay Genocide as Literary Trope: A Cautionary Reading of Cautionary Tales." Panel, "AIDS and the Politics of Fiction." Pleasure/Politics Conference, Harvard U, 28 Oct. 1990. Unpublished ms.

INDEX